The Complete Guide to

DIGITAL
COLOR
CORRECTION

The Complete Guide to

DIGITAL
COLOR
CORRECTION

Michael Walker with Neil Barstow

LARK BOOKS

A Division of Sterling Publishing Co., Inc.
New York

contents

The Complete Guide to Digital Color Correction

10 9 8 7 6 5 4 3 2 1

Published by Lark Books, a division of
Sterling Publishing Co. Inc,
387 Park Avenue South, New York, N.Y. 10016
www.larkbooks.com

Copyright © 2004 The Ilex Press Limited

This book was conceived by
ILEX, Cambridge, England

Distributed in Canada by Sterling Publishing,
c/o Canadian Manda Group, One Atlantic Ave,
Suite 105, Toronto, Ontario, Canada M6K 3E7

If you have questions or comments about this book,
please contact:
Lark Books,
67 Broadway,
Asheville, NC 28801

All rights reserved

Walker, Michael (Michael E.), 1962
 The complete guide to digital color correction /
Michael Walker and Neil Barstow.-- 1st ed.
 p. cm.
 Includes index.
 ISBN 1-57990-543-9 (pbk.)
 1. Photography--Digital techniques. 2. Image
 processing--Digital techniques. 3. Color
 photography--Processing. I. Barstow, Neil. II.Title.
TR267.W33 2004
775--dc22
 2003022535

WHY WE NEED TO GET COLOR RIGHT

the call for color

We all want to get color right. And we've been trying to do so for a very long time; from the development of color photography in the first half of the twentieth century, through color television in the 1960s, the introduction of electronic repro in the '70s, desktop publishing in the '80s, and the World Wide Web and multimedia in the '90s, the goal has been the creation and reproduction of the best-looking color images in each new medium. We want to get color right for a variety of reasons. These range from personal satisfaction or the desire to create memorable and compelling commercial illustration or advertising, through accurate reproduction of fine art, to the commercial requirements for mail-order catalogs, and a growing desire for consistent corporate identity and image use across a variety of media and materials.

The penalties for getting it wrong are commensurate; if you get your inkjet print wrong, your family probably won't notice or mind, but if you are trying to sell your work, this could make all the difference between commercial success and thinking of a new career. In advertising, the fruit of your labors has a second or less to catch the viewer's eye and engage his or her attention in order to deliver the message; mail-order firms can't afford to have customers sending goods back because the color of their products is nothing like what customers saw in the catalog; fine art galleries don't expect their clients to make six- or seven-figure purchases based on anything less than the very best reproduction of the works in question.

In the corporate and product-branding world, the image not only has to be perfect, it has to be the same everywhere, from printed materials and signage to vehicle livery, fabrics, and websites. There's never been such a demand for color that's right.

why do we get it wrong?

So why, at the beginning of the twenty-first century, with the fruits of a century of technological development in color image reproduction available to us, do we still get color wrong?

There are lots of reasons. The original image, whether shot on film or captured digitally can have faults—too little or too much exposure, color casts introduced by unusual or mixed lighting sources, film processing errors in the analog world, white balance problems in the digital one, poor quality CCDs in scanners or cameras, lack of calibration or profiling of image capture devices...and that's just on the input side. Add to that the choice and varying characteristics of photographic papers, computer screens, inks and papers on the output side, and perhaps it's more a question of "How do we ever get it right?"

And even if we fix all those things, was the original image how we wanted it to be? Often in image editing, accurately reproducing reality is the last thing we want. As well as retouching blemishes or—more controversially—removing or adding objects or even people that weren't really there when the shot was taken, we might want to completely change the mood of a shot, adding a warm evening glow to a scene or portrait, or to completely change the color of a vehicle or other manufactured product, for example. Even if you don't want to do anything as overt as this, there are subtle tweaks that can be made to improve the impact of almost any image, so even the perfect scan of the perfectly lit, composed, and exposed photo can benefit from judicious color editing.

above Getting the color right can make the difference between an unusable image and one that works. Here an underexposed shot with localized color casts becomes a moody twilight scene

now is a good time

The good news is that it's never been so easy to play with color, whether you do it for fun, for a living, or both. Scanners and digital cameras let you capture color, personal computers and a range of software applications let you tweak it endlessly, and inkjet printers let you see the results of your efforts immediately and at increasingly high quality.

Depending on whether you're a serious amateur or professional photographer, artist, commercial illustrator, or graphic designer, a good inkjet print for personal enjoyment or for commercial sale may be the limit of your aspirations, or you might be hoping to sell your work to a photo library. Or it might be destined to appear in print, on a CD, on a website, in a corporate video, on broadcast TV, or even in a Hollywood blockbuster.

Whatever your situation, you want to get your image looking just how you envisaged it, and then, wherever it's going, you want it to look as good as possible when it gets there. But as you'll already know if you're a imaging professional, and have probably just discovered if you're an amateur, "there's many a slip 'twixt cup and lip"—just having the hardware and software isn't any guarantee of good results. What's more, the range of options and variables that you'll find in professional quality software can sometimes only serve to make things more confusing.

Today's digital tools give you unparalleled creative control of your images at prices that only 15 years ago would have been thought impossible. Professional color image-editing suites used to cost hundreds of thousands of dollars. Today, however, you can set up a studio for considerably less than $5000 and—provided you know what you're doing—produce work to rival anything created with them.

how and why

And that's the key—knowing what you're doing. This book aims to give you the theoretical underpinnings of digital color, together with practical tips and worked examples of how to use digital color correction tools to make the most of any image, and to ensure that it can be passed on for use in a variety of media with the best possible reproduction from each. Although we assume that you're mostly interested in getting hardcopy output via inkjet or photographic printer or commercial offset color printing, we also look at

latter is concerned with giving it the best chance of still looking like that when it's printed on an inkjet, on an offset press, or sent to someone else to view on-screen. Most jobs will require elements of each type of correction, so in order to get the best from your work, it's essential to have an understanding of both how to achieve your creative goals and how the various reproduction techniques work—and how those two processes can sometimes be at odds with each other.

preparing images for use on the Web or in multimedia and in video applications.

There are really two fundamental categories of color correction—aesthetic and production-related. The former is all about getting the image to look exactly as you (or your client) want it; the

This isn't a book about creating wacky layered photomontages or surreal freehand illustrations on a computer; it's about working with and optimizing color images that originate as photographs, whether shot on traditional film and scanned, imported directly from a digital camera, or acquired in any other digital format. All the examples given to illustrate both creative and reproduction-focused tasks use Adobe Photoshop because this is the market-leading, professional level image-editing program.

However, the general techniques and principles involved should be applicable to any professional quality image-editing software for personal computers.

As well as showing you how images can be optimized, we'll point out the limits too. Virtually any picture can be improved, though not always as much as you may want. We'll provide guidance along the way about difficult problems to watch out for and how to work within the limits of your eventual output process—for example, there's no

Chapter 4 introduces the general principles that underlie all color correction and then demonstrates the use of the various tools of the color correction expert in the context of real jobs in a wide range of photographic conditions. A variety of problem images and creative briefs are addressed in detailed, step-by-step work-throughs.

Chapter 5 is all about getting from your perfect image to output in a variety of forms—whether that's an inkjet print; a digital file for the Web, for video, or for submission to a magazine or

point turning up the colors on your computer screen if you can't print them.

Chapter 1 starts with a review of the fundamentals of light, how and why we see and interpret color, and what our eyes and brain are good—and bad—at differentiating. In Chapter 2, we explain how color is quantified and processed in the digital world, and introduce the concept of color management, which is central to managing the "production" aspect of color correction in a digital environment. In Chapter 3 we lay the ground work for your color correction studio, explaining how to capture and save images ready for further work and how to color manage your own equipment.

photo library; a digital photographic print or any kind of offset printing.

By the time you've worked through it all, you will be familiar with color correction concepts and techniques and in a position to prepare and hand-off suitably formatted files for any purpose as well as to produce your own prints. All that remains is to practice—and enjoy yourself.

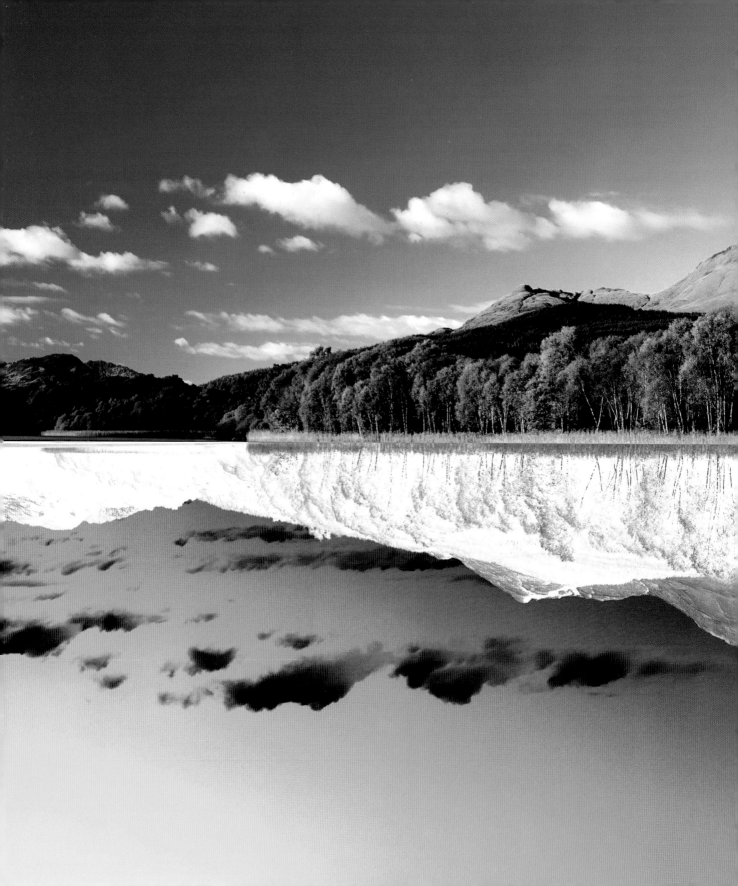

WHAT ARE YOU LOOKING AT?

Before you can "correct" color, you need to understand what it is and what factors affect the way we see it and try to reproduce it. After millions of years of evolution, the human eye is enormously discerning, but the tools we use for light and color capture, editing, and reproduction —less than a hundred years old—are still catching up. The huge differences between nature's system and man-made ones explain why what we think we see isn't always what we get.

We also need to think about what is meant by "right color" in different contexts. Imagine a photograph of a model on a beach, under tropical vegetation, beneath a cloudless sky. If the picture is for a vacation brochure, you probably want both sea and sky to be deep blues (though not the same blue), with the vegetation a lush green. However, a clothing catalog may be more concerned with getting the color of the model's clothes accurate, even if other colors suffer. A botanist might want maximum detail in the vegetation, while a lifestyle magazine needs the model looking natural and healthy, and the setting to look inviting.

There are different criteria according to the purpose of a picture, then, but there are also some rules common to all. No one will find the picture acceptable if the model's skin looks green because of the shadow of palm fronds; equally, no one will be impressed if your efforts to improve the greens in the vegetation change the sand or sky to unappealing or unlikely colors.

This is because of what's known as "memory colors." We all have a strong (though not necessarily accurate) idea of what color certain common things are, like skin, sky, grass, or water. Get these wrong and no amount of cleverness in other areas of a picture will make up for it. There are some things that we must get right, and others that aren't so essential. This is important, because most color correction involves a trade-off: making one part of an image look better, but only at the expense of another. Our eyes and brain do this automatically, but image capture devices (cameras, scanners, and so on) can not. This is one reason why we need color correction.

One thing worth stressing is that, ultimately, color correction is about making things look better—this should be your yardstick for anything you do. All the technical stuff, particularly relating to color management, is intended to help us get color right automatically. Remember though, that whatever the machines say, you are working on an image that's going to be looked at by humans. So use your eyes too.

how we see and interpret color

To produce the sensation that we call color requires three things—an object (to be seen), light (to illuminate the object), and an observer (to see the object by the light it emits or reflects). So color depends on what you're looking at, how it's lit, and who's looking.

let there be light

To understand how we see color, let's first have a bit of physics and biology. The light that's visible to humans is part of the electromagnetic spectrum, which also includes heat radiation (infrared), radio waves and microwaves, X rays, and gamma rays. The part of the spectrum we can see is defined by wavelengths from about 700nm, which corresponds to the red end of the spectrum (see below) through to about 400nm which is the blue/violet part (nm = nanometer—a nanometer is a billionth of a meter, or a millionth of a millimeter). In between the extremes we see the familiar orange, yellow, green, and blue colors.

You'll notice that this gives us only a very small set of colors—no browns, no pinks, no grays. So, if those are all the colors in the wavelength range of light we can see, where do all the others that make our vision so rich come from?

The answer is that all these millions of other colors come from mixtures of these basic colors. An equal mixture of all the colors gives us what we call white light (though as we'll see later, the brain is very good at adapting to some quite non-white lighting conditions, and still letting us see things as white). The classic prism experiment, in which a beam of white light is split into the familiar colors of the rainbow, is a perfect illustration of this.

above All the colors we can see are made by mixing the colors of the rainbow in different proportions

below The ideal and typical measured wavelength mixtures for the main printing ink colors, with percentage reflectance shown in the vertical axis

CYAN

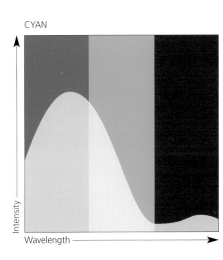

Intensity

Wavelength

MAGENTA

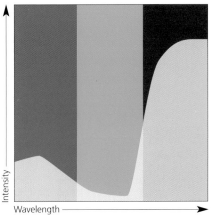

Intensity

Wavelength

YELLOW

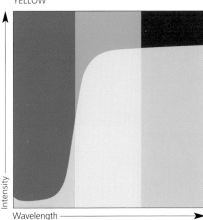

Intensity

Wavelength

eyes to see

So much for the light. Now how do we see it? The illustration opposite shows the eye's construction. Light coming through the lens is focused on the retina, a layer of light-sensitive cells on the inside of the eye. These cells take two forms, known as rods and cones. The rods are sensitive only to overall brightness, while the cones come in three kinds, each sensitive to a different color range, broadly red, green, and blue. These cells are distributed unevenly. There's a small dimple in the back of the eye called the fovea, packed with the color-sensitive cones, which is the area that gives the most acute color vision. The rest of the retina has progressively fewer cones as you move away from the fovea.

When you "look at" something, your eye is moving and focusing so that light from the exact point of interest is focused on the fovea—we don't really look at a whole face, scene, photo, or page at once; our focus continually skips from point to point as each is brought to focus on the fovea in order to extract maximum information.

It's worth throwing in some numbers to show how complex this system is: there are about 120 million rod cells in each eye and about six million cones; around a million nerves link each retina to the brain via an optic nerve. The brain itself is a far more sophisticated image processor than anything that Apple, IBM, or Silicon Graphics has yet built. It's here some of our problems with image reproduction start. The eye/brain combination is tremendously flexible in adapting to a wide range of conditions, including huge variations in brightness and color of light.

As well as being able to see under full sun in desert landscapes, we can see on overcast days, in fog, at dusk, and even by moonlight (though the cones in our retinas don't work at low intensities and the rods take over, which is why we can't see color in near-dark conditions). Think how many f-stops that would be on a camera.

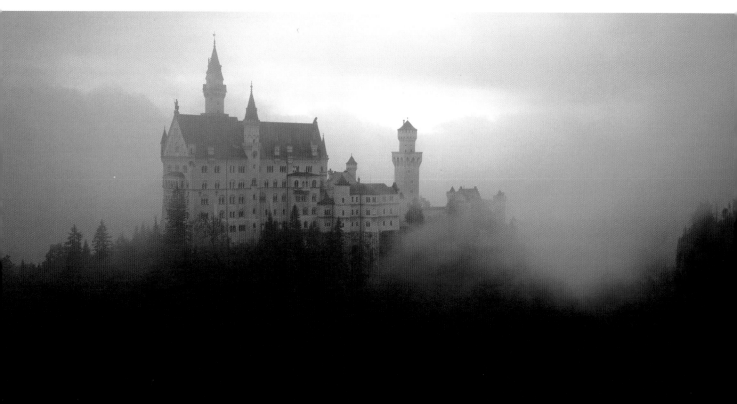

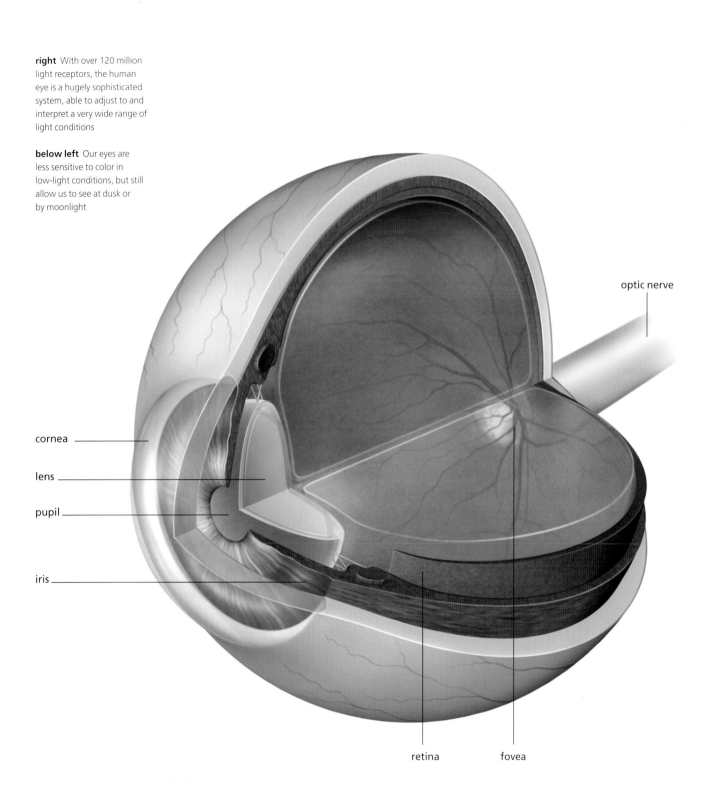

right With over 120 million light receptors, the human eye is a hugely sophisticated system, able to adjust to and interpret a very wide range of light conditions

below left Our eyes are less sensitive to color in low-light conditions, but still allow us to see at dusk or by moonlight

optic nerve

cornea

lens

pupil

iris

retina

fovea

can we believe our eyes?

When we step into a forest, everything doesn't go green. If we read by candlelight the paper still looks white, not yellow. This is the brain adapting to the surroundings, and it's done immediately and unconsciously (technically it's known as color constancy). More than that, when we go into an area where one color predominates, such as the forest, a desert or a snowfield, the eye and brain adapt to provide maximum differentiation between the similar shades. If there aren't any reds, blues, or yellows around, then we see more shades of green.

In addition, there is a phenomenon known as simultaneous contrast. It could be summed up as "What things look like depends on what's around them," but it's probably better to look at the diagram on the opposite page. Technically, the

green stripes are all the same color, but they certainly don't look like it. If you don't believe it, try punching some holes at appropriate distances in a sheet of paper and looking at the two sets of green bars through them. With the surrounding colors hidden, they will look identical.

There's another perceptual oddity to be aware of, perhaps even more important than those already discussed. Metamerism is the ability of a pair of objects to appear the same color under one light source but different colors under another. You may well have experienced this—have you ever bought clothing only to find that the colors that matched in the shop don't match outside?

Described more scientifically, metamerism means that different spectral signals reaching the eye can produce the same response in the cones,

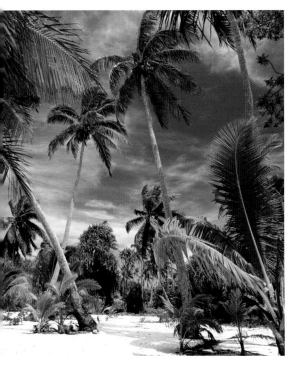

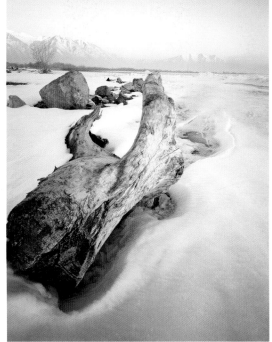

left Our eyes are extremely adaptable and work to extract the maximum information whether a scene has a single dominant color or a mixture of hues

right How we see a color is affected by what's next to it—the two sets of green bars in the illustration opposite are actually the same color as a machine would measure it, but they don't look the same

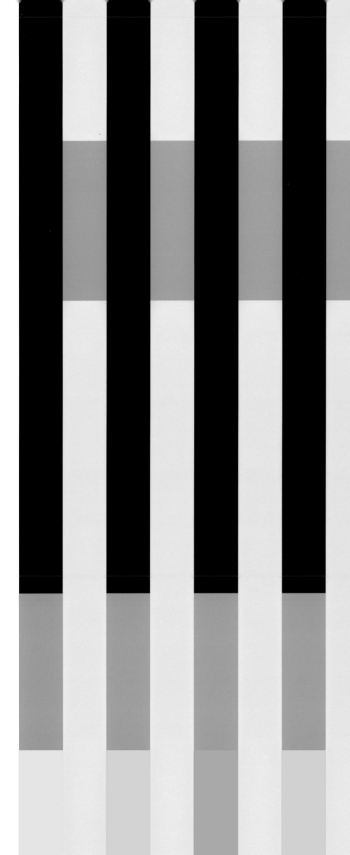

which means you see the same color. As the spectral signals reaching the retina depend both on the objects being viewed and the light shining on (or from) them, a change of light (such as from fluorescent, halogen, or tungsten bulbs to daylight) can alter the spectral content and hence affect the colors you see.

Metamerism is often (and mistakenly) described as a kind of fault in digital color printers when colors don't appear to match or grayscales don't look neutral under certain lighting conditions, but it's actually a useful phenomenon. Because objects with different spectral characteristics can look the same, we can print a plausible image of a green leaf using only blobs of cyan and yellow ink—there's no green there at all, but our eyes can be fooled into thinking there is. There's no yellow on a computer screen either, but the combination of red and green makes us think there is when we look at an image of a daffodil. Without metamerism, printing anything realistically in color would be virtually impossible. It's also the reason why we should standardize lighting conditions when viewing proofs.

The flip side to metamerism is that changing the observer can make or break a color match, even if the objects and light source remain the same—what looks the same to a human doesn't necessarily look the same to a machine such as a scanner or digital camera. This, unfortunately, is a restriction in our quest for image fidelity.

Aside from their evolutionary benefits, these characteristics of human vision are more than interesting coincidences—they have a direct bearing on how we should set about any kind of color correction. We'll come back to this in Chapter 3, when we get ready to put color correction into practice. Meanwhile, we need to turn our attention to understanding how color is described and manipulated by machines.

1

capturing and reproducing color

Humans have a long history of trying to reproduce color. From the cave paintings at Lascaux in southwestern France (estimated to be around 15,000 years old), through the illustrations in the Egyptian tombs at Luxor, the works of the Greeks and Romans, the flowering of the Renaissance, the Dutch grand masters, and the invention of color photography in the early 20th century to today's film and digital cameras, camcorders, scanners, and even picture-taking cell phones, it has been one long progression in trying to capture and reproduce what we see.

Although getting color right isn't quite the trial-and-error process that it was for our ancient ancestors, neither has it been reduced completely to a mechanical process that requires no intervention or judicious consideration. There still needs to be some art in the science.

Color photographic films capture color via emulsions that are sensitive to red, green, and blue light in roughly the same way that the cones in the retina are. Processing the films transforms the latent image into cyan, magenta, and yellow dye clouds in the finished transparency or negative (with colors inverted in the latter case).

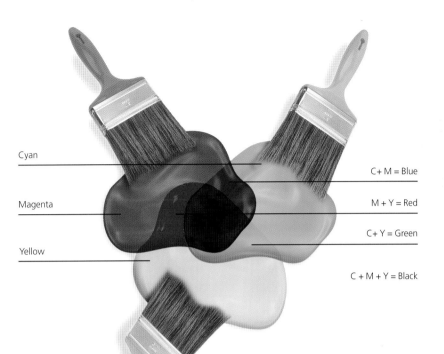

Cyan

Magenta

Yellow

C + M = Blue

M + Y = Red

C + Y = Green

C + M + Y = Black

color arithmetic: addition and subtraction

This transformation from red, green, and blue light into cyan, magenta, and yellow dyes illustrates a fundamental division in how colors can be created or shown and this has profound implications for color reproduction, and therefore for color correction. As described earlier, mixing light of all different wavelengths (colors) together produces white light, and selectively mixing combinations of the primary colors—red, green, and blue—can create all other colors. This is known as additive color mixing—you can remember it because adding all the colors together makes white. Computer monitors, TV screens, and data projectors all use additive color mixing to create color images. You can see this illustrated on the right.

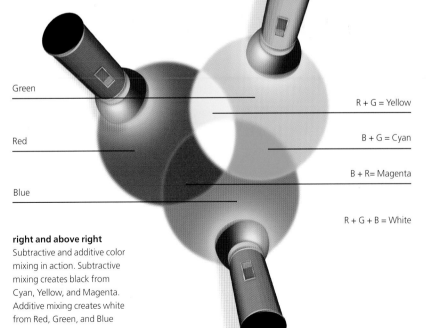

Green

Red

Blue

R + G = Yellow

B + G = Cyan

B + R = Magenta

R + G + B = White

right and above right
Subtractive and additive color mixing in action. Subtractive mixing creates black from Cyan, Yellow, and Magenta. Additive mixing creates white from Red, Green, and Blue

When we want to put color on paper or other surfaces, we have to switch to what's called subtractive color mixing. We shine white light (which contains all colors) onto the ink on our paper; some of the wavelengths (colors) are reflected and some absorbed, or "subtracted," from the light. Cyan ink absorbs red but reflects green and blue light; yellow absorbs blue but reflects red and green; magenta absorbs green but reflects red and blue (*see previous page, bottom illustration*). Mixing these primaries results in more colors being subtracted from the reflected light—cyan and yellow together subtract blue and red, leaving just green; magenta and yellow together subtract green and blue, leaving just red; and so on. Adding all three primaries subtracts all the reflected colors and gives us black.

A useful way to depict the relationships between the additive and subtractive primary colors is with a simple table (*see below left*) depicting the inverse relationships, or a color wheel (*see below right*) like that found in the Apple Color Picker. Unlike the kind of color wheel used by artists, in which red, yellow, and blue are considered to be primary colors, this one is based on the RGB components of light. It shows how the subtractive primaries are derived (in additive mixing) from RGB, and more usefully for color correction, it shows the inverse relationship of the additive and subtractive colors. If you want to control a color that's not a primary in the mode you're working (RGB or CMYK), look for the color diametrically opposite and use that to fix a cast (or introduce one if that's your aim).

If you're working on an RGB image and it looks too cyan, vary the red to correct it. If a CMYK image looks too green, start with the magenta (though there are important caveats when turning up the complementary color to fix a cast in CMYK; see Chapters 4 and 5). But be aware that in either color mode, you may have to adjust all three (or four) colors to preserve tonal values after a change like this.

RGB CMY

above The relationship between the primaries in the additive and subtractive color mixing models can be summarized by the letter table above, in which each color is vertically aligned with its complement

right The color wheel shows the same relationship in terms of diagonal opposites, with intermediate shades

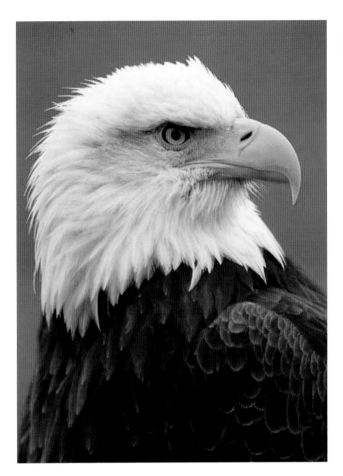

The subtractive primary colors are cyan, magenta, and yellow, so why do we need black ink as well? If we had ideal inks with perfect reflectance and absorption characteristics, we wouldn't, but this is real life and inks aren't perfect. Mixing solid cyan, magenta, and yellow doesn't give a good black, but a muddy brown color, so we add a proper black ink.

This is referred to as K for "key" and to differentiate it from B (blue).
It's also simpler to print black-only items such as text, rules, and linework using one ink. Otherwise the register (the alignment) of the overprinting inks becomes an issue on press. Black ink is cheaper, too, and one layer of ink will, of course, dry faster than three. The maximum amount

of ink you can put onto paper without it tearing, wrinkling, or needing excessive drying time is also a big concern in commercial printing, especially in newspapers. Black ink can be used to replace equal amounts of the three other colors via processes known as Gray Component Replacement (GCR) and Under Color Removal (UCR), reducing the

ink "weight" and drying time as well as saving money. The illustration above shows CMYK separations of an image—note how the black is mostly very thin except in shadow areas. The way that the black plate is generated and maintained in a CMYK file is critical to its printability and quality, and this will be discussed, along with GCR and UCR, in Chapter 5.

Why do we print CMYK?

capturing color

So much for how colors are mixed in emitted and reflected light. How do we get color information into a form where software can get at it?

There are two main types of image capture technology. The more modern (and more widely used these days) is based on an electronic component called a Charge-Coupled Device (CCD). The basic principle of a CCD is this: if you shine light on it, it generates a tiny electrical charge that is (within limits) roughly proportional to the intensity of the light. By building large arrays of CCDs and putting red, green, and blue filters over them, you can make a high resolution RGB image-capture device.

CCDs are at the heart of digital cameras and all flatbed scanners, from office units to repro-quality models. The ones in cameras tend to be rectangular arrays that allow a full-frame image to be captured more or less instantaneously, while those in scanners are usually wide strips that are moved steadily along the item being scanned, effectively building up the image a row of samples or pixels at a time. Some types of studio digital camera also use this scanning technique to provide higher resolution (and therefore more detailed) images than would be possible using a single-shot CCD.

An older technology that was (and often still is) used in top-quality repro scanners is the Photomultiplier Tube (PMT). A bit like an old-fashioned valve, the PMT has a photosensitive element (cathode) at one end and a sensor (anode) at the other. Light hitting the cathode causes electrons to be emitted, which are then effectively amplified in several stages along the length of the tube to give very good sensitivity to small changes in the incident light. In a PMT scanner, light is either shone through a transparent original or reflected off a print or other medium, split into RGB by filters or a prism, and then into three PMTs to create RGB signals as the scanning head is slowly moved along the rotating drum on which the original is mounted.

below Consumer and semi-professional cameras and office scanners use CCDs to capture color image information. CCD performance continues to improve, bringing higher resolutions and better density ranges

right CCDs are also used in dedicated 35mm slide scanners aimed at the semi-pro and professional photography market

below Many high-end repro houses use drum scanners based on photomultiplier technology. This still has an edge over CCD in quality

Drum scanners with PMTs used to be unquestionably superior for high quality image reproduction—particularly in their density range (the ratio between lightest and darkest values that can be detected)—but significant advances in CCDs, electronics, software, and optical design over recent years have brought the best professional-quality flatbed units to the point where most of us would find it impossible to see the difference between scans done on each type of machine. Flatbed scanners are vastly cheaper than the drum variety and almost always far easier to use.

CCD development in digital cameras (and in scanners) continues apace, with appreciably higher pixel counts (*see Chapter 2*), improved color accuracy, and image quality being brought out at less than yearly intervals.

1

above Blue skies make blue shadows; artificial lighting is usually orange-yellow or yellow-green. Your eyes and brain are very good at compensating for this, but cameras and image-capture devices are not

the effect of color temperature

We said earlier that white light was the combination of equal amounts of all the different "rainbow" wavelengths. But there's white light and white light, as anyone who's ever taken a photograph under tungsten or fluorescent lighting (or worse, a mixture of the two) will know. Different kinds of light sources have different mixtures of the various wavelengths and hence impart different color casts to things they illuminate.

We don't tend to be aware of this because of the brain's rapid and unconscious adjustment of the "white point" (the color that we think is white). To us, an object that is "white," like a sheet of paper, a shirt, or a cup, continues to look white as we view it under a variety of lighting conditions. But machines like cameras and scanners can't make that adjustment and so capture the scene as it "really" (in a technical, measurement sense) is, with results that are probably all too familiar: tungsten light is very warm, giving a strong red-yellow cast; fluorescent tubes give a particularly unpleasant yellow-green effect.

It's not just limited to artificial light sources. Sky light in shadow areas on a clear sunny day is distinctly blue, and you may well have noticed people or objects in the shade in your summer vacation photos looking distinctly bluish.

Getting the whites right

If we want to have any control over reproduced color, we need to standardize what we mean by "white" light. To quantify this effect, we use a measure called color temperature. This is based on the idea of a theoretical "black body radiator," an object that is not illuminated by any kind of external source but, as it is heated, begins to emit first infrared (heat) and then visible radiation. The temperature scale is measured in Kelvin (K), which are equivalent to degrees Centigrade (Celsius) but referenced to absolute zero (a state at which an object has no heat energy at all), which is about –273°C.

At about 2,000K objects start to radiate visible light, starting with dull red, then moving up through orange and yellow between about 3,000 and 4,000K—tungsten-balanced photographic film is optimized for light at 3,200K. Fluorescent lamps of different types span a range of values on this scale, from a little over 3,000K all the way up to about 7,500K. Between about 5,000 and 7,000K, the emitted spectrum is more or less flat across the wavelengths, giving a

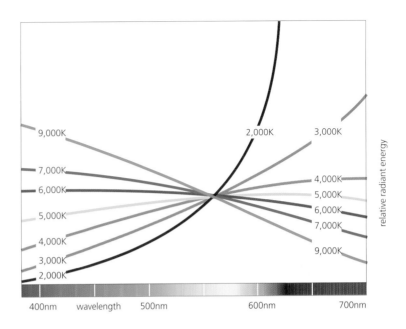

fairly neutral white light—noon sunlight is around 6,000K. At higher temperatures, the blue/violet part of the spectrum dominates, giving bluish light—a north-facing skylight will let in light at a color temperature of nearly 8,000K, while a clear blue sky at noon is more like 12,000K. The illustration above shows how the spectral distribution changes according to color temperature.

Unfortunately, correcting for the effects of color temperature can't always be 100 percent successful—if a scene is shot under tungsten light, there may be so little blue wavelength light in the light source that blue objects will reflect hardly any more light into the camera than black ones, making the two virtually indistinguishable even after removing a color cast from other colors. This problem is pretty much restricted to conventional film-based photography since most digital cameras have a white-balance control built in (you may choose to bypass it if working with "raw" digital camera data, see Chapter 3). However, even this may not be able to compensate for the strong green wavelength "spike" that is produced by many fluorescent lamps.

above How the spectrum of "white" light varies with color temperature. The shorter wavelengths represent the blue/violet end of the spectrum, red is at the right-hand end of the scale

color models, spaces, and gamuts

Having discussed the nature of color, how we see and measure it, and why those two things aren't always the same, we need to introduce some theoretical constructs that provide a mechanism to move color from an original photo or piece of art into a computer, onto its screen, and out to inkjet or offset print, to transparency recorder or to another digital destination, such as a CD or Web page.

We've touched on additive color mixing using red, green, and blue light (RGB) and its subtractive complement that uses cyan, magenta, and yellow (plus black for real-world printing). These appear to give us the basis for systems to define colors in terms of three (for RGB) or four (for CMYK) values or coordinates—"this much red plus this much blue plus this much green gives such-and-such a color." We call these "color spaces."

But there's a problem with these color spaces—unless we know exactly which red, green, and blue (or C, M, and Y) we are giving values for, someone else we give them to won't really know what color we mean. If the R, G, and B they use are even a little different, the mixtures they get from those numbers won't be the same colors that we had; their reproduction of our color will be wrong. When they open our files, they'll immediately have to make an assumption (even if it's done automatically by the software's default settings) about which R, G, and B (or CMYK) we meant, and if that's wrong, all the colors will be wrong.

The underlying difficulty here is that RGB (and CMYK) are mostly "device-dependent" color spaces. In order for either of them to give an unambiguous color description, we need to know not only the unit values for each of the primary colors (the coordinates) but also exactly what colors those primaries are (a definition of the axes and scale, to use a mathematical analogy). To do this, we need an absolute color reference that is completely independent of either of these systems.

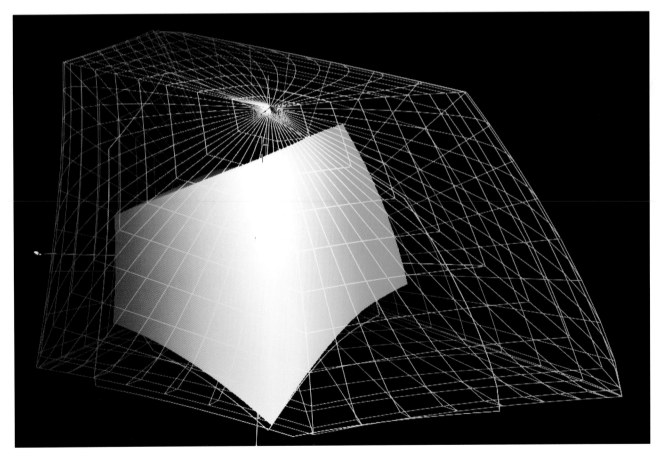

defining LAB in the lab

There has been much scientific research into color perception, measurement, and description over the last century or so, and it has produced a variety of "color models." Some of these attempt not only to provide absolute definitions of color (in terms of agreed references based on unvarying parameters such as particular wavelengths of light) but also to provide a representation that corresponds reasonably well to the human perception of color.

The favorite candidate for our purposes is the CIE LAB color model. CIE stands for the Commission Internationale de l'Eclairage (International Commission on Illumination), an international scientific and technical body founded in the 1920s to study and model human vision. As a result of various experiments into human perception of color, which involved subjects varying the strength of red, green, and blue lamps to match a series of sample colors (illustrated on the opposite page), the CIE developed a number of models of color that usefully represent various characteristics of the human visual system. These form the basis of all current colorimetry (the science of color measurement) and color management (something we'll be saying a lot more about in the next chapter and which in our opinion is a fundamental aid to doing color correction).

LAB stands for the three parameters ("axes") in this color model. L is the luminance of a color—in everyday speech, the "brightness," from solid black to the brightest white—while A and B are "color" axes that range from red to green and blue to yellow respectively. One of the characteristics of the LAB model is that it attempts to arrange colors such that equal distances between color definitions correspond to equal perceptual differences as far as humans are concerned. It does this pretty well, but it's important to remember that the full human visual system is far more complex than was allowed for in the original CIE experiments— read the theory, do the color management, but always remember to use your eyes as well.

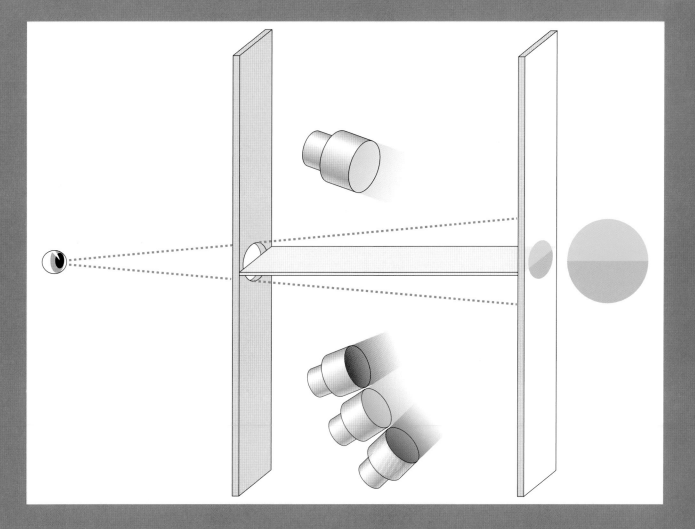

device-independent color

CIE LAB gives us a way to define colors that isn't dependent on the physical characteristics of colorants (such as printing inks or monitor phosphors). If we have RGB (or CMYK) values and have the definition of the RGB (or CMYK) primaries as CIE LAB colors, we can work out the CIE LAB equivalents for all the colors in our color spaces. This gives us a color description that can be understood correctly by anyone, without them needing to know anything about our original setup. Further, having a CIE LAB description of a color also allows us to convert it into values that our monitors or printers can use to produce exactly that color (assuming they can—see below).

CIE LAB is a device-independent way of defining colors and it's the keystone of color management because every color we can capture, display, or output can be described within it.

CIE LAB is designed to represent the entire range of colors that the average human being can see. However, once we start transforming the color spaces of real-world devices such as scanners, monitors, inkjet printers, and printing presses into CIE LAB, it quickly becomes apparent that none of them fill the entire CIE LAB space—in other words, none of these devices can detect or reproduce the entire range of visible colors.

The range of CIE LAB colors that a device can differentiate or reproduce is called its "gamut" and it also swiftly becomes apparent that RGB color spaces or gamuts are generally larger than CMYK ones —that is, RGB devices can describe more of the CIE LAB colors than CMYK ones. However, you'll also notice that there are colors that the CMYK space can handle but RGB can't, usually in the green/cyan region and often also in the extreme yellow part of the spectrum as well. You can see this in the two illustrations on the opposite page.

This has critical consequences for the conversion of scanned or digitally shot photographs for print—there are colors in your photograph that just can't be printed using conventional CMYK printing. "Wide gamut" inkjet printers using special additional ink cartridges with orange and green inks go some way toward making up for this, but they still fall short of what you can get in RGB (the inkjets with additional light magenta and cyan inks don't have a wider gamut; the extra inks just allow smoother gradations to be printed). What happens to those "out of gamut" colors in the conversion is a major concern for anyone sending images to print, and a key factor in setting up color management to get the best possible results (more on this in chapters 2 and 3).

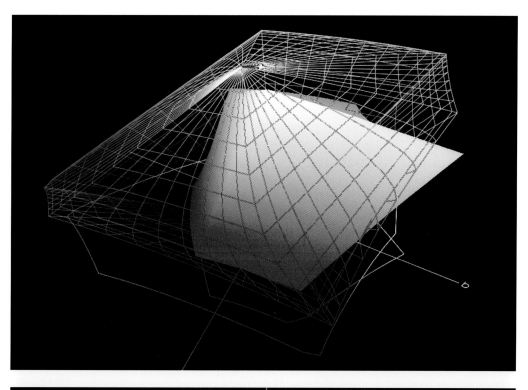

above right A comparison of the sRGB (wireframe) and Euroscale coated (solid) color spaces in ColorThink

below right The same color spaces viewed from a different angle, showing where the CMYK gamut exceeds that of RGB

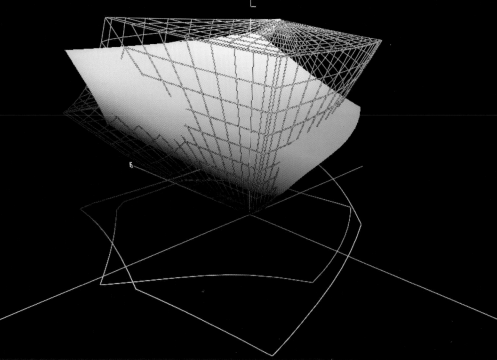

COLOR IN THE DIGITAL WORLD

chapter 2

In photography, the original transparency or negative is everything, but in the digital world, the computer file is all. Working with color in digital format brings enormous creative freedom, together with the ability to make unlimited copies for experimentation without degrading the original—no more duping transparencies or making extra prints from negatives.

By converting your images to binary digits—1s and 0s—they can be stored indefinitely on your hard disk, copied to writable media such as CD or DVD, sent via e-mail, or posted on a Web page. This makes it possible to exchange color information without loss of quality or detail (within the capabilities of each device) between digital cameras, scanners, personal computers, and a variety of output devices—and, of course, between people.

It may be that the end product of your color correction efforts is not an inkjet print or an offset printed magazine or brochure, but is itself a digital file that you sell via a photo library, or to a website developer or TV production company. The image may end up in print or on someone's TV or computer screen, but your control over its quality will end with the delivery of the file, so getting the file right is paramount.

Magazines, newspapers, and graphic design studios are increasingly able and willing to accept digital files instead of physical media. It's faster (no waiting to dupe transparencies or for overnight deliveries), safer (because you send a copy of your file, the "original" remains safe with you) and offers better quality (since the copy you send is in every way identical to your original).

Given the key central role that digital files play in the image workflow these days, you need to know a little about how they're made up and how computers work with them. As well as this, you'll also need to know how to prepare files for reliable, accurate transmission of color information from one place to another, from one medium to another.

This chapter introduces the fundamental types of image file and explains the basic parameters that govern image quality, and then looks at how that image information can be accessed, displayed, and manipulated using image-editing software. We then look in some detail at color management—the underlying technology for accurately describing and transferring color information from device to device in the digital world.

2

describing color digitally

There are two fundamental graphics file types: bitmaps and vectors. Bitmaps are rows of dots, or "pixels" (from "picture elements"), of different color, which build up line by line to form an image. Also called raster graphics (the raster is the line-by-line sweep), this is how your TV picture is made, how a digital camera or scanner captures an image, and how your computer monitor displays it. Bitmaps are the file type that all image-editing programs use.

Vector graphics don't deal in pixels. A vector graphic file describes objects in terms of their shape, position, angle, and color—for example, "a red square tipped 45° with a blue circle inside it" (*above left*). The benefit of vector graphics is that they can be scaled to any size and still look sharp, while bitmaps that are blown up too much look blocky or "pixellated." Vector graphics files are generally smaller as well.

Vector graphics are usually created and edited with "drawing" or "illustration" programs like Adobe Illustrator, Macromedia FreeHand, or Corel Draw. Another key use for vector graphics is fonts—although you don't need a drawing program to use them, PostScript, TrueType, and OpenType fonts use vector outlines (*above right*), enabling the characters to be scaled to any size and orientation yet still display and print crisply.

Since this book is primarily concerned with color correction of photographic or photorealistic images, we won't be spending a great deal of time with the vector format, which is best for completely synthetic drawings or technical illustrations (though we will touch on how to handle the colors assigned in files of this type later on).

There are two crucial things to know about a bitmap graphic file: how many pixels there are in it (because this determines how much detail it can show and how large you can reproduce it) and how many potential colors there can be per pixel (because this determines how good the color quality can be).

The former quantity is sometimes referred to—wrongly—as the "resolution" of the file. Resolution is a measure of samples or locations per unit length, such as pixels per inch or lines per millimeter. An image that is 3,000 columns by 2,000 rows of pixels doesn't have any resolution until you specify the dimensions. Once you're told that it's 10 inches wide, you can work out that the resolution is (3,000/10) 300 pixels per inch (which is suitable for high-quality printing, but more of that in the next chapter). To convey how detailed a file might be, it's best to give the pixel dimensions or the file size (and format, as this affects file size; see next chapter) on your hard disk.

a bit about bits

There's some terminology that we need to explain regarding the second quantity—the number of colors that any one pixel might be. In the simplest case, each pixel is represented by a one-bit digital number, a 0 or a 1, which will mean that it is either black or white. This is fine for describing a piece of line art where there are no grays or colors, but as a color-image medium it's of no use at all. Strictly, a "bitmap" is only a 1 bit-per-pixel file, but the use of the term to refer to files with more possible shades/colors per pixel is widely accepted.

If we allow more bits to be allocated to each pixel, we can have larger digital numbers and hence a wider choice of possible shades for each pixel. If there are eight bits allocated to the color description for each pixel, this allows any one of $256 (=2^8)$ different colors to be assigned to each point in the image. This sounds like a drop in the ocean given that humans can distinguish millions

of different shades, but it was the standard for most color computer displays until the mid-1990s. More importantly, it's a sufficient number of levels to allow a smooth black-to-white gradation to be represented without obvious stepping or banding between tones.

However, what we would term realistic color doesn't become possible until we allow at least 24 bits per pixel. This is the magic number because it allows you to have three "channels" of 8 bits— one each for red, green, and blue. This allows each of the RGB components or channels to have 256 levels (and therefore permit smooth gradients within each channel) and gives us a theoretical space for 16.7 million colors (=256 x 256 x 256). The three images below show the same photograph in 1-bit, 8-bit, and 24-bit versions. On the opposite page, you can see the three channels (red, green, and blue) that compose the image.

Now this may seem like overkill. Research suggests that humans can distinguish between one and seven million different colors (and the fact that the estimates differ so widely shows that

we don't yet have a scientific consensus), so why would we need to be able to describe millions more, which we wouldn't be able to differentiate even if we could display or print them all (which we can't; we can display or print far fewer than we can see)? The reason that we need 24 or more bits per pixel is to provide a fine enough "grid" of permitted color values to which we can fit the results when we start manipulating pixel color values as part of color correction.

opposite page 1-bit, 8-bit, and 24-bit versions of the image on this page

below The red, green, and blue channels of the same image in RGB

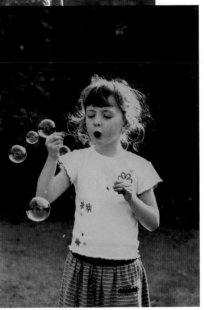

from pixels to channels

At this point, we need to introduce another bit of terminology. So far, we've been talking about bits per pixel. Once we get up to 24, it begins to make more sense to talk about bits-per-channel. A 24 bits-per-pixel RGB image can also be described as an 8 bits-per-channel RGB image. And of course you can have (and will need, if you're planning to go to offset print) an 8-bit-per-channel CMYK image too.

CMYK images have four channels. At eight bits each, that makes 32 bits per pixel, so you can see it would get confusing to talk about a 32-bit image. In terms of image quality, especially when editing, correcting, or otherwise manipulating color data, the number of bits-per-channel is a more meaningful description. And

it doesn't stop there. Many image-capture devices—both digital cameras and scanners—are capable of finer color discrimination than eight bits (256 shades) per channel. Some work at 10 or 12 bits per channel, some to 14 or even 16. Fortunately, rather than having to deal with such a multitude of bit depths (as they're known), Photoshop treats anything above 8 bits per channel as 16 bit, often referred to as "high-bit." (That said, you'll find that Photoshop CS still has some restricted functionality with high-bit images. We'll discuss this in Chapter 4).

Wherever possible, we recommend using high-bit because it allows the maximum quality to be maintained when adjusting pixel color values as part of the color-editing process. As you make changes to levels or color curves, pixel values are recalculated mathematically, but often the resulting value will not exactly fit one of the 256 levels, so it has to be fitted to the nearest available one. This can result in two values that should be slightly different being forced to the same level, thus losing the difference between them, while

others that were not much further apart are forced onto different levels, exaggerating the difference. Some levels might become altogether empty of data. This kind of rounding error won't always have an appreciable effect on your images, but in areas with smooth color gradations over relatively small color ranges (such as skies, for example), you might see banding appear because of this. The more extreme your adjustments, the worse this effect can be.

The same effects still occur in 16-bit files, but because 16 bits-per-channel allows more than 65,000 levels (2^{16} or 65,536, to be precise) the errors introduced are dramatically smaller. Another benefit is that you have that much more information to work with in 16-bit.

left The upper image is an 8-bit scan, the lower one 16-bit (note the difference in file sizes). When manipulating image data in an 8-bit image, smooth graduations—like the sky here—can show signs of banding, as there are fewer levels available (shown by the '"toothcomb" in the histogram). The 16-bit image has enough levels to cope, though as CMYK print is a forgiving (or inaccurate, depending on your viewpoint) medium you can't see any difference in this instance

color-editing modes

We've talked about RGB, CMYK, and LAB, so we know there are different ways of representing color information. The first two color spaces mostly represent types of physical device: cameras, scanners, monitors, and some photographic output devices are RGB, while commercial print is CMYK. Inkjet printers fall into both camps and print with CMYK (or CMYK plus extra inks), although most are set up to accept RGB files as input. The third color space attempts to represent color in absolute terms, based on the characteristics of human vision.

Not surprisingly, therefore, it is possible to work with all these color spaces or "modes" in a program like Adobe Photoshop, and to convert images between them. But which mode should you choose?

The answer depends on where your image has come from and where it's going to. Since there are effectively only two color spaces in which your images are likely to arrive and might need to leave (unless someone asks for or supplies you with an image in LAB), that gives four possible courses which your color information might need to follow. They are tabulated below, together with examples of situations in which they might arise:

Scenario 3 is most likely if the content of a printed publication, such as a magazine, needs to be reused for a screen-based application, as a Web page graphic, for example. In this case we'd recommend converting immediately to RGB and carrying out color correction there, as RGB gives more space to work in. You can manually expand the color saturation back into the wider gamut that RGB allows, though it's not the same as starting in RGB. The original conversion to CMYK (whether done at scanning or subsequently in Photoshop) may have discarded color information that can't be restored, and any properly color-managed transformation from

color routes

source color space	destination color space	example workflow
RGB	RGB	scanned or digital-camera image being prepared for transparency output, Web/TV/video, RGB printer, photo library, inkjet
RGB	CMYK	scanned or digital-camera image being prepared for commercial print, inkjet with RIP, color laser printer
CMYK	RGB	preseparated or high-end scanner image being prepared for Web/TV/video or any other RGB output as above
CMYK	CMYK	separated or high-end scanner image being prepared for (different) commercial print output

Since Photoshop will switch automatically to the mode of an image when it's opened, the choice for examples 1 and 4 above seems pretty obvious—work in that mode. This is not just expedient, it is also generally best practice, as changing color modes invariably loses some data—even switching between RGB and LAB and back will lose tonal detail, and that loss may become visible after further color corrections have been made. This is because of rounding errors when calculating color values with only 256 levels per channel to which to fit the results. As explained earlier this is effectively not an issue if you can work in high-bit color.

CMYK to RGB will try to match the source CMYK colors as accurately as possible.

CMYK into RGB isn't usually a problem, mostly because CMYK color spaces tend to be smaller, describing a smaller range of colors than most—but not all—RGB color spaces. However, it can be problematic reversing the black plate generation accurately into RGB. If you're starting with CMYK and your final output is to be CMYK (scenario 4 above), don't be tempted to switch into RGB for editing and then reconverting to CMYK: it's better to work directly on the CMYK data (see Chapter 5 for a fuller discussion of this).

why RGB for CMYK print?

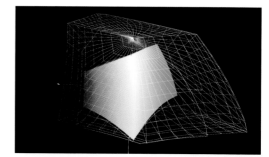

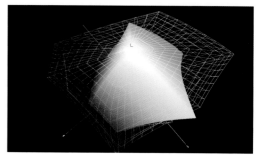

That leaves scenario 2, the one that's most likely to present itself to graphic designers working in print or photographers asked to supply a CMYK "ready separated" file. Here we'd propose something different from the advice above—keep your image in RGB for as long as you can and change it to CMYK only at the last possible moment. That's not to say you shouldn't do any editing in CMYK, but do as little as possible of it

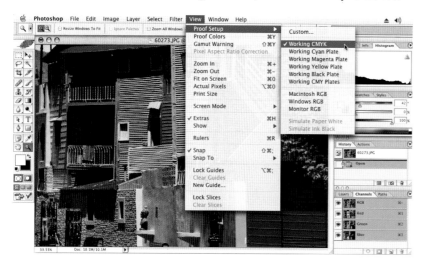

above If working on an RGB image, you can see what a CMYK conversion will do to your colors using Photoshop's *Proof Colors* option

top right The difference in gamut between the Adobe RGB (1998) color space (wireframe) and that of a Euroscale calibrated press (solid) printing on coated stock—a lot of intense, saturated RGB colors can't print—except yellows

there and only the bits that are best done there (see Chapter 5 for a fuller discussion of this).

There are several reasons for this approach:
* CMYK color spaces are (almost always) smaller than RGB ones; as soon as you convert, you're throwing away color information.
* CMYK color spaces are device-specific. OK, so are device-based RGB color spaces, but RGB working spaces are not (see panel opposite). So what if you need the file again for a different CMYK setup? CMYK to CMYK transformations are problematic. What if you need the file again for

an RGB output? Once you've converted to CMYK, you've lost that extra data.
* A potential trap in CMYK working is violating ink limits. You can't do this when working on an RGB file, but you can still measure the CMYK values in Photoshop before converting (*see Chapter 5, page 166*).
* You can soft-proof CMYK output on your screen (which is an RGB device anyway) while working in RGB, with CMYK gamut warnings in Photoshop, so conversion should yield no surprises.
* RGB files are 25 percent smaller than CMYK ones, so they open and process faster as well as taking less storage space.

But what if you are working for output in CMYK only (and one particular CMYK destination only, as might be the case for a designer working on a magazine that is always printed by the same printing firm)? Should you bite the bullet early and work in CMYK? We would still advise carrying out image correction in RGB if that's how your image arrived; print-specific correction can then be done in CMYK after conversion, if necessary.

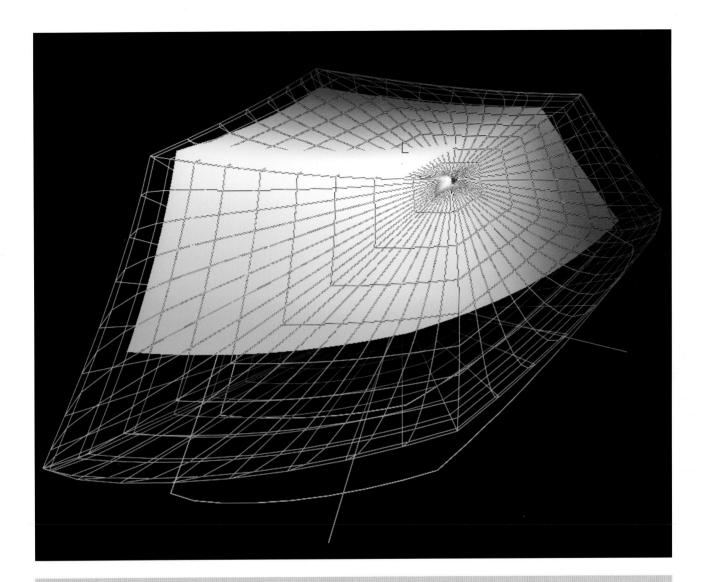

In addition to the RGB color spaces based on various input devices, there are RGB "working color spaces," such as ColorMatch or Adobe RGB (1998). These use RGB values, but are artificial constructs: they haven't been made by colorimetric measurement of a specific device. The major benefit of these RGB working spaces is that they are gray-balanced— equal amounts of R, G, and B will always produce (or represent) a neutral gray, which isn't true for most physical devices.

If other color spaces are associated with input, display, or output, it may be helpful to think of a working space as a storage or editing space. The main difference between RGB working spaces is the size of their color gamuts. We'll look at deciding which to use in the next chapter.

working spaces—theoretical RGB

color management

We've talked about why you would need to change color modes when preparing images for different kinds of output and when we think you should do it. Now we need to understand how it's done in a way that makes our eventual output—from whatever device—look something like what we see on screen.

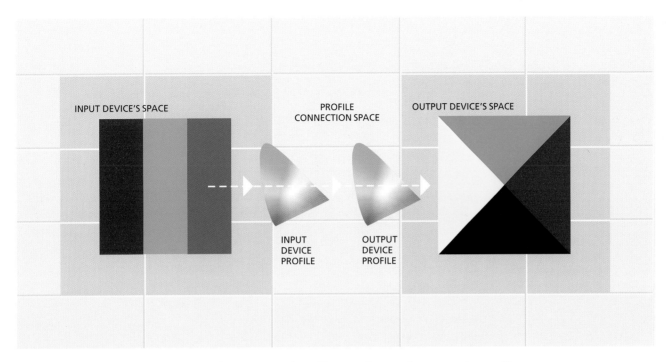

INPUT DEVICE'S SPACE

PROFILE
CONNECTION SPACE

OUTPUT DEVICE'S SPACE

INPUT
DEVICE
PROFILE

OUTPUT
DEVICE
PROFILE

As we've explained, RGB and CMYK values aren't really colors in themselves; they're merely recipes for reading or producing colors on specific machines. To know what actual colors are being referred to, we need to know about the characteristics of the devices concerned so that we can work out the "real" colors in question. Once we know these, we can express them in any color model, such as CIE LAB, that isn't dependent on any particular device or set of colorants. Using that information, it becomes possible to work out what RGB or CMYK values would be needed on another device to accurately reproduce that color.

This is the basis of a color management system. We take the raw numbers from our image-capture device in RGB or CMYK; reference them to device-independent CIE LAB colors using a device "profile" that describes the behavior of that capture device (scanner, camera, film); convert them using the referenced CIE LAB values to a working space for editing; and then convert them to output device numbers (for an inkjet, film recorder, press) using another profile. And along the way we can use a profile of our monitor to give a good preview of how the output will look, converting colors for display as you go. The illustration above represents this process.

You would be forgiven for thinking at this point "Wait a minute, I thought I was reading a book about color correction, but so far it's all been scientific theory, and now I have to learn about something called color management as well?" Well, yes, but you need to understand the theory or you may not understand what you're doing in the practical sections later on. Likewise, you need to know about color management because it takes care of a lot (though not all) of the basic color-correction issues that used to have to be fixed manually for every job, such as removing a scanner-based color cast, for example. This will give you more time to focus on the really interesting bit: the creative aspects of getting the image just right.

So let's look at color management in a bit more depth, starting with why we need it at all.

above The basis of color management: color information from a specific device is converted via a device profile to a device-independent color definition (the Profile Connection Space, CIE LAB in ICC-based color management systems). From there, it can be converted into values for a specific output device, again using a profile for that device

in and out of the loop

It's only in the last decade that personal computers have made high-quality manipulation of color images possible. Before that, most color origination was carried out in what's known as a closed loop arrangement. The people who captured (scanned) an image were also responsible for preparing it for print (and very often for the printing as well), so they controlled every stage of the process.

This meant that they could tweak the whole system to get good results. If images were coming out too red, for example, they could adjust the scanner, the separations, or the press itself to correct for that. If you're producing prints from your own photos on an inkjet printer and never need to send files to anyone else or produce output on any device, you're in a closed loop too, but fiddling by eye with the picture to improve what comes out of the printer is still not the best way to work and is unlikely to produce either the best match to the original or the best that the printer is capable of. You might get the color balance right for skin tones, for example, but find that it's wrong for landscapes.

Nowadays, by comparison, there are many more "output" options (some of which don't involve a physical hardcopy of the image at all) and the stages of the process are often handled by different people in different places, often with no knowledge of the downstream conditions under which their work will be used: a photographer may sell an image via a photo library to a designer who puts it in a printed piece or on a website. How can the photographer (or the photo library) prepare it for a use that's unknown at the point of hand-off?

It was in recognition of this difficulty that in the early 1990s Apple Computer set up what was initially known as the ColorSync Consortium, a group of software developers and hardware manufacturers trying to build a device-independent way of transmitting color between applications and repro equipment, based around the eponymous piece of Apple system software. This became the International Color Consortium (ICC) and its remit expanded to bring a color standard to the Windows computing platform (and to any other that might require it) as well as to the Macintosh. The ICC has published and continues to develop a number of standards that relate to the description and transmission of digital color and of color-capable device behavior, foremost among which is the ICC color profile.

what is a profile?

A color profile is a digital file that describes the way a particular device works with color. There are three basic types of profile—input, display (which includes RGB working spaces), and output. The first deals with devices that read or capture color (scanners, digital cameras) while the latter two are for devices that show or print color respectively. Computer monitors and TV screens are display devices. Output devices include desktop color printers, photographic output devices (such as the Cymbolic Sciences LightJet, Durst Lambda, or Fujifilm Pictrography), plus offset and digital presses.

Everything that works with color has deficiencies and inconsistencies. Not only are there colors that devices can't see or reproduce ("out-of-gamut" colors), but also their responses within the colors they can handle aren't usually

linear—for example, a scanner that's good at capturing neutral midtones might have a blue cast in highlight areas, or a press that reproduces quarter tones and midtones well may block up on shadow tones, losing detail. The ICC profile creates a "map" of the device's behavior across a wide range of colors and densities, from which the "real" or required values can be calculated.

For an input profile (scanner, digital camera), this means working out what was the real color in the original that produced a given RGB value in the scan. For display and output profiles (screens, printers), it means calculating what values should be fed into the device to produce the desired color. It's important to understand that a profile isn't an image, it's a "tag" (you may come across ICC profiles being referred to as "tags"). A tag is a key for decoding the color numbers in an image file; when you embed a profile in an image, you are not changing any of the pixel data values in file, but you are appending information that a profile-aware system can use to interpret those color values accurately.

below A color management system allows color input, display, and output between an effectively unlimited range of devices, using profiles for each and the profile connection space as the central "exchange" point

only connect

The key to getting from our original color, via the computer, to our best possible match output color is something called the Profile Connection Space (PCS). This is basically a device-independent color model of the kind introduced in the previous chapter. Some types of profile use CIE LAB as a PCS, others CIE XYZ (another device-independent color model). The good part is, that's really all you have to know about it. For a basic idea, the illustration below left shows how a color-management system connects all the different devices via ICC profiles and reference to the Profile Connection Space.

Another component we'll introduce briefly is the color-matching module or CMM. This is a bit of behind-the-scenes software that actually does the mathematics involved in color space transformations. There is more than one CMM, and although the respective vendors claim various advantages for theirs, sometimes including extra capabilities unique to their own profiles and CMM, there's not a huge difference between them.

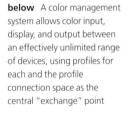

Monitor profile

Inkjet profile

Scanner profile

CMM

Camera profile

Color laser profile

Press profile

a color too far?

The other main aspect of color management concerns what happens when dealing with colors that are outside the gamut of the output device. What do you do when the input color can't be reproduced by the output device, as often happens in preparing scanned images for print?

Color management systems define four types of "rendering intent"—procedures for handling this eventuality. They are:

Perceptual
in which the color space of the original image is mapped onto that of the output device. This aims to preserve the visual relationships between colors and will usually end up changing most of them, including the ones that the output device can reproduce correctly. It is most useful for images with many out-of-gamut colors or those in which being able to differentiate out-of-gamut colors is important.

Saturation
involves mapping saturated input colors to saturated output colors but not worrying too much if they aren't quite the same ones. This suits "business graphics" such as pie charts, where it's more important to have bold, bright, and clearly differentiated colors, but is rarely useful for reproduction of photographic images.

Relative colorimetric
is the one to use most of the time (and it's the Photoshop default). It takes advantage of the fact that human eyes adjust to whatever looks like it ought to be white in an image, so it maps the white point of the original (say a transparency highlight) to that of the output (the paper white for any kind of print). Those colors it can reproduce correctly it does. All the out-of-gamut colors are "clipped"—that is, mapped onto the nearest available color. You lose the out-of-gamut colors, but the rest will be as accurate as they can be with the devices concerned.

Absolute colorimetric
is similar to the relative version above but doesn't map the white points. This type of conversion is used for proofing where we want one device (an inkjet printer, for example) to simulate the exact output of another (typically an offset press or analog proof type), including its white point. As a fairly extreme example, an output profile for London's *Financial Times* newspaper will have the pink color of the newsprint as its "white" point rather than a pure white. You'd use an absolute colorimetric conversion to map the white point of your image to the pink of the paper so you could see on screen (or on an inkjet or other digital proof) exactly how it would look when printed.

see it on screen

color casts, or lack of contrast. Quite the opposite—it will do its best to reproduce them as accurately as possible. So we still need to do color correction; color management will help us gauge the results of our efforts more accurately while working and automate much of the process of preparing the corrected image for output. Having a properly calibrated and profiled monitor (and desktop printer) will give you a reliable view of your image data to help you to gauge the success of your color-editing efforts.

The description here of color management is very much a top-level, theoretical one, but it is vital to understand that whether you investigate and adjust the settings or not, some type of color management is going to happen when you start working with images. By taking some time to understand it and to set it up correctly, you can take control and make sure that what you get on output isn't a nasty surprise.

left The Photoshop *Proof Colors* gamut warning allows you to see on screen which colors can't be properly reproduced in print, and gives you an accurate preview of what will happen to them. Because both the screengrab and original are printed, we can't show you the colors in the RGB original that have been lost

Absolute colorimetric conversion is key to one of the most useful features of color-managed systems (after the main one of getting color reliably from your original to your output, as far as the latter permits). This is the ability to proof images, either on your screen, or on a desktop printer, to get a good idea how they would appear in print. By using the appropriate output profiles, it's possible to get a pretty accurate preview of the eventual job, which of course helps in evaluating any color correction you're doing. Looking at an image on a screen is never going to be perceptually the same as looking at a printed copy, but we can certainly get a genuinely useful preview.

It's important to understand that color management isn't a substitute for color correction. Color management doesn't fix problems in images, such as poor shadow detail,

how do you make a color profile?

ICC profiles are at the heart of working color management. Most professional or semipro equipment ships with profiles these days, which is a fair starting point. However, these profiles are usually generic to the model rather than to your particular unit, so you'll get the best results by creating your own (or having someone else do it for you—it does need some specialist equipment, knowledge, and patience). Here in outline is how it is done:

For input devices—scanners and digital cameras—you scan or shoot a reference "target" of known color values (*see below*). Profile-creation software then reads the scanned color values and compares them against the known values to create a table that describes how your

scanner or camera behaves. This can then be saved as an ICC profile that can be used on your system or embedded in your image files to give a context for the RGB or CMYK values. This enables applications, such as Photoshop, and the display and output devices attached to your computer to interpret the colors correctly.

However, while profiling a scanner is relatively straightforward, digital cameras are much more difficult because lighting conditions have such a major effect on the captured image. This means that any digital camera profile will apply to that camera shooting under those lighting conditions only. This is acceptable for a studio camera where you can be sure about recreating the lighting conditions, but is tricky for one that's used on location. There is another route for data capture and color balancing with digital cameras and Photoshop, called Camera Raw. It's discussed in the next chapter.

right Hardware monitor calibration in action

below A scanner calibration target, usually made for a specific type of film

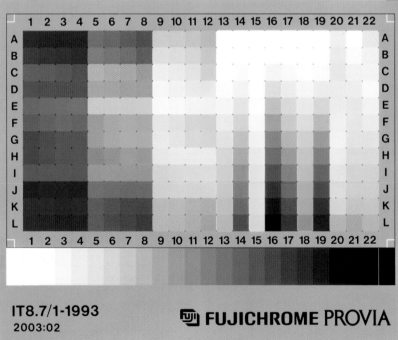

IT8.7/1-1993
2003:02

FUJICHROME PROVIA

To profile a monitor, the profiling software displays a sequence of test color patches which are read by a colorimeter (or sometimes a spectrophotomer) attached to, or suspended in front of, the monitor. This compares the displayed colors against the requested colors and tabulates the differences into a monitor profile. You can also create monitor profiles visually with some profiling tools, though this is less thorough and more susceptible to variations in external conditions. There is also a built-in monitor profile generator in the Mac OS X System Preferences Displays panel and Windows Photoshop users can use Adobe Gamma. These are also visually based, but they still provide working profiles that color-management-aware applications, such as Photoshop, can use to display colors more accurately.

Profiling printers involves printing a chart of test patches (supplied as a digital file) and then measuring the printed color values, ideally using a spectrophotometer, though lower-cost systems use colorimeters or even scanners for this function, with commensurately less accurate results. The profile-making software compares the measured colors against the target colors and builds a profile. Profiling any printing device always depends on the paper being used, so your profile will be for that combination of printer, print settings (such as resolution), inks and paper only. There are many variables involved in profiling a press, so unless you're in a situation where your work will always be printed on the same one (as might happen in a newspaper, for example), it's easier to use a generic press profile such as those developed by an organization like FOGRA.

We have shown that you need some special equipment to make color profiles: a colorimeter or spectrophotometer to measure screen or printed color respectively, as well as color profile creation and editing software. Not everyone is going to want to have to buy and learn to use this equipment, particularly if they have just one scanner or camera and one desktop color printer. Professional-level profile-creation software is complex, expensive, and takes time to master, but entry-level products do not have the complete functionality of their professional counterparts. If you do want to make your own profiles, see the Resources appendix for details of vendors of this type of equipment and software. If you don't want this but are concerned to get the best possible quality, you can hire a color-management consultant to set up your system and create the profiles for you. Although they'll charge for their time, it should be worth it to save yours and to get the best results from your equipment. Starting points for finding color-management specialists are listed in the Resources appendix. Other possibilities will be explained in the next chapter, where we set up for image capture, editing, and color management.

Who's going to do it?

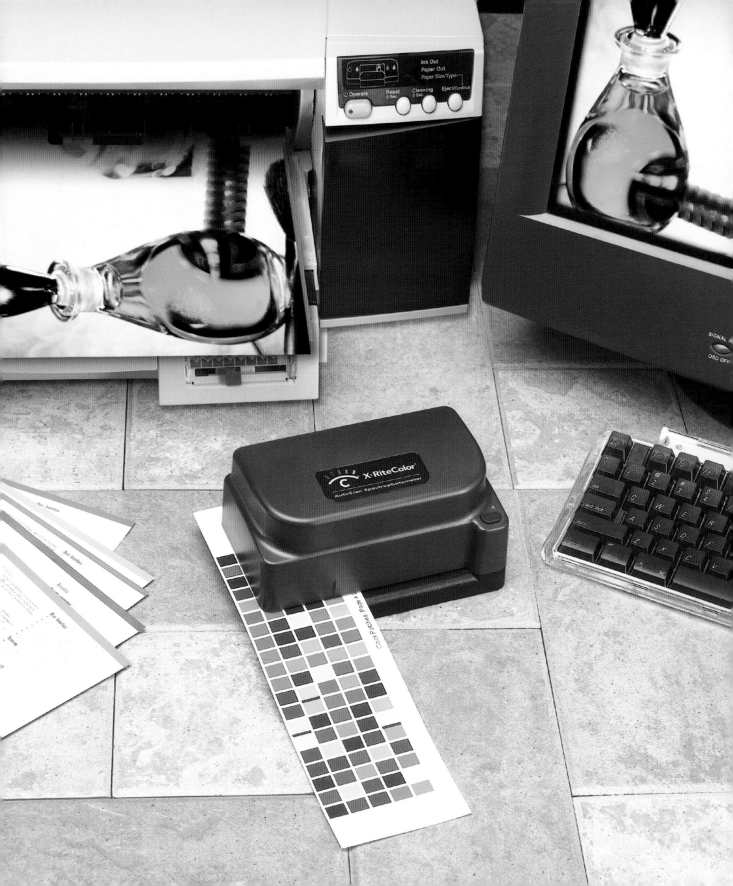

GETTING READY TO WORK WITH DIGITAL COLOR

chapter 3

Before you can start work on your images, you'll need to get them into digital form. They may be supplied digitally if they come from a photo library or repro house, and if they're shot with a digital camera there's no other option, but if they originated as transparencies, prints, or other artwork, you'll need them scanned. High-quality scanning used to be the exclusive preserve of the repro house or printing firm, but advances in technology have brought reasonable quality scanning within the reach of consumers, while repro quality devices are now affordable for quite modest design agencies. Neither type of device does away with the need for an understanding of color and image reproduction on the operator's part, whatever manufacturers claim.

Whichever route your images take into the digital domain, there are parameters and settings that you need to know and control to get your images into the format which best suits their eventual purpose and which maximizes their quality. The choices you make when capturing or creating a digital image have consequences for its subsequent use, so you'll need to grasp the relationship between image resolution and

size, especially for printed output, as well as understand the key digital image file formats and which are appropriate to what kinds of use. These issues are explained in this chapter, as well as the limitations of various file types as far as color fidelity and image quality are concerned.

Sometimes, you'll have more than one application for an image, so you'll need an image capture and archiving strategy that allows for the greatest possible use of an image without having to recapture it each time. The same image may be required for a brochure, point-of-sale materials, a Web page and perhaps a promotional video. You don't want to scan it four times to make a file to suit each of these—the optimal workflow is to scan once, then prepare targeted versions from this master file to suit each specific use.

The ability to "repurpose" images with minimal effort is one of the benefits of a color-managed workflow, as your master image can be saved together with its input profile and then copied and converted for specific outputs using the appropriate output profiles. We'll look at routes and practicalities for setting up your own color-managed workflow in this chapter.

3

capturing images

As explained in the previous chapter, the main factors that affect the quality of your image file are how many pixels there are in it and how many bits are allocated to describing the color of each. As we said, there are definite advantages to image editing in high-bit (i.e. more than 8 bits-per-channel) mode, even though file sizes increase and the editing tools in programs such as Photoshop are restricted.

Many desktop scanners now support 12, 14, or 16 bits-per-channel output. Use it if you can—you should always aim to start with the highest quality data even if you have to throw some of it away later on. Similarly, many semipro or professional digital cameras support high-bit output, so save images using this wherever possible. In the first part of Chapter 4, we'll explain how to get from a 16-bit image to an 8-bit one in order to maximize both image quality and the editing options available in the software.

Scanning software usually comes with a range of controls that let you optimize your image at the time of scanning. As well as setting highlight, shadow, and mid-tone points in your image, you may well have the opportunity to adjust input/output curves for the three component colors (R, G, and B) and to control sharpening.

Assuming you're using Adobe Photoshop or another professional-strength image-editing program, we'd advise that you do the minimum adjustment in the scanner software and work on everything else in the image editor. This is because the prescan window in much low-end scanning software doesn't always give you a good enough view to make critical color or tonal correction decisions. More importantly, though, there's no going back when correcting at the time of scanning, so if you do anything wrong, you'll have to start all over again.

below A typical example of the control software bundled with consumer scanners. Picture scaling, cropping, output size, and resolution can be set by the user

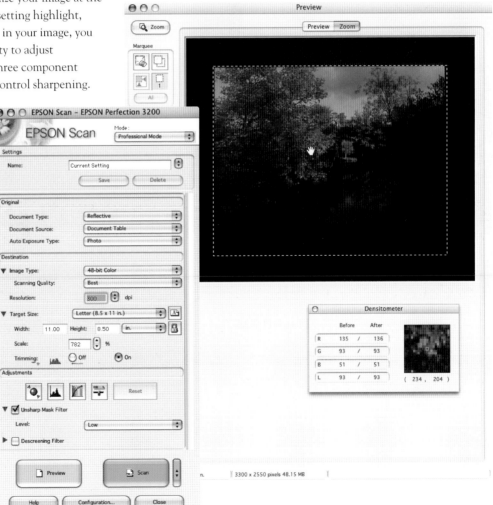

By comparison, there's always the undo or "revert to saved" function in image-editing software. Alternatively, if you're using Photoshop, you can perform your corrections via Adjustment Layers (once you've converted your image to 8 bits-per-channel), which give enormous flexibility and the option to vary or undo any of your tonal and color corrections without affecting the original data.

The exception here is if your scanning software supports 16 bits-per-channel editing but only outputs 8 bits-per-channel, or if your image-editing program can't read 16 bits-per-channel files. In this case, you should perform major adjustments on problem originals (those with serious under- or overexposure or strong color casts) in high-bit using the scanning software, and save the fine-

below and right
Comparing histograms between your image-editor and your scanner software can help you interpret the latter more accurately

tuning for the image editor. There's a fuller discussion of this in the image-editing workflow section at the beginning of the next chapter.

We recommend using a scanner profile as part of your color management setup and adjusting only the highlight and shadow settings in the scanning software (see the example, above right). This allows you to make full use of the scanner's dynamic range (the difference between the lightest and darkest values that it can read) to give you the most data for subsequent work. A word of warning, though—always look at the levels histogram (see next chapter for an

explanation of the histogram) before committing to a scan, as the "auto" settings in some software may truncate tonal levels that you wanted to keep, especially if you have difficult originals with strong shadows or burnt-out highlights.

Scanning software histograms can be inaccurate too, so it's worth comparing the histogram for a small scan between your scanner software and your image editor to find out how good it is. If it's accurate, fine; if not, after a few test scans and histogram inspections, you will be able to learn to interpret the scanning software one reliably.

Most digital cameras also provide controls for color and exposure balancing, but there is an alternative for users of certain professional models who have Photoshop. Photoshop CS (and Photoshop 7, using the Camera Raw plug-in) allows users to capture the "raw" CCD data from the camera. As well as providing a speed advantage (processing and saving image files in the camera can be quite time-consuming), it gives you a great deal more control and potentially better image quality from digital cameras. Not all digital cameras can output raw data, particularly those aimed at the consumer end of the market, while of those that can, not all are supported. Check first, especially if you are about to buy a digital camera and think you might be interested in this feature.

in the raw

Canon EOS 300D: CRW_0293.CRW (ISO 100, 1/80, f/5.6, 18.0 mm)

Skip	
Cancel	
○ Basic ● Advanced	

Settings: Custom

Adjust | Detail | Lens | Calibrate

White Balance: Custom

Temperature 5550
Tint +28

Exposure 0.00
Shadows 0
Brightness 50
Contrast +50
Saturation 0

20.6% ☑ Preview R: --- G: --- B: ---

Space: Adobe RGB (1998) Size: 3072 by 2048
Depth: 16 Bits/Channel Resolution: 240 pixels/inch

pixels, resolution, and image size

If you get your images from a digital camera, you have no control over how many pixels there will be—you'll get an image that has as many as the camera can produce. Professional-quality models range from 3.2 million pixels for SLR models (images captured at about 2,000 pixels wide,

below An image from a 6 million pixel camera prints at this size at a resoluion of over 450 pixels per inch

landscape orientation) to 85 million or more for studio quality scanning digital camera backs (16,000 pixels wide). So how big can you make an image with a given number of pixels?

The answer, as always, is, "It depends." In this case, it depends on what you want to do with the image. If it's going on a website, you only need to work at computer-screen resolution (usually taken to be 72 pixels per inch) and the chances are that a digital camera image as supplied will be too big. TV and video images don't need any more resolution than this (usually less, if anything), but inkjet or commercial print requires more, up to

right 72 pixels per inch (*bottom image*) is fine for screen use, but the lack of resolution is clear on the printed page, especially compared to a version at around 300ppi (*top*)

about 300 pixels per inch for high quality results. If you're outputting your work to a film recorder, a resolution of 3,000 pixels per inch or more may be in order (though the output format is typically 5 x 4-inch transparency or smaller, that's still a very big file).

So you need to ensure that you capture your image with enough pixels for the highest resolution output you'll need. As professional retouching for output to film recorder is a highly specialized and expensive business, it's outside the scope of this book (though the principles outlined here still apply), so we'll assume that the highest resolution output you're likely to have will be for commercial print or your own inkjet printer.

big dots and little dots

At this point, you may well object that your inkjet printer can print at 1,440 dots-per-inch (or maybe even twice that), or if you're familiar with repro equipment, that your film- or plate-setter works to 2,450 or higher dots-per-inch. So shouldn't you scan or acquire images at those resolutions? The answer's no because neither type of output device is capable of revealing detail in color images at these resolutions (and neither are your eyes capable of resolving it). They have to work at such high resolutions because they are effectively printing in single colors but need to produce the illusion of continuous-tone color.

The principle is the same for each, but the details are different, so let's consider the ink-jet printer first: it fires microscopic globules of ink at the paper where they stick and dry. But there are usually only four ink colors—cyan, magenta, yellow, and black (though some models have light cyan and light magenta as well, and wide-gamut models include orange and green inks in addition to the standard CMYK set). To mimic all the colors in your image, these ink droplets have to be printed in the correct proportions within each part of the image to provide the desired (subtractive) color mix. To allow enough variation in the number of droplets of each ink to create a sufficiently wide range of perceived "mixed" colors for photorealistic results, the effective resolution of the printer when printing a continuous-tone image has to be much lower than the 1,440 or more dpi that the printer can address, typically equivalent to around 180–200 pixels per inch (though the printing techniques used in inkjets don't actually produce a regular grid of square pixels).

A similar thing happens with a filmsetter or computer-to-plate device. As these devices output color separations (one for each printing ink), they "print" in only one color—black. They build a halftone dot from the individual dots that their lasers can expose on the film or plate surface, and again, to produce a satisfactory range of halftone dot sizes and shapes for good tonal reproduction, the halftone dot or cell used for calculation has to be many times bigger than the actual dot that the output device creates.

Both inkjet printers and prepress output equipment employ a wide range of clever software

right A greatly magnified view of halftone dots. Each one is built from smaller output device dots, which is why such high resolutions are needed for quality print

refinements to maximize the amount of detail and number of tonal values that they can produce within their output resolutions—refinements which are too complicated to go into here. For most practical purposes, scanning to around 300 dpi at the intended output size is more than sufficient (though note that current inkjet printers from Epson seem to prefer resolutions that are integer divisors of 720 dpi—360, 240, 180 dpi, etc).

The key phrase in that last sentence was "intended output size." If you're enlarging a 35mm transparency so it fits a width of, say, 200mm, that's a scaling factor of about 5.6. (200/36, as the width of a 35mm film image is 36mm). So to get an image resolution of 300 dpi at the enlarged size, you need to scan the original at (300 x 5.6), around 1,680 dpi. Different scanner control software handles this differently: some programs let you specify the target size and resolution so you don't have to do any arithmetic, some set scanning resolution relative to the size of the original.

above A magnified view of an inkjet print, showing how small dots of primary colors are used to build up dithered patterns

right Setting image crop, scaling, and resolution in a professional scanning application

predetermined pixels

This is all well and good provided you are in control of the scanning. But what happens when you are given an image (from a photo library, on a CD, or from a digital camera), and told to get on with it?

If the image is too big (too many pixels, too high a resolution for the size you want to use it in whatever medium), there are two possibilities: leave it alone or "downsample" it. The former is an option for print output only, and it's not recommended even then, as the resampling process in a prepress system may interfere with your sharpening settings in your image (see next chapter). Using unnecessarily large files also slows down processing and the images take up more disk space.

As general good practice, it's better to downsample the image to the size you need, and for Web use, where the image will be displayed pixel-for-pixel on the viewer's screen, this is essential. "Downsampling" means to produce a

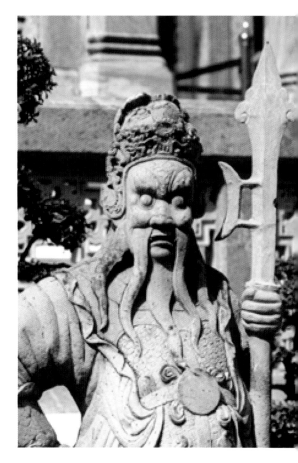

version of the image using fewer pixels. It makes a difference what order you do things if you have multiple uses for the image: we'd recommend doing basic color correction and editing work on the high-resolution original and then creating smaller versions as you need them. Enhancements like boosting saturation and other output-specific adjustments—including sharpening—are best done after creating the individual targeted files.

left Photoshop's *Image Size* dialog lets you resize and resample images by pixel, percentage, or actual dimensions. The *Bicubic* mode gives the best results

Image Size

Pixel Dimensions: 48.0M

Width: 3293 pixels

Height: 2549 pixels

OK
Cancel
Auto...

Document Size:

Width: 27.88 cm

Height: 21.58 cm

Resolution: 300 pixels/inch

☐ Scale Styles
☑ Constrain Proport
☑ Resample Image:

Nearest Neighbor
Bilinear
✓ Bicubic
Bicubic Smoother
Bicubic Sharper

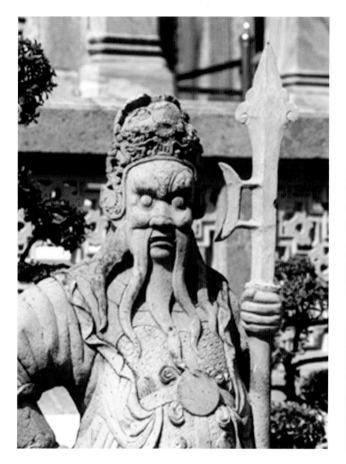
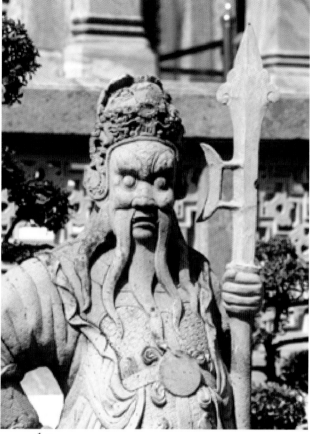

above Resampling in action. A 72ppi original (*left*), resized to 300ppi using the Bicubic (*center*) and Nearest Neighbor (*right*) options

Adobe Photoshop offers a choice of methods for downsampling, based on different algorithms for calculating the new pixel values from the original ones. The *Bicubic* method is the one to use for photographic images. It's often necessary to sharpen the image slightly after downsampling, as it can produce a softening effect. Photoshop CS has added a *Bicubic Sharper* option to counteract this tendency.

So far, so good. But what if there aren't enough pixels in the image to achieve the resolution you want at the image size you need? If you just scale up an image that doesn't have enough pixels, you'll eventually be able to see the pixels in your output in the same way as if you zoom in with your image-editing software.

Depending on the picture, this effect can become visible at greater or lesser degrees of enlargement. Hard edges running at angles turn into jagged stepped lines pretty quickly, but soft images with no hard edges can withstand more enlargement.

You can address this problem to some extent using the resample option in Photoshop to increase the number of pixels, but of course the software can't introduce detail that wasn't there in the original file. Photoshop can sometimes oversharpen the image when resampling to increase the pixel count—the Photoshop CS *Bicubic Smoother* option is one way of getting around this. Generally speaking, however, resampling to increase resolution is best avoided.

file formats

Getting the image pixel count right for your eventual output is more than half the battle, but once it's scanned or otherwise acquired and resampled (if necessary), you need to save it. At this point, you need to make a decision about the file format. Image-editing programs like Photoshop have their own "native" file formats, which are fine to use if you are printing directly to your own printer, but they can't necessarily be opened, placed, or printed by people who don't have the same software.

DCS

Desktop Color Separation is a CMYK file format developed in the early 1990s for page layout and commercial printing using QuarkXPress. It is not relevant for inkjet or any other form of RGB file/output, and is not widely used in printing either these days. TIFF (without layers, see TIFF section, overleaf) or EPS are more common formats if you need to supply a CMYK image to a commercial printer.

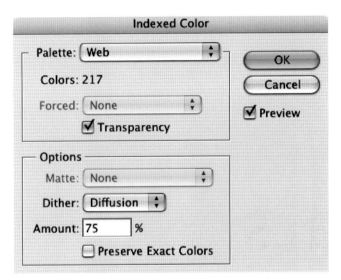

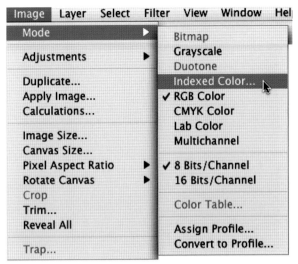

EPS

Encapsulated PostScript is a useful format for prepress work as it supports clipping paths for image cutouts/runarounds described in the PostScript page description language that is universally used for commercial print output. It's not a very compact file format, though, so unless you need to include a clipping path it's probably better to use TIFF (*see page 71*). One feature of EPS is that page layout software and prepress systems are unable to manipulate or alter the content (hence "encapsulated" PostScript), so if you've set up special PostScript commands in the file that govern how it will reproduce, they won't be lost along the way. You'll need EPS for duotones as well.

GIF

Used on websites, the Graphics Interchange Format uses an indexed color system to represent images using a reduced set of colors, typically 256, though lower numbers are also possible (as seen at left). Designed for minimal file size in the early days of the Internet and other online services that preceded it, GIF also supports simple animation through a sequence of images stored in one file. The only time you'll need to use this is if your image (or part of it; see page 180) needs to be animated on a Web page (for example, to produce a rollover, a button that "depresses" when clicked).

JPEG

Named for the Joint Photographic Experts Group that developed it, JPEG (or JPG) is widely used on the Internet and also sometimes in commercial print. The most significant thing about JPEG is that it uses lossy compression to reduce file size (which it does quite dramatically, compared to formats like TIFF). When you save as JPEG, the software analyzes the content of your image and decides which data is redundant and can be thrown away. Dramatic reductions in file size can be achieved, but there's a price to pay: image

quality is degraded—subtle tonal details can be lost even at fairly low compression settings, while the higher settings can generate artifacts such as fringes and speckles, particularly around areas of high contrast. Because of the way the image is analyszed and compressed, resizing or even slightly cropping a JPEG image can cause the entire compression process to be recalculated, resulting in an unexpected degree of image degradation.

For high-quality print work, we'd recommend avoiding JPEG. That said, there are prepress vendors who claim that minimal JPEG

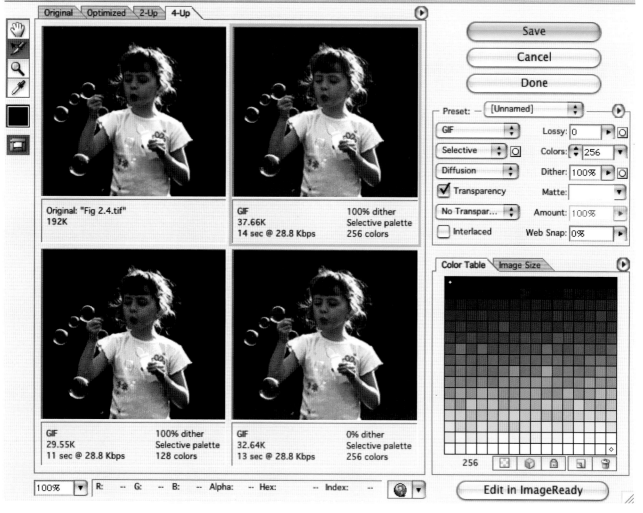

SETTING UP FOR DIGITAL COLOR

compression in the output stages has no visible effect on the resulting image quality, and newspapers use it all the time, as the reduced file size means that pictures can be wired in right up to the press deadline.

If your work is destined for the Web, JPEG is the favorite format for presenting "true" color photographic images (though subject to the vagaries of viewer's screens, Web browsers, and system configurations; see Chapter 5). Programs like Photoshop/Image Ready and Macromedia Fireworks allow you to preview the effects of JPEG compression on Web graphics while reading out the resulting file size so you can balance quality against download time.

PNG

A comparative newcomer to most people in professional imaging, though it has actually been around since the mid-90s, the Portable Network Graphic is a lossless-compression format. It has a number of features that lend themselves to both Web use and professional print output. However, while it's a better choice than JPEG for many applications, it hasn't been taken up so widely.

TIFF

The Tagged Image File Format originated as a printing format, but caters for both RGB and CMYK data. It supports both lossless (LZW and ZIP) and lossy (JPEG) compression, and is probably the most widely supported high-quality image file format in use. Adobe has a variant supported by Photoshop, which can include layers, clipping paths, and adjustment layers, much like a native Photoshop file. The price for this is compatibility—only Photoshop will recognize these additional features. The LZW and ZIP compression options produce useful file size savings too, although such files may take longer to save and open. Also, the ZIP compression mode may not be understood by other image-editing or page-layout applications.

setting up for color management

In the last chapter, we explained why you need color management and how—in general terms—it's done. Now we need to look at the specifics of setting up your color-managed workflow. There are various options, ranging from no color management (which we don't recommend) to a fully custom-profiled workflow, which you might implement yourself if you want to buy and learn to use all the specialist equipment, or which a color management consultant might do for you.

get the light right

Before setting up anything on your computer, you need to do what you can to get your working area right. As well as obvious things like not positioning your monitor facing a window so that all you can see is a reflection, you need to think about the surfaces inside the room. Avoid having strong colors in your field of view when looking at the screen, as they will affect your color judgement. A neutral gray is ideal, and that goes for your computer desktop too—no lurid patterns or colors to knock your own color balance off. Some professional-grade monitors come with hoods to reduce glare and keep extraneous light out, and many top-notch retouchers carry out color-editing work only in environments with carefully controlled lighting. Try looking at your screen with the lights off and then with them on to see the difference it can make.

You may not want—or be able—to go to these lengths, but you can at least control incoming daylight with a blind and arrange to have no distracting colors around your main work area. If you are using Photoshop, have a look in the online help—"Creating a viewing environment for color management"—for more advice.

To anyone at all serious about color quality, we'd recommend getting a good-quality inkjet printer and having it profiled professionally. This acts as a reference for other people to show how you thought your images should look and also allows you to see some detail in areas of saturated colors that probably won't display properly on your monitor (see the examples below). A properly profiled printer gives you a second check on how your work is progressing, but you need to give some thought to the conditions under which you view print-outs or proofs. The graphic arts industry has standardized "D50" viewing booths, based on a light source at 5,000 Kelvin (see Chapter 1 for color temperature explanation). However, trying to set this color temperature for

degrees of color management

Depending on your circumstances and budget, there are a range of color-management options that you might consider:

1. No color management

We don't think this is really an option, but it's worth explaining why not. If you don't enable any color-management options in your image-editing application or your operating system, color

above Comparisons of ICC profile color gamuts between an Apple 17-inch Studio LCD display (wireframe) and Epson 1160 inkjet printer on glossy photo paper (solid). Although the screen can show more saturated blues and violets, the printer has a wider gamut in both yellow and cyan—it can resolve tonal differences in these saturated colors that the monitor can't show

your monitors doesn't tend to work very well (see pages 80–81 for a description of the visual calibration of monitors). If you have such a booth, use it; otherwise, try to arrange a constant 5,000K lighting source. You can get fluorescent tubes that give light at this color temperature, such as the Osram Color 950.

management of a type is still being performed, in the sense that when you open and edit an RGB file, real colors have to be allocated to the RGB values in the file in order to show you anything at all on screen. In Photoshop 6 and later, you can select "Color Management Off," but a working space is still assumed for new or unprofiled images (*see "Choosing a working space," page 77*). Other applications may send the raw RGB values straight to your computer's video card. Either way, the effect is you'll be working in your monitor's

color space. Real-world device color spaces are seldom linear or gray-balanced, as noted in the previous chapter, so you'll find that your efforts to control color on screen are hampered by this, let alone trying to get it to match any kind of printed output. The only method of previewing CMYK output will be to print to a CMYK device and see what happens—and what you get from an inkjet won't match what you'll get from a press.

If you only ever want to print your own images out on your own printer, you could get by like this, but it'll probably involve a lot of test prints, and as soon as you change either the screen or the printer (or the brand of paper or ink), you'll have to start over. Corrections carried out in this way may also vary from one type of an image to another—what works for a landscape may not fix a portrait, or vice versa. And as soon as you send an image file to someone else, it almost certainly won't display or print for them as it does for you. Not recommended.

2. sRGB throughout

An option that works reasonably well if you are mainly concerned with getting basic inkjet output is to use sRGB as your working and output space. sRGB is derived from an attempt to characterize the "typical" Windows monitor. Although it's not a very big color space, compared to other RGB color spaces like Adobe RGB (1998), it's a passable match to the gamut of many inkjet printers, though dependent on the printer driver settings used for output, such as the "photo-realistic" option with Epson printers. It's also a reasonable match to most digital cameras on the input end, though not so good for commercial print. If you're printing to your own inkjet only, you could set your working space to sRGB to save conversion at output time (*see "Choosing a working space," page 77*). However, this approach fails to capitalize on the full gamut of many inkjets which can print colors outside sRGB—and you could lose colors in the initial conversion to sRGB if your image comes from a scanner.

above A comparison of the sRGB working space and the Epson 1160 profile on the opposite page. The printer can print yellow/oranges and green/cyans that the working space excludes, so if you have these colors in your original, sRGB might not be a good choice; it will "clip" them to the nearest available colors

3. Use manufacturer's profiles

Another option that doesn't cost any extra money and which should at least get you started is to use manufacturer's profiles for the equipment in your workflow—scanner, digital camera, monitor, and output device. Most manufacturers of these devices ship them with profiles (identifiable on PCs by their .icm or .icc suffix) or they can be downloaded from their websites. You must bear in mind that these profiles will represent the typical characteristics of the model; they won't have been made for your particular unit. They may also be of variable quality, depending on how well the profile-making measurements were taken and how good the quality control is in the manufacture of the devices in question.

For commercial print output, you may find it most practical to use good-quality generic CMYK output profiles for presses or proofing devices.

Although all presses can vary from day to day because of environmental variables such as temperature and humidity, the SWOP and Euroscale press profiles included with Photoshop are a good starting point, or look at the more specific sets developed by industry bodies such as FOGRA (*see Appendix II, page 182*). Otherwise, working to a standard proofer output profile (such as Cromalin, Matchprint, or ColorArt) gives printing firms something they are familiar with and used to matching on press. Ask the bureau or printer what they normally work to.

4. Make your own profiles

The best way to implement color management is to profile your own equipment. You can either buy the tools to do this yourself, or hire a consultant to do it for you. It may not be very cost-effective to buy the equipment and learn to use it properly, and hiring a consultant may be a better approach unless you need to profile a lot of devices or expect to reprofile them very frequently. (CRT monitors do tend to drift over time, and you would need to reprofile an inkjet printer for a new type of paper or different ink supplier). Producing printer profiles can be particularly time-consuming, as you will need to read in hundreds of color patches, a tedious and error-prone process unless you buy an automated spectrophotometer, which then adds to the cost. See appendix I (*see page 182*) to find details of recommended equipment and some starting points for finding consultants in your area.

Making (or having someone else make) profiles of your equipment is the best route to accurate color reproduction, as the exact characteristics of your own system will be measured and built into the profiles. This will give you a solid basis on which to begin your image correction.

below Reading printer test swatches in by hand to make profiles is tedious and prone to error. Varying degrees of automation are available to suit your budget

choosing a working space

The problem with the larger working spaces is that if you're working with 8 bits-per-channel images, there are still only 256 tonal levels available per color. If the total color range being described by them is wider in a particular color space, then the gaps between the levels are going to be correspondingly larger. This means that any edits you make could damage the image as color values are rounded to fit nearest available levels—the widely spaced levels in a large space could introduce posterization. Conversely, in a smaller space, the levels are all that much closer together, which means the fine edits are better supported, but at the price of possibly losing critical color information right at the start. If you can work in high-bit (16 bits-per-channel), this isn't a concern. If you're still using Photoshop 7, the powerful adjustment layer features aren't available in 16-bit mode, and making selections can be impractical (though we suggest a workflow that gets around this as far as possible). In Photoshop CS, working in high-bit has fewer restrictions.

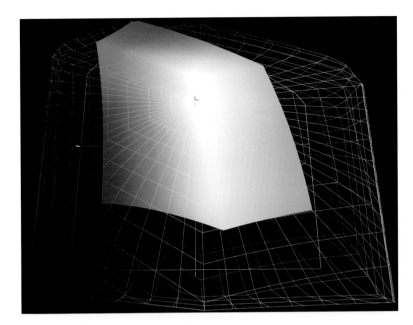

above Kodak's ProPhoto (wireframe) dwarfs sRGB. However, for 8-bit images, its levels are too far apart for fine editing

In the last chapter, we introduced the idea of a "working" color space, a device-independent color space that is more linear and predictable environments for image-editing than real-world RGB device-based color spaces tend to be. A working space is designed for editing and storage of images and should be gray-balanced (equal R, G, and B values always give gray) and perceptually uniform (the same increment should produce the same degree of perceived change anywhere within the color space). Photoshop will create all new files in the working space you set as the default in its Color Settings; it assumes that nonprofiled images are to be assigned this profile (though how automatically this happens is under your control).

But there are several RGB spaces, so how do you decide which to pick? Some color spaces are very large (such as Kodak ProPhoto RGB), while others are comparatively small (sRGB, or ColorMatch RGB, for example).

above and right
Photoshop warnings for no embedded profile and nonmatching profile. Ignore these at your peril!

As ever, the choice of working color space depends on what you're trying to do. In theory, the benefit of a large working space is that it can preserve a wider range of colors and therefore the most information about your image, but how much you need to do that depends on what's in the image and how you expect to output it. If everything is going to commercial CMYK print, more of those extreme colors are going to be lost and a smaller space might be more appropriate (though still an RGB space for editing, as explained in Chapter 2).

But if you're going to output to film recorder, photographic printer, or wide-gamut inkjet, you'll want to hang on to as many of the rich saturated colors as you can. And you might want to do both, in which case you'd still be best to work in a larger color space, and lose the out-of-gamut colors when converting to CMYK for commercial print at the end. You also need to be aware that in moving color information from the input (scanner or camera) space to a working space, tonal detail can be clipped if the working space isn't big enough.

Some RGB working spaces you might use are:

Adobe RGB (1998) This is a fairly large space that includes the majority of CMYK and RGB printed output device gamuts (presses and photographic printers such as the Durst Lambda, Cymbolic Sciences LightJet, or Fujifilm Pictrography). Some of the yellows possible in CMYK are clipped, and it also doesn't quite cover the gamuts of all inkjet printers.

Bruce RGB Developed by color specialist and writer Bruce Fraser to provide the best editing space for 8 bit-per-channel images intended for print output, i.e. it matches most CMYK and RGB output device gamuts and is particularly useful for editing images that need large amounts of correction and which fall apart in larger spaces. As scanners have improved greatly since its creation in 1998, there is perhaps less call for this space nowadays.

Ekta Space PS 5, J. Holmes Also known as Ekta · Space or Joe RGB. This is a freely downloadable working space designed as an image-archiving space by photographer Joseph Holmes to just cover the color gamut of Ektachrome transparency film so that no colors are "clipped" on conversion from the input color space; it also preserves the characteristics of individual film stocks. There is also a paid-for family of Ektachrome spaces designed to offer different levels of chroma (color saturation), from which you can choose the version that provides the best result for your purpose. These work well with wide-gamut inkjet printers and are recommended for use with images that originate on transparency film.

sRGB As already described, this is a small gamut space promoted by HP and Microsoft as a Web color space. Based on a "typical" PC monitor, it doesn't match offset printing gamuts too well—it potentially clips the cyans and adjacent blues and greens quite a bit, but whether this matters will depend on whether you have any of those colors in your original. In Photoshop, you could try soft-proofing an image in its input/capture space to sRGB with gamut warning turned on, to see if you're losing anything (see the next chapter for how to do this). However, it is a good choice for working on Web graphics (see pages 179–180 for a more detailed explanation). It's also a good match to the input gamuts of many digital cameras.

Kodak ProPhoto RGB This has an immense gamut, intended to cover all the colors possible to capture with transparency film (including some

colors invisible to human beings and impossible to create in the real world). It's appropriate for archiving when you want to preserve the maximum color information or for wide-gamut output types like transparency or Hexachrome printing (*see Chapter 5*), but it needs 16-bit files to allow safe editing. For the majority of cases, we think that one of the Ektachrome spaces would do just as well. See appendix I for details of where to buy/download these profiles.

this page An unprofiled image assigned three different colour spaces: Adobe RGB (1998) (*left*), sRGB (*top*) and Ekta Space (*above*). If you need to work with an image that has no embedded input profile and you can't identify the correct one, try several and judge by eye (with a calibrated monitor or printer) which profile produces a good starting point

profiling your monitor by eye

Although we recommend having a monitor profile produced by measurement, you can create one by eye using the ColorSync Utility (Mac OS) or Adobe Gamma (Windows). These allow you to set the color temperature for your display and gamma values and (Adobe Gamma only) the phosphor types. Without going into great detail (or repeating the on-screen instructions), a key point here is setting color temperature—the D50 graphic arts standard looks quite dull and yellow, but 6,500K (known as D65) is an acceptable value. Anything higher may look too blue and won't help you make comparisons between your inkjet printer output and your screen—though if your viewing condition for proofs are very blue-ish this might, of course, be appropriate. Remember that if you are producing work which will be seen in specific lighting conditions—as in point-of-sale, for example, you should aim to view proofs under that lighting too.

Experience has shown that matching overall intensity (brightness) is more important than color temperature when making comparisons between screen display and printed output. A 6,500K monitor white point setting and 5,000K viewing light for hardcopy work quite well, despite not being exactly the same color temperature. It also seems to be the case that while people will generally agree on how well monitors match each other, or how well printed samples agree, they can have quite different views about how well screen and printed versions match. We recommend that you experiment a little to see which combination works for you—but don't hold the print-out next to the screen. Instead, look at the screen and then turn away to look at the proof. While this might seem a less accurate way of checking, you should find that you can remember colors well enough to judge how well they match.

Mac users can set their screen gamma to 2.2 (gamma quantifies the relationship between input signal and measured screen brightness). A gamma of 2.2 is the same as on PCs (and useful if you're preparing Web graphics on a Mac, since most of your audience will have PCs), but color-managed applications like Photoshop will take into consideration system-level gamma settings to show images using your monitor profile—an image viewed on similar screens but with different system gamma settings will appear very similar. It also matters what the viewing conditions are when you do this, so make sure they are the same as those you will be working in.

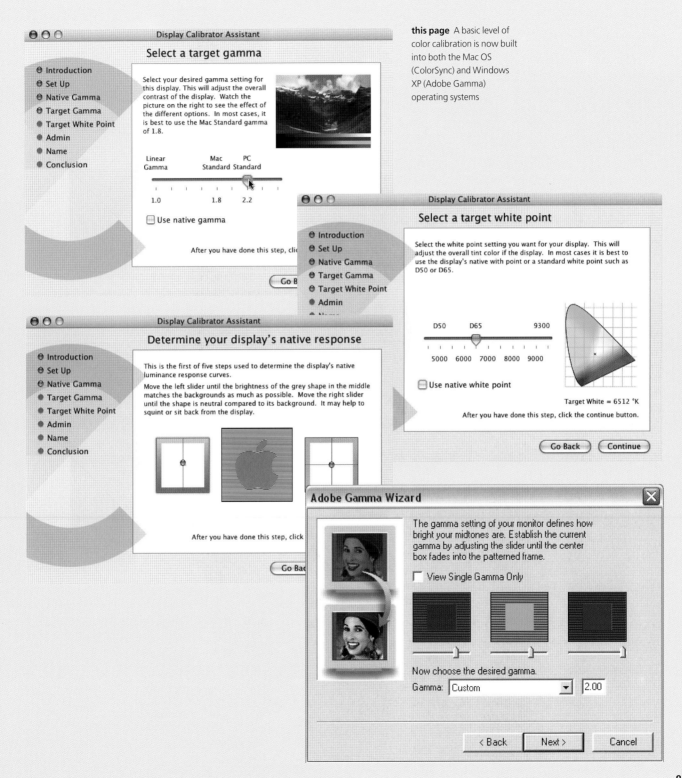

this page A basic level of color calibration is now built into both the Mac OS (ColorSync) and Windows XP (Adobe Gamma) operating systems

Display Calibrator Assistant

Select a target gamma

- Introduction
- Set Up
- Native Gamma
- Target Gamma
- Target White Point
- Admin
- Name
- Conclusion

Select your desired gamma setting for this display. This will adjust the overall contrast of the display. Watch the picture on the right to see the effect of the different options. In most cases, it is best to use the Mac Standard gamma of 1.8.

Linear Gamma — Mac Standard — PC Standard

1.0 1.8 2.2

☐ Use native gamma

After you have done this step, cli...

Go B...

Display Calibrator Assistant

Select a target white point

- Introduction
- Set Up
- Native Gamma
- Target Gamma
- Target White Point
- Admin
- Name

Select the white point setting you want for your display. This will adjust the overall tint color if the display. In most cases it is best to use the display's native with point or a standard white point such as D50 or D65.

D50 D65 9300

5000 6000 7000 8000 9000

☐ Use native white point

Target White = 6512 °K

After you have done this step, click the continue button.

Go Back Continue

Display Calibrator Assistant

Determine your display's native response

- Introduction
- Set Up
- Native Gamma
- Target Gamma
- Target White Point
- Admin
- Name
- Conclusion

This is the first of five steps used to determine the display's native luminance response curves.

Move the left slider until the brightness of the grey shape in the middle matches the backgrounds as much as possible. Move the right slider until the shape is neutral compared to its background. It may help to squint or sit back from the display.

After you have done this step, click

Go Bac...

Adobe Gamma Wizard

The gamma setting of your monitor defines how bright your midtones are. Establish the current gamma by adjusting the slider until the center box fades into the patterned frame.

☐ View Single Gamma Only

Now choose the desired gamma.

Gamma: Custom ▼ 2.00

< Back Next > Cancel

DIGITAL COLOR CORRECTION

chapter 4

This is where we leave the theory behind and get to some real color correction. If you've read to here from the beginning of the book, you'll be well acquainted with the why, where, and when of color correction; this chapter tells you the what and the how of it. If you've flipped straight to this page because you can't wait to get started and learn some techniques, that's fine. However, if you're not already working in a color-managed environment, we strongly urge you to go back and look at the preceding chapters. Otherwise, you may find that your best efforts are for nothing when you pass your work onto others—or even when you try to print them out yourself.

This chapter is split into two parts—a general introduction to the key tools and techniques you need for color correction, using Adobe Photoshop as the example software (see "Doing it the Photoshop way" on page 85 for our reasons), and a wide variety of worked examples covering an extensive range of image types and sources.

In the tools and techniques section, you'll be introduced to key tonal and color correction concepts such as *Levels*, *Curves*, eyedroppers, the *Hue* and *Saturation* controls, and adjustment layers. We explain the theory of what these tools do, as well as the practical applications of each

and explain which to use for what purpose, as there is often more than one way of achieving a particular image manipulation. We discuss the 16-bit/8-bit image dilemma and provide practical guidance on when to convert.

The work-throughs then cover a range of production-related and creative tasks using real-world images captured from digital cameras; from consumer-level and professional scanners; from transparency and color negative originals; from 35mm to 5 x 4 formats. We show you how to deal with under- and overexposed originals, global and localized color casts, and contrast and saturation problems, while working in CMYK as well as RGB. In the creative projects, we explain how to introduce a color cast or make major hue changes for effect, as well as how to make great mono- and duotone images from color originals.

The first work-throughs generally illustrate a single technique, but we build up to multiple techniques on some of the more difficult images. We've included a wide range of subjects, from fashion to food, interiors, and architecture to travel, sports, and natural history. Whatever picture you work on, you should be able to find something here that helps you to meet your brief and get the image looking the way you want it to.

4

above Portrait, architecture or fashion shot? The purpose of the photo will affect your color priorities

tonal and color correction

We've done the theory, set up for color management, acquired our images at a usable size. Now we're ready to color correct them. Before we work through a variety of examples covering a range of "problem" images and creative enhancements, there are some standard tips and techniques you'll need that will help you with pretty well all of the images which you're likely to encounter.

But before we get to the mouse and menus, take your hands away from the keyboard and use your eyes. This is always the first step—to *look* at the image. Before deciding what's wrong or what might need improving in an image, think about what's in it. What is it a picture of? What do you want to show or emphasize, what's immaterial and what do you need to downplay or disguise? Sometimes there's nothing really wrong with the image to start with, it's more a case of deciding what needs to be emphasized or enhanced.

This analysis is essential, and not just so you can formulate a suitable plan of attack—it's important to understand that you can generally only emphasize or improve one part of a picture at the expense of another. Consider the image to the left. This photo could be intended as a portrait, an architectural shot, or a fashion shot. In the first instance, we'd want to balance the skin tones and clothing; in the second, we'd be more concerned to bring out the textures in the walls and floor; in the third, the detail and texture in the clothing would be our main concern.

You might argue that with some careful masking we could achieve all three things, but what happens when you do this is that the image

starts to look unnatural. Remember back in Chapter 1 we talked about how flexible the eye and brain are in adapting our vision to deal with different circumstances? In some respects, the human visual system is very forgiving—deciding what's meant to be "white" in a particular scene, for example—and in others, much more discerning. Playing around with tonal and color values separately in different parts of an image can give the brain conflicting sets of clues about the lighting in an image, and as a result, the illusion of viewing a "real" scene fails.

Another example of this would be if you noticed that the shadows in a picture taken on a bright sunny day have a blue cast and decided to correct that—one of the clues that the brain interprets as meaning that it's sunlight is the blue shadows. Take those away by neutralizing the cast and you can no longer be so certain that it's sunlight any more (*right*).

This doesn't mean that you can't work differently with various parts of the image— you just have to do it carefully and with an appreciation of how the viewer's eye and brain will interpret the results. The golden rule when assessing any move you make in color correction is "Does it look better to you?"

above Not every color cast is bad, as your brain sometimes needs them to interpret the image. Remove the blue cast from the shadowns in this example and you also remove the sense of sunlight

Throughout this chapter (and much of the rest of the book), we use Adobe Photoshop as the image-editing application to demonstrate techniques and illustrate the points we're trying to make. This is because Photoshop is by far the market-leading program for serious image editing, used throughout the world by photographers, graphic designers, and prepress specialists. But of course it isn't the only image editor. If you're going to buy software for color correction, we'd recommend Photoshop way above anything else, but if you already have something else and don't want to spend any more, we'll try to introduce the concepts and Photoshop controls in such a way that you can take the ideas and work with them in your own application. For reasons of space, it just wouldn't be practical to try and cover the multitude of programs available; and for consistency, it's better to treat everything in the same way, i.e. hence the use of Photoshop throughout the book. Another reason to recommend Photoshop is its tremendous depth and versatility. You may find that other programs simply don't have equivalent tools or controls; where we do discuss tools that may be unique to Photoshop, we'll try to explain what they are doing in such a way that you could recreate the effect using other tools in other programs. Ultimately it's all just a question of changing color values in pixels, and all the image editors should let you do that.

doing it the Photoshop way

on the level

There are really two stages to any image correction or optimization—tonal correction and color correction. You could even argue that color correction is just a special case of tonal correction, applied only in one or two color channels instead of in all three (or four, in CMYK working).

Rather than splitting hairs, let's define tonal correction. By "tones" in an image, we mean the range of shades from light to dark. When you acquire an image, it will have a distribution of tones and these can be displayed using a kind of graph called a histogram (*below and right*). The horizontal axis represents the levels from dark to light (from left to right); the vertical axis denotes the relative frequency of that level in your image—that is, how many pixels there are at that level. In terms of pixel data, the histogram is a vitally important view of what's in your image.

right A normal histogram has an even distribution of values. Excessive or missing levels at any point in the range could indicate a problem with the image

far right Underexposure shows up as a concentration of levels at the shadow end of the scale

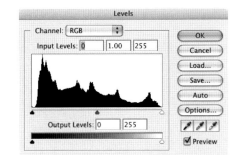

Learning to interpret and then modify the histogram is the first step in image assessment and manipulation. A normal histogram will usually show a smooth distribution of values across the range from dark to light. One that's seriously skewed toward one end of the scale or the other signifies an image with no dark or light detail or may indicate a problem either in the original or in its capture. A scan of an underexposed

transparency, for example, has a histogram like the one below—everything is concentrated into a very small part of the range. Similarly, in an overexposed shot (as shown on the opposite page) all the image data is compressed into the lighter end of the scale.

This isn't necessarily telling you anything you couldn't already see for yourself in the image, but there's a further histogram message that you might otherwise miss. Look at the two lower histograms on the opposite page. They show levels for images that have already been edited. The spikes represent levels where pixels have been assigned the same value, while the gaps are

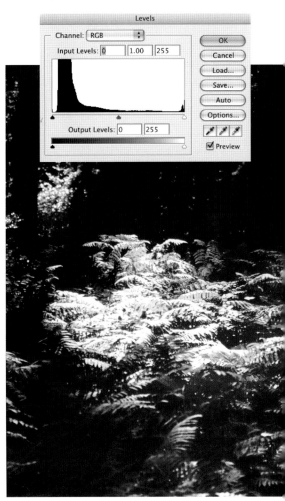

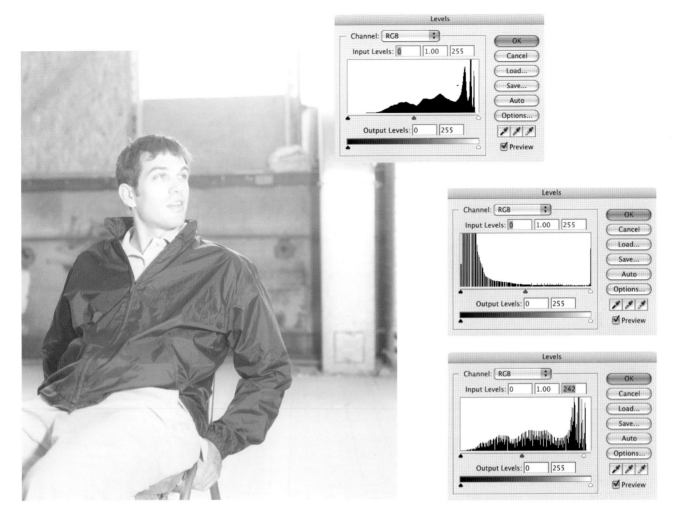

have that value. In a synthetic graphic with only a few flat colors (like a computer screen grab), this wouldn't be significant, but it's a sign to proceed with caution if you're dealing with a photograph—those empty levels could lead to posterisation after further manipulation.

Pixels which previously represented tonal differentiation in the image have been mapped onto the same values, and can no longer be differentiated. Further image manipulation may serve only to increase the clumping of pixel levels, which ultimately leads to visible banding in colors as there just aren't enough different tonal values to produce smooth gradations.

This is the reason for working in high-bit (more than 8 bits-per-channel) for as long as you can—when you're editing an image, it always involves changing the R, G, or B (or C, M, Y, or K) values of each pixel. Effectively, data may be discarded by every color shift or tonal alteration. If you're working in 8-bit there are only 256 levels available, so if your pixel data spread is already skewed, the chances are that the effect will only get worse with further operations. In 16-bit, there are so many more levels available for fitting pixels to that even quite major tonal moves can be done without danger of image degradation. The examples on the next page show the before and after effects of the same tonal adjustments on an 8-bit and a 16-bit version of the same image: the 8-bit one shows the toothcomb effect, while the 16-bit one still looks smooth.

above left In cases of overexposure, the levels group together to the right of the range

above The more your manipulation causes your levels to clump together in the histogram, the more danger there is of the final image looking posterized

So that's what the histogram can tell us, though it can only ever be a guide—some images might look right, even with unusual histograms, depending on what's in them. But in Photoshop (and most other image editors), it's not just an information display. While the histogram in the Photoshop CS *Histogram* palette just offers information (like the older *Image > Histogram* display) the histogram in the *Levels* dialog is an interactive tool as well.

the right of the current position of the slider) shows up in its own color: if the blues are clipping the affected pixels will be blue. At the shadow end, clipped pixels show in their complementary shades on a black screen—clipping in the shadows in the red channel shows up as cyan pixels, for example. Or you can inspect each channel independently to see where pixels are being forced to the extreme values as you play with the *Levels* sliders.

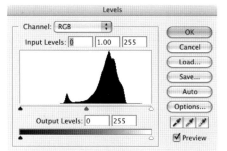 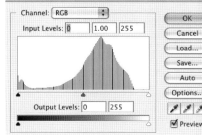 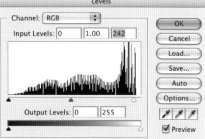

above The effect of a tonal adjustment on an 8-bit image (center) and a 16-bit image (right). The levels in the former break up, but remain smooth in the 16-bit version

right Hold down the Alt key as you move the *Levels* sliders to see when you start to clip the data in each channel

By moving the input (upper) sliders at either end of the lightness scale, we can instruct the software to remap the pixel values to the limits we set, effectively saying "Take any value outside the point to which the slider is set and set it to the extreme value, either shadow (on the left) or highlight (on the right)." The values in between the extremes you set are remapped accordingly to fill the full range of levels.

In Photoshop, you can see the effect on the image of moving the sliders (as long as the *Preview* box is checked). For a more accurate idea of how you are affecting the pixel values, try this useful trick—hold down the Alt key (Option key on the Mac) as you move the slider and you'll see when you start to clip the data in each channel (that is, force pixels to either pure white or solid black depending on which slider you're using).

You can even see which channel clips first as you move the sliders. At the highlight end of the clipped channel, the screen is blank white and any "clipped" pixel (i.e. one whose value falls to

above The histogram shows the black rebate (the spike at extreme left) and the lack of highlight values

below Adjusting *Levels* with the Alt key pressed shows when you are clipping the shadows

right the effects of trimming the shadow values in the rebate and stretching out the highlights

The effect of such a move is that all the values in between have to be stretched out accordingly. For an 8-bit scan, fewer than 256 values will have to be stretched over 256 "slots." The images towards the bottom of this page show the effect of a basic "trimming" of highlight and shadow values, both on the image and on the *Levels* histogram.

The middle slider in the *Levels* dialog controls "gamma," which in this case is the relationship between the input and output levels for your image. Moving this to the left or right "stretches out" the highlights while "compressing" the shadows, or vice-versa. While you can see the effect while you move the slider, it's difficult to control precisely, and not as subtle or powerful as the *Curves* dialog (*see next page*).

with the *Levels* sliders.

Generally you wouldn't want to clip very much at either extreme, since clipping discards tonal detail, but it's a useful way of finding out if the histogram is skewed by the presence of a film rebate, which usually ought to be solid black (*see histogram above*).

The values you have set with the sliders for highlight and shadow appear in the *Input Levels* boxes above the histogram. The default shadow input value is 0 and highlight 255 (the extremes of the 256-level scale; these values don't change even if you're working in 16-bit). If you set the highlight input value to 230, for example, that means the program will map all pixels at 230 (or above) to the maximum value 255—white. (We can change what color a 255 output represents by altering the output value in the lower set of sliders.) Similarly, setting a shadow value of 36 means that anything at 36 or less will be mapped to 0 (or as above).

drop by drop

The adjustment of input-end and midpoints can also be done using the black, white, and gray eyedroppers which appear—and work exactly the same—in both the *Levels* and *Curves* dialogs. The difference between moving sliders in the composite *Levels* dialog and using the shadow, highlight, and midtone eyedroppers is that the latter are usually set to neutralize the color as well as assign a particular tonal value for all three channels—the default values are 0, 0, 0 for shadow; 128, 128, 128 for midtones; and 255, 255, 255 for highlight. However, these can be altered and saved as new defaults (see worked examples later in this chapter).

The other major difference is that while the *Levels* sliders always work according to the computer's analysis of tonal values in your image data, setting the "dark" and "light" points, the eyedroppers allow you to choose the exact colors in your image that you wish to set to black, white, or mid-gray.

For this reason, many users set "black" to 8, 8, 8 (RGB values) or 10, 10, 10 and white to 247, 247, 247—this lets them click on a shadow or highlight point they wish to make neutral and in which they still want to see some detail when printed. Setting the shadow eyedropper to 0, 0, 0 is useful for setting an absolute black, if you're clicking on the film rebate, for example. This often proves more effective when the image does not have a complete tonal range—we are effectively setting the unexposed film base to neutral black. It doesn't always produce the result you might want, though, so try it and observe the effect. Holding down the alt key changes the *Levels* dialog's *Cancel* button to *Reset*, so you can always undo the eyedropper if it doesn't seem to be helping.

You can also adjust the target color values for the midtone eyedropper to introduce deliberate color casts, such as a "warm light," by selecting an appropriate color in the *Color Picker* and clicking in a neutral midtone area of the image (assuming there is one, of course). It's a bit of a trial-and-error process—if you don't like the result, you've got to double-click the gray eyedropper again to bring back the *Color Picker*. There is, however, a more direct and interactive way to experiment like this, using the *Auto Color* features (*see "Manual or Automatic?," page 94*).

throw us a curve

Our next major port of call is the *Curves* dialog box. This doesn't tell us anything about the pixel values in our images the way the *Levels* histogram does, but it does give a very detailed view of how we want to control them. Along the horizontal axis are the "input" levels for our image; the vertical axis displays the corresponding output

levels. The default curve setting is a straight line at 45°—any input level is passed on unchanged. But as soon as you start changing that straight line into a curve, interesting things begin to happen.

right The *Curves* dialog offers precise control of the relationship between input and output tonal values.By 'pegging' parts of the curve, you can adjust some tones without affecting others

DIGITAL COLOR CORRECTION

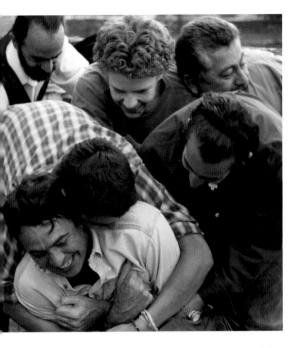

tonal values in an image where they are while you vary others so that you can optimize selected parts of your image's tonal range without changing others: you can increase contrast and tonal separation without changing the shadow and highlight values, for example. There are limits, of course—if all or part of the curve winds up flat or sloping downward from left to right, it's almost certainly going to ruin the image, at least in part.

left Pulling the curve down makes the midtones darker. Pulling the curve up lightens the midtones and opens up the shadows. The *Curves* tool can do everything that *Levels* can, and more

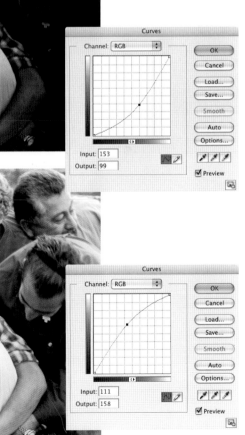

Clicking a single point onto the middle of the curve and pulling up or down is the same as altering the gamma value (the middle slider) in the *Levels* dialog, but with more precision in selecting the point to be altered. Experiment with it—pulling the curve down makes the midtones darker; pulling it up lightens them and opens up the shadows. Note that these "up" and "down" directions apply if the curve is the "right way up"—the default for RGB is to have shadow values at the bottom left. You can reverse it by clicking the small box inside the grayscale ramp if you prefer.

Sliding the end points along the edges of the graph affects the dark and light extremes—you can limit the minimum shadow and maximum highlight levels to less than the extreme values, or force parts of your image to pure white or black, just like adjusting the endpoints in the *Levels* dialog.

Curves can do everything that the *Levels* controls can—and more. The beauty of *Curves* is that you're not confined to one control point – you can add several and manipulate them separately (though not entirely independently) of one another. This enables you to "peg" some

getting the point

You'll notice that when you have the *Curves* dialog open, your cursor turns into an empty eyedropper when you move it across the picture. If you hold down the mouse button while moving this eyedropper around, this lets you see which point on the composite or individual channel curve corresponds to the part of the image under the cursor by placing a "live" moving point on the curve. Command-clicking on a point in your image will put a control point corresponding to that sample on whichever curve you're viewing at the time (RGB composite or any individual channel); Command-Shift-clicking in the RGB composite puts control points on all three channels (but not the composite one) at the appropriate R, G, and B levels for that sample of the image. This enables you to quite precisely pick the parts of the image (in terms of tone) that you want to work on—or to lock those that you don't.

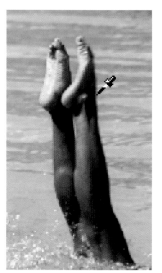

above Use the *Curves* eyedropper to pick the tones in an image that you want to work on, and lock those that you want to protect

right Setting the eyedropper sample size to 3x3 average prevents rogue pixels from causing unpredictable results

You should normally set your eyedropper sample to *3 x 3 Average* pixels. Select the eyedropper in the main tool palette to see its selected size displayed in its toolbar (*below right*). This will average out any effects from "rogue" pixels in your image, which could give you unexpected results if you use *Point Sample* (1 pixel only) sampling. There is another thing to be aware of: in CMYK editing in Photoshop, you can't put a single point on the composite CMYK curve by Command-clicking from the image, but you can put points on all four curves with a Command-Shift-click.

Some of the workthrough examples later in this chapter show you how to use both *Levels* and *Curves* to make tonal corrections which deal with tonal information in a color-indifferent way. So

what about color correction? Suppose the highlights are as bright and the shadows are as dark as you want them to be, and it's just the color that's wrong?

Color correction turns out to be just a form of tonal correction. If you bear in mind that color information in digital files is contained in channels, and that those channels each represent one of the primary colors (RGB or CMYK), then adjusting color balance can be seen as a case of tonal correction within one or more of the channels.

Put more practically, if your picture is too blue, some tonal editing in the blue channel will probably fix it. If you're working in CMYK, then you'd control blue via its complement, yellow (see the RGB/CMY color relationship chart in Chapter 1, page 24). You might then have to compensate in the other channels to maintain overall tonal balance, though. If you turn a color "up" in RGB, that's like adding light, which makes the image lighter overall, so it might be necessary to compensate by reducing the other channels accordingly. Conversely in CMYK working, the curves normally work the opposite of the RGB default, with 0 percent ink at bottom left. In this cases, raising a curve adds ink and thus darkens the image.

brightness and contrast

You might be wondering why we don't use the *Brightness & Contrast* adjustments for tonal correction. After all, they relate to visual parameters that we are all used to thinking about, without the apparent complexity of *Levels* and *Curves*.

The trouble is that neither of these adjustments offer the subtlety of their less familiar counterparts. A *Brightness* adjustment when viewed in *Levels* simply represents a shift of the entire histogram either to the left or the right, depending on whether it was an increase or decrease in brightness respectively . A *Contrast* change expands (increasing contrast) or contracts (decreasing contrast) the histogram shape. The danger with either type of adjustment is that it can simply force some pixel data values off one end of the scale or the other (a contrast increase can do both), turning pixels that were previously different to pure white or solid black. This means losing tonal detail, and once it's gone you can't get it back.

But more importantly, these adjustments don't change the relationship between the various levels—the fundamental shape of the histogram doesn't change, it's only moved or stretched, and proper selective tonal and color editing involves changing that shape, by changing the relationship between the different tones in the image.

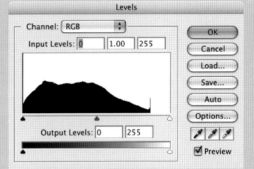

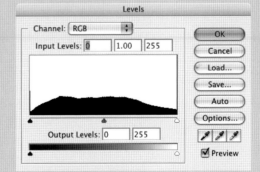

above A *Brightness* decrease shifts the entire histogram (*top*) to the left (*center*). A *Contrast* increase expands the histogram (*bottom*). Both changes lose tonal information

manual or automatic?

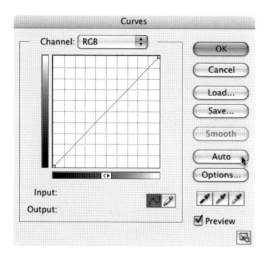

top left Both *Levels* and *Curves* have an *Auto* option. Click the *Options* button below it to control how this operates on your image

bottom right Configure the *Auto Color Correction Options* using the *Shadows, Midtones,* and *Highlights* swatches, plus the *Clipping* value settings. These affect the *Auto Contrast, Auto Color* and *Auto Levels* tools

If you've played with Photoshop's *Levels* and *Curves* dialogs, you'll have noticed that they both have a button marked *Auto*. There's also a bunch of *Auto*-prefixed commands under the *Image > Adjustment* menu. If you've tried these, you'll have seen an instant change in your image— sometimes for the better, though not always. So what are the *Auto* options? Are they shortcuts that get the computer to do the thinking for you? If you thought that the *Auto* options can fix all ills, you wouldn't be reading this book, so you've probably tried them on a few images and found that they didn't really do what you wanted.

That doesn't mean that you should just forget them, though. Sometimes they will do part of the job for you or help you decide how best to do it even if you wind up doing it manually, particularly when correcting color casts. So let's take a look at them.

Instead of selecting *Image > Adjustments > Auto Contrast, Levels,* or *Color,* we suggest that you take a look at the full *Auto* controls from the *Levels* or *Curves* dialog to see more choices—so

click *Options* and you'll see the *Auto Color Correction Options* panel (*below*).

This dialog box brings together the various *Auto* functions in one place, though you wouldn't necessarily recognize them from the names. Working down from the top, *Enhance Monochromatic Contrast* is the same as *Auto Contrast,* which automatically trims the levels in the composite RGB (or CMYK) histogram. You'll see a change in contrast, but the color balance won't be affected.

Enhance Per Channel Contrast is the same as *Auto Levels* and performs the *Levels* histogram trimming on each channel separately. This affects both contrast and (in most cases) color balance and can be helpful in establishing what changes you need to make to correct a cast.

Find Light & Dark Colors is equivalent to the *Auto Color* command (note that this one only works on RGB images). The image is analyzed to find the average lightest and darkest colors and the pixel values altered to makes these conform to the values specified by the swatches in the *Target Colors & Clipping* section at the bottom of

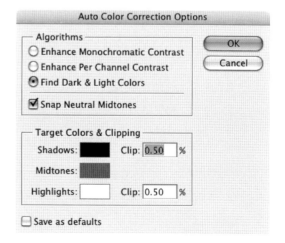

the dialog box. According to Adobe, this algorithm "maximizes contrast while minimizing clipping," so it's a sort of trade-off between the first two modes.

The real power of the *Auto Color Correction Options* comes from playing with these swatches and the associated clipping values. Clicking on any of the swatches brings up the *Color Picker*, just the same as double-clicking the shadow, mid-tone, or highlight eyedroppers in the *Levels* or *Curves* dialogs, and any changes you make and save here will be used when you go back to those eyedroppers. These target colors will be used by all three of the color algorithms when clipping the data in your image—you can play with the values and see the effect on your image.

The clipping value boxes for shadows and highlights are there to help reduce the effect of stray pixels with extreme values (such as scratches, specks of dust, or CCD noise from a scan or digital camera capture). This means that they don't yield false values and throw off the auto correction process; the percentages you specify are the proportion of pixels with extreme values (dark or light) that will be disregarded by the software when clipping the *Levels*. Keep these values as low as possible—Adobe's recommended value is between 0.5 and 1 percent, but it's worth experimenting to see if lower values produce strange results or not. Higher values will sacrifice more shadow and highlight detail in order to achieve more midtone contrast, but in a quite indiscriminate way—contrast increases are better done using *Curves*.

Normally you'd leave the shadow and highlight swatches set to neutral colors, either pure black (0, 0, 0) and white (255, 255, 255) or the slightly amended values discussed earlier in the *Levels* section. The real fun comes when you check the *Snap Neutral Midtones* option and then open the midtone *Color Picker* by clicking in the gray swatch. Clicking around in the *Color Picker* can have huge effects on the color balance of your

image, as the software maps all neutral and near-neutral tones in your image to the color you specify. Unlike using the gray (midtone) eyedropper in the *Levels* or *Curves* dialogs, here you'll see an immediate preview, because the software is selecting the near-neutral midtones for you, so you can keep clicking around to find the exact color that works. You can read off the color values if you want to go back and adjust manually using the gray eyedropper without having to accept the *Levels* clipping that the *Auto* option so frequently imposes.

Used carefully, you can balance out many color casts—or even add them creatively—using this approach and it's very easy to experiment quickly to see which color bias you need to introduce. As with the eyedroppers, each click in the *Color Picker* starts from the underlying image pixel values, and not the last thing you saw in the preview, so there's no need to undo anything; just keep clicking around until it looks right. Since even small changes here can make a big difference to the color balance of an image, this might be one to do on an 8-bit image with an Adjustment Layer (see *"Well adjusted,"* page 97) so that you can then vary the effect further using the layer's *Opacity* slider.

above The *Snap Neutral Midtones* option can dramatically affect the whole color balance of your image, remappping all the colors using the color selected in the *Color Picker*

knowing who's hue

The other key tool is the *Hue/Saturation* dialog. This lets you control the intensity of selected colors and to shift their hues by small or large amounts. Going back to our color theory from Chapter 1, saturation represents the spectral purity of a color in terms of the mixture of wavelengths that comprise it. More saturated means fewer wavelengths (the extreme being only one, meaning an absolutely "pure" saturated color); less saturated means a greater mix of all wavelengths in the color (the extreme being gray, where there is an equal mix of all wavelengths).

Hue is the attribute we mean when we ask, "What color is it?" Red, green, blue, and yellow are all hues. In scientific terms, hue relates to the predominant wavelength of the light in the spectrum. Changing hue means shifting the wavelength along that spectrum, either toward the red or blue ends. It can also be useful to think of hue as the angle measurement, set around a color wheel like that shown on page 24; this is how Photoshop specifies hue in the *Hue/Saturation* dialog box, which we'll see a lot of later in this chapter.

In practical use, the *Hue* controls allow you to change the "color" of selected tones in your image, as you might need to do in advertising or fashion work. You can select color ranges to adjust or select areas using any of Photoshop's selection tools. The *Saturation* control allows you to "turn up" selected colors for a vivid eye-catching effect, or to desaturate them for a more muted feeling, the extreme being a monochrome image. That said, a simple desaturation isn't necessarily the best way to make a good mono picture from a color one, as we'll see in the second half of this chapter.

Again, these effects can be applied to any selected area or color range within an image. Some of the examples later in this chapter show the use of these controls for creative adjustment. The *Hue/Saturation* dialog has some strengths compared to the *Selective Color* dialog box, in that it enables you to choose exactly which color range you wish to work on (*above*), as opposed to the preset choices in the latter (*left*).

top the *Hue/Saturation* dialog. Color ranges can be selected and fine-tuned for precise control

right The *Selective Color* drop-down menu enables you to edit base colors but the base color definition is left to Photoshop

well adjusted

One of the most powerful and flexible capabilities of Photoshop is adjustment layers. Unlike image layers, which hold pixels that can be variously superimposed or mixed, adjustment layers make changes to the pixels in the layers below them. The great thing about this is that the pixel data in the image underneath isn't affected when you add or change an adjustment layer. This goes even further than Photoshop's *History* palette, which only lets you move back and forth among the operations you performed; you can't undo some but keep others that were performed subsequently. The adjustment layer palette not only provides a selective "undo" capability, but also gives you a "volume control" for your effects. The *Opacity* slider on the *Layers* palette can vary the strength of a change or effect, so if it's hard to achieve a subtle change using the regular controls, you can make a too-large one and "turn it down" using the *Opacity* slider.

What's the downside?

There are two limitations with adjustment layers, one you can throw money at and one you can't: layers use memory, and the bigger your image, the more memory they're going to need. If you can afford it, you can buy RAM up to whatever limits your computer supports to help this, but the other problem is in the software. In Photoshop 7, you can't use adjustment layers on 16-bit images, only 8-bit ones (fortunately, in Photoshop CS this is no longer the case). So, should Photoshop 7 users forget the benefits of 16-bit in favor of the flexibility of adjustment layers?

Not at all. Use 16-bit as far as you can; make the biggest changes in 16-bit. Do any major tonal and color shift corrections in 16-bit, then convert to 8-bit and use adjustment layers for fine-tuning any further corrections. You can always keep a copy of the original 16-bit file in case you find the scope for adjustment in 8-bit insufficient after conversion; indeed, it's always good practice to archive the 16-bit "master" file if you have space, in case you need to retrace your steps or produce a different version of the picture for any reason.

below Adjustment layers can be created with a single click from the *Layers* palette. The combination of their flexibility and the *Opacity* slider allows for extremely subtle adjustment

working examples

You've probably got the sense by now that there is usually more than one way of carrying out a color correction or creative change. It's not really surprising, as all any of the tools do in the end is enable you to change the color values of some pixels relative to others in your image. What will only become clear from experience is which tool is the best for a particular job. The following worked examples aim to illustrate a range of color correction jobs that show how a variety of Photoshop's main tools are used to fix problem images and take creative control.

simple tonal correction

There's nothing wrong with the color in this image (*right*), just a "mistiness" and lack of detail in the dark wood paneling above the bath and very bright highlights inside the bathtub, as well as in the window beyond on the right. Straightforward tonal correction should bring this under control.

1 After converting from the scanner color space to our working space (*Image > Mode > Convert to Profile*), and opening the *Levels* dialog, we bring in the shadow slider (while holding down the Alt key) until some real black just starts to appear in the panel under the bath-tub. To set highlights, we do the same thing with the right-hand slider. The bright areas in the window quickly start to clip, but we decide it's OK to lose a little detail here as it's not really the focal point of the image. Our trimmed histogram looks like the one shown right (1B).

2 There's more contrast in the image now, but we still can't see much detail in the dark wood paneling. Opening *Curves*, we command-click on a suitable point where we'd like to be able to see the wood grain and put a control point on the composite RGB curve, then move that point upward a fair bit (2A). This opens up the dark wood tones nicely, and although the brighter areas on the right-hand side go a bit lighter too, we think the balance is good. The important areas have enhanced detail while the room in the distance has lost some, taking the eye straight to the foreground (2B).

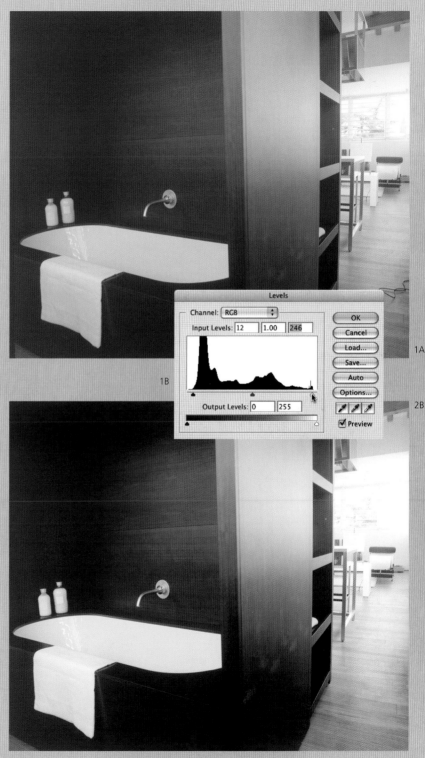

1A

1B

2A

2B

tonal and simple color correction

This image (*below left*) has very high contrast. In addition to the specular highlights on the faucets and showerhead, the bright white of the bath is a key area that must be handled carefully. At the other end of the tonal range, we don't want to lose detail in the shadowed marble walls.

1 After converting the image from its scanner color space (*Image > Mode > Convert to Profile*) to our working space (ColorMatch RGB, requested by our printer), we open the *Levels* dialog box. The histogram is a reasonable shape, but it reveals that there are no real blacks in the scan. Because this image contains bright highlights and dark shadows that are likely to benefit from being made neutral, it's a good candidate for fixing with the eyedroppers so that we can retain precise control over the shadow and highlight extremes.

We double-click the black eyedropper. In the *Color Picker,* we set the shadow value to 8, 8, 8 in R, G, and B to define a not-quite-black but still neutral shadow. Clicking *OK* to close the *Color Picker,* we then click with the black eyedropper in a part of the shadowed marble to set the deepest shadow tone we wish to distinguish from solid black and to neutralize any color cast in the shadows.

We then go through the same process to set the highlight point to 247 each in red, green, and blue and click in the brilliant white area inside the bathtub. This sets the white to a neutral value that should ensure no paper-white spots (1A) when the image is printed, so the basic tonal correction is complete (1B).

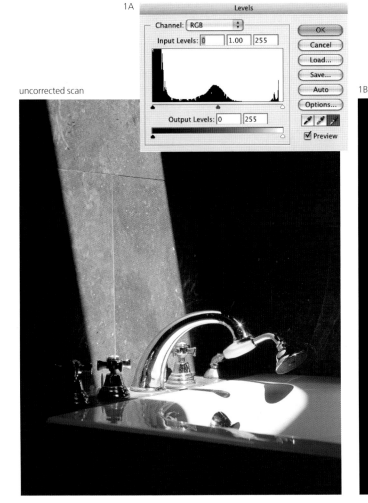

uncorrected scan

1A · 1B

2A

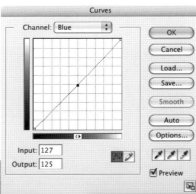

2B

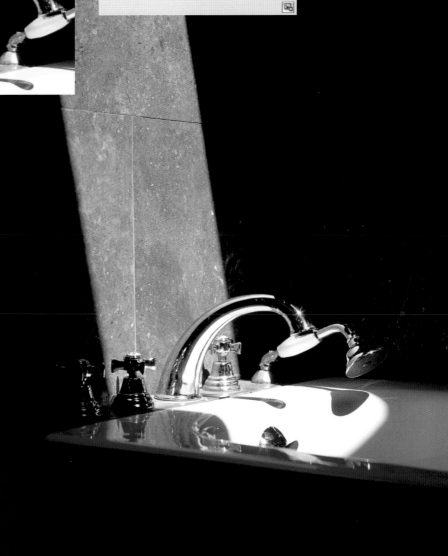

3

2 Neutralizing the casts on the shadows and highlights has left the patch of marble in the sunlight looking a bit cold, so we open the *Curves* dialog box and Shift-Command-click to place a control point (2A) on all three color curves (*above*). We've put a sample point here only to show you where we clicked to assign our *Curves* control points—you wouldn't need to put one in yourself. As we just wanted to give the stone a sunlit feel, we went to the blue curve (blue is the complement of yellow, remember) and moved the control point down a couple of notches with the cursor keys (2B).

3 That's given the stone a warmer feel, but the reduction in blue has darkened the midtones slightly, so we make compensating increases in the red and green curves to maintain the overall luminosity, and we're done (3).

tonal and color correction with masking

This picture (*below left*) has a lot of light in it and is probably a bit overexposed. We need to bring out the contrast in the various surfaces and textures—wood, steel, worktop—and bring the bright window under control.

To see how a high-quality repro scanner would cope with this image, we also asked for an auto-corrected scan to be made (*below right*). This goes a long way toward sorting out the tonal correction, but the window and the far end of the room, with its predominantly white surfaces, are still too bright. Here's a complete work-through, starting from our original file:

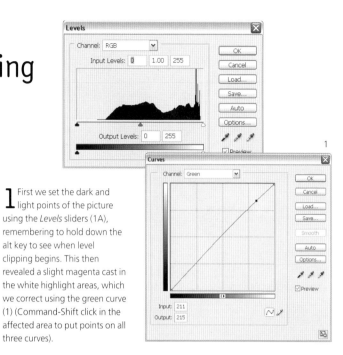

1 First we set the dark and light points of the picture using the *Levels* sliders (1A), remembering to hold down the alt key to see when level clipping begins. This then revealed a slight magenta cast in the white highlight areas, which we correct using the green curve (1) (Command-Shift click in the affected area to put points on all three curves).

uncorrected scan

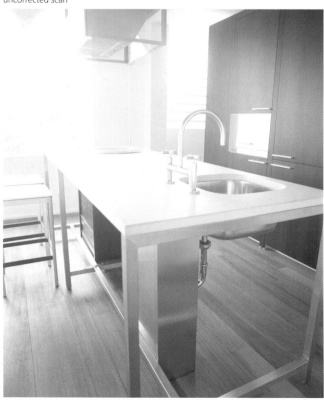

auto-corrected scan

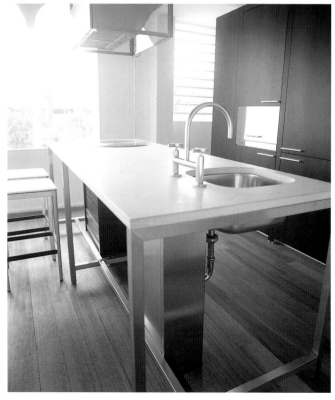

2 The main part of the picture is now OK, but the area through the windows is too bright. Converting our image to 8-bit allows us to add a *Curves* adjustment layer. Clicking *OK* to the *Curves* dialog without any adjustment at this stage, we delete the white-filled mask that's automatically created (just drag it to the *Trash* icon in the *Layers* palette). We then create a new mask filled with black by Alt-clicking on the *Mask* icon. Using Photoshop's paths tools, we draw the shapes of the windows—using straight lines and simple curves—and fill those shapes with white (2A). Where the mask is black, the layer will have no effect on the image below; where it's white, any *Curves* adjustment made will show through (2B).

3 This allows us to play with the tone curves in the window areas only. Clicking on the *Curves* icon in the *Layers* palette to open the *Curves* dialog, we drag the shadow end of the composite RGB curve a fair way across while leaving the highlight end untouched (3A). This puts more depth into the view outside the windows without spoiling the light airy feel of the shot (3B).

2B

2A

3A

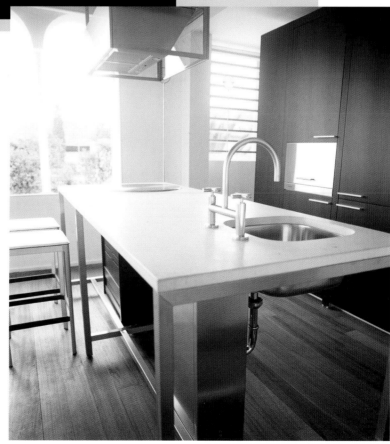

3B

handling high-key images

This soft, light image (*right*) has no real black in it, so it's useful to have some of the film rebate included in the scan to give us a reference for solid black—many "blacks" that appear in images are not really neutral and it's best to use the shadow eyedropper to set a black than just work with the *Levels* shadow slider. There's a nice high-key feel but no real punch and not much detail in the food.

uncorrected scan

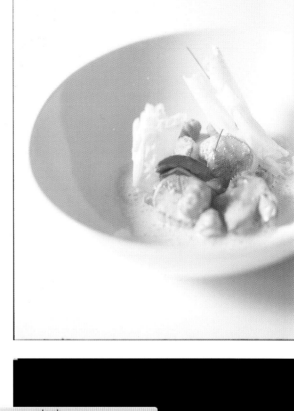

1

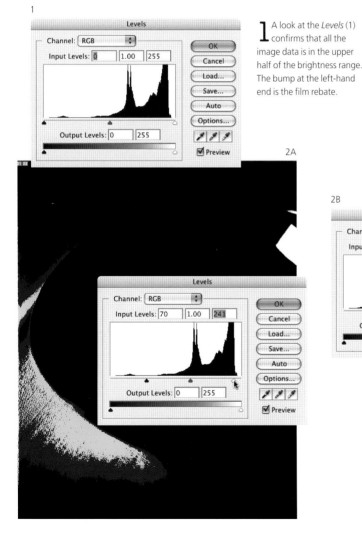

1 A look at the *Levels* (1) confirms that all the image data is in the upper half of the brightness range. The bump at the left-hand end is the film rebate.

2A

2B

2C

4A

4B

3 The tonal range is much improved (*left*), but now there's a gray balance problem: either the film or the scanner has an unwanted magenta cast. Also, the image is too contrasty; it has lost the pastel feel.

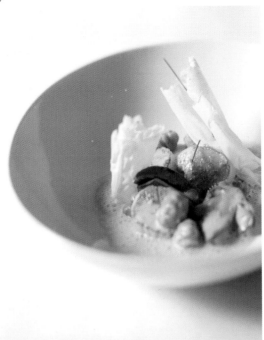

2 Using the shadow slider, we clip the rebate to force it to solid black, but without forcing anything in the picture. Switching to the highlight slider, we experiment to see where the highlights are. After moving the slider a long way in to level 241 (2A), we decide that only the specular reflection inside the bowl should be pure white and so back off to level 247 (2B).

5

4 To fix this, we use the gray eyedropper from the *Curves* palette to pick a point inside the shadowed side of the bowl (4A). Setting this to a neutral gray corrects the magenta cast (4B).

5 Now we need to lighten the picture using *Curves* to restore the high-key feel. This adjustment doesn't affect the dark/light extremes of the image, only the midtones, since the end-points are anchored. Sometimes you might want to add anchor points a little way in from the corners to preserve the last shadow and highlight levels from being lost while making midtone corrections.

6 The finished image has taken on more impact and definition in the food without losing the bright high-key feel.

6

images with strong dominant color

Although a single color predominates in this image (*right*), it should be possible to bring out more depth and detail in the texture of the wall tiles and the fittings—as it stands, there's a "red mist" feel to this shower cubicle.

uncorrected scan

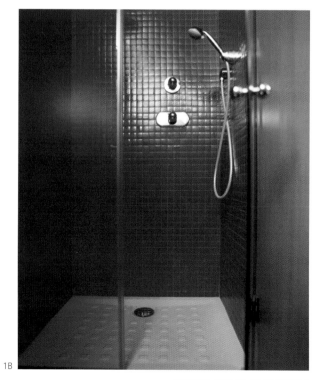

1A

1 After conversion to our working color space, our first port of call is the *Levels* dialog. In this case, we use the shadow and highlight eyedroppers at their default settings (0, 0, 0 and 255, 255, 255 respectively). This is because we want to set absolute black and white points, the former in the shadow at the bottom left shadowed part of the horizontal door frame, the latter in the specular highlight on the upper faucet's mounting ring, to give the image shown below right (1B) and the accompanying histogram (1A).

2A

2 There's more punch to the image now, but the red looks a bit dull, so we'd like to beef it up a bit. However, we immediately run into trouble with the printable gamut. Because this image has such saturated colors, we thought it a wise precaution to set up a soft-proofing window. You do this by opening a duplicate window on your file (*Window > Documents > New Window*) and with that window foremost, turning on both *Proof Colors* and *Gamut Warning* (2A). This makes the new window preview the image as it will appear when converted to our CMYK output profile for printing (without actually converting the data), with any pixels whose color in RGB falls outside the CMYK gamut highlighted. We chose a bright green for the highlight for easy visibility; the Photoshop default gamut warning is a mid-gray, but if you click on the swatch you can set it to any color you like—do this in *Preferences > Transparency & Gamut.*

1B

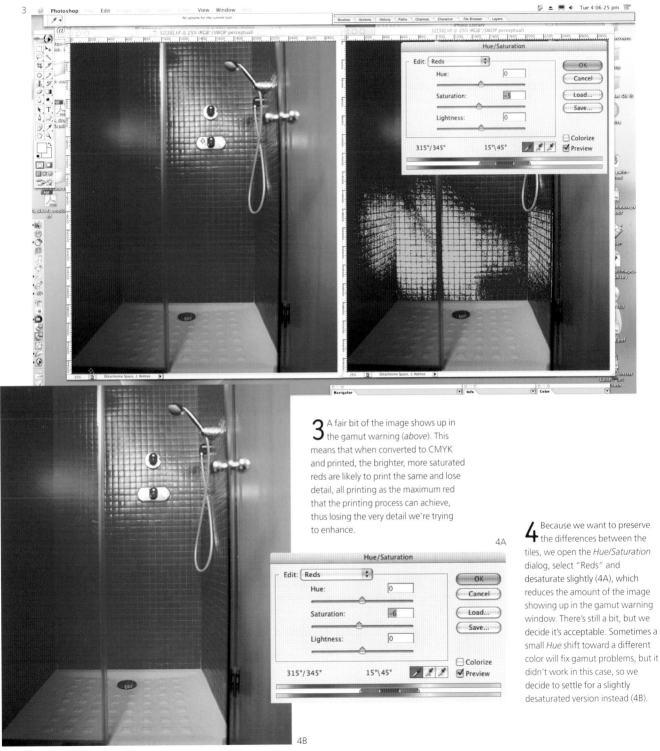

3 A fair bit of the image shows up in the gamut warning (*above*). This means that when converted to CMYK and printed, the brighter, more saturated reds are likely to print the same and lose detail, all printing as the maximum red that the printing process can achieve, thus losing the very detail we're trying to enhance.

4A

4 Because we want to preserve the differences between the tiles, we open the *Hue/Saturation* dialog, select "Reds" and desaturate slightly (4A), which reduces the amount of the image showing up in the gamut warning window. There's still a bit, but we decide it's acceptable. Sometimes a small *Hue* shift toward a different color will fix gamut problems, but it didn't work in this case, so we decide to settle for a slightly desaturated version instead (4B).

4B

underexposed images

This shot (*right*), snatched by available light in a shop in Marrakesh, shows typical underexposed transparency film characteristics—deep shadows and intense saturation of the bright colors. To make matters worse, our scan comes from an unprofiled desktop scanner.

1 First we need to assign a suitable profile. After some experimentation, we decide that our working RGB for this book, ColorMatch, gives the best starting point. We try our usual *Levels* and *Curves* techniques to open up the shadows, but the result is flat and loses too much of the vibrant color in the goods on the shelves that make the picture interesting. One trick that can work with underexposed image is to duplicate the background (the original image) and set the layer blending mode to *Linear Dodge* (see page 111 for a description of what this does) to brighten it up without affecting the absolute shadow areas.

To use *Layers,* we have to first convert to 8-bit. Next, we make a duplicate layer and set the blending mode to *Linear Dodge* (2A). This brightens the image considerably (2B), but the backlit bottles on the shelf at the bottom are overenhanced to the extent that detail inside them is lost.

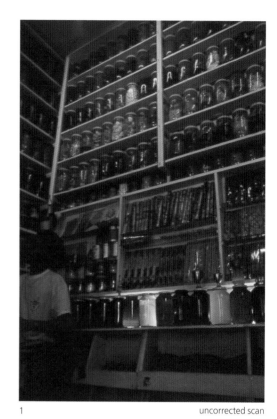

1 uncorrected scan

2A

2B

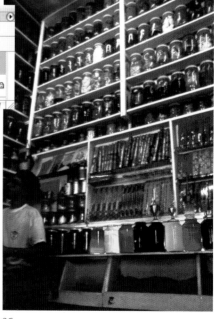

2 To bring the colors in the bottles under control, we add a layer vector mask filled with white. We then paint on the mask with a soft-edged black brush to remove the *Linear Dodge* effect from the bottles. Where the mask is white, the blend works fully on the layers below; where it's black, there's no effect (*above*). Now the colors in the bottles are back under control (2C).

2C

3 The man in the bottom left corner is still too dark, so we try repeating the whole duplicate background layer and *Linear Dodge* blend. It works on the figure but is too much on the shelves, so we again make a layer mask set to blend as *Linear Dodge* and this time filled with black (3A) (hold down Alt [PC] or Option [Macintosh] when clicking on the *Add vector mask* button at the bottom of the *Layers* palette). This makes the *Linear Dodge* layer have no effect except where we now paint the mask white (3B), allowing the additional lightening effect through only on the figure. The result (3C) looks better balanced for exposure.

3B

3A

3C

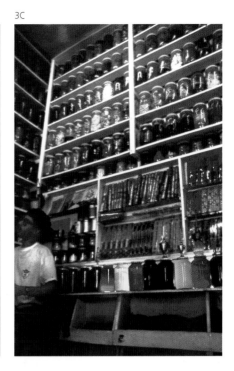

4A

4B

4 Although the image is tonally OK now, the man's skin tone looks too rich as a result of the original underexposure, so we add a *Hue/Saturation* adjustment layer to allow us to desaturate his skin color. Again, this needs a mask. As the area we want to affect with the desaturation is small, we make a black mask and paint white on it (4A) to allow the effect through on his face and arm only. That takes care of the skin color and, after flattening the file (*Layer> Flatten Image*), we're finished (4B).

"unusable" images

Sometimes you're given what appears to be a completely unusable picture and told that for whatever reasons, it has to be used. This 16-bit silhouetted image of a girl (*right*) from a digital camera would appear to be a case in point.

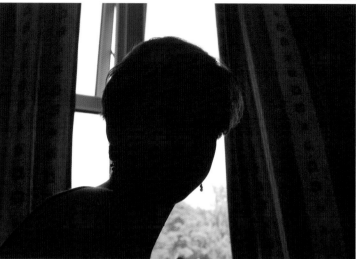

1A

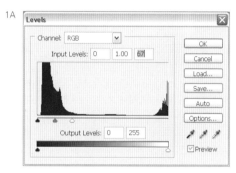

1 Examining the *Levels* histogram, we see that all the usable image data is in the extreme left-hand (shadow) part of the range (1A). We move the highlight slider a long way to the left with the Alt key held down to find the edges of detail in the face (1B). Clicking *OK* to this gives us this result (1C), which is now showing some detail in the face, though it's still flat and shows noise from the digital camera.

1B

1C

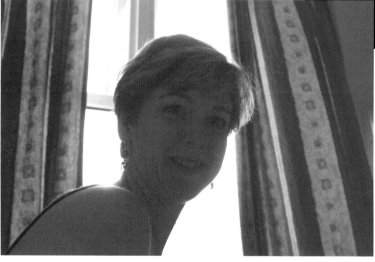

2 Now we convert the image to 8-bit. We open the *Layers* palette, duplicate the background layer with our image in it (*Layer > Duplicate Layer...*), select the duplicate layer, then use *Desaturate* (on this layer only) fully to mono. Then we set the layer blending mode to *Linear Dodge*.

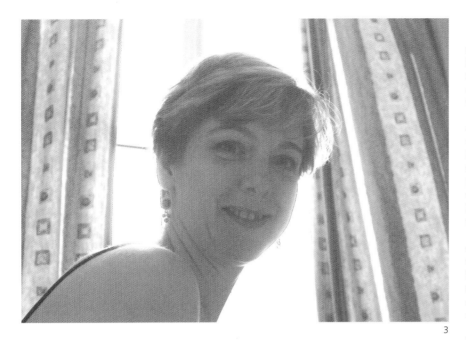

3 So what's a *Linear Dodge*? Photoshop's blending modes are a very powerful way of selectively manipulating tonal and color information between two images, or of using any of the program's painting tools to affect tone and color in an image. The *Linear Dodge* (is named for the mono photographic printing technique of "dodging," in which light is selectively blocked during exposure to produce a lighter print). It works by lightening the "base color" (our background image layer in this case) according to the corresponding pixel values in the duplicate layer (the "blend color" in Photoshop's terminology). It's made the light areas lighter, a bit like a contrast increase but without making any of the dark colors darker.

We converted the duplicate layer to mono in order to avoid a "color contamination" effect from the camera noise (a speckling effect in the image), in which we get colorizing as faults in the image amplify themselves in the blending calculation. By converting the blend layer to mono, we get a more or less purely luminosity-based effect.

The result has better contrast and detail but looks undersaturated. However, attempting to increase saturation using the *Hue/Saturation* dialog just increases the appearance of camera noise and gives a pink color wash effect so we decided to leave it alone.

3

4 We can work on the contrast, though. We open a *Curves* adjustment layer, and add control points to the curve corresponding to the darkest and lightest points on the face (the shadow under the eyelid and a point on the cheek respectively). We move them apart vertically (4A) to increase the contrast (a steeper gradient means greater contrast), giving us the result shown here (4B).

4A

4B

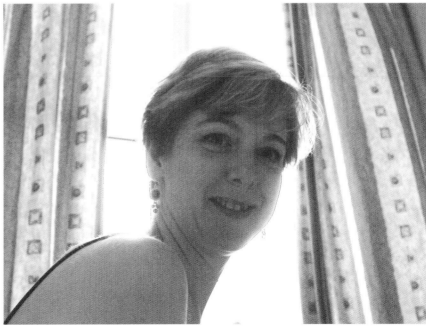

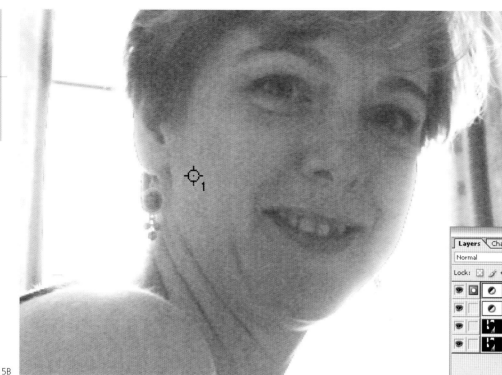

5B

5 We now have a recognizable likeness from an apparently unusable original, but there's a magenta streak down the left side of the face (as we see it), probably a result of camera noise. So we open a *Hue/Saturation* adjustment layer (5A) and pick a point in the affected area to work from (5B).

5A

6 From the *Hue/Saturation* dialog box, we click on that point with the eyedropper to select those colors (Photoshop reads them as "reds"). We then change the *Saturation* by −15 to reduce the effect (6A), giving us the image on the right (6B).

6B

6A

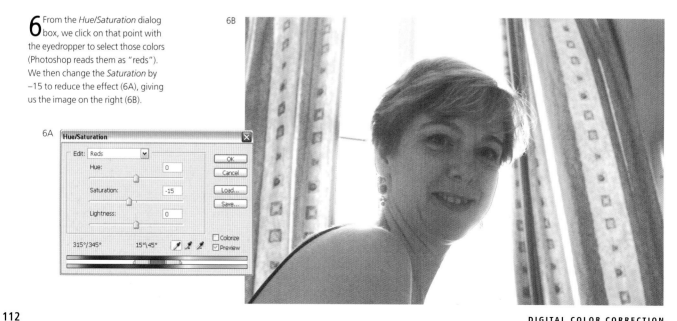

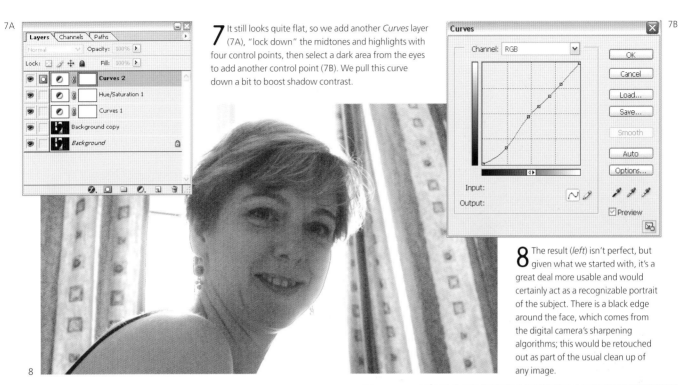

7 It still looks quite flat, so we add another *Curves* layer (7A), "lock down" the midtones and highlights with four control points, then select a dark area from the eyes to add another control point (7B). We pull this curve down a bit to boost shadow contrast.

8 The result (*left*) isn't perfect, but given what we started with, it's a great deal more usable and would certainly act as a recognizable portrait of the subject. There is a black edge around the face, which comes from the digital camera's sharpening algorithms; this would be retouched out as part of the usual clean up of any image.

8

new highlights

Photoshop CS has an easy route to rescue difficult images. Its new *Shadow/ Highlight* filter offers a range of controls that enable the Photoshop user to adjust the tones in an image without multiple trips to the *Levels* and *Curves* palettes. You can preview the changes in realtime, and the results are surprisingly effective.

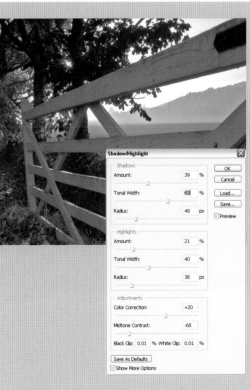

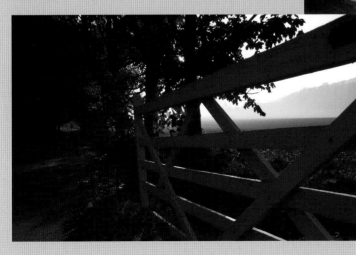

overexposed images

This shot (*below*) looks like the film was developed wrongly: it's both thin and has a strong blue/violet cast. On top of that, there's not really much tonal detail to work with in the subject's face.

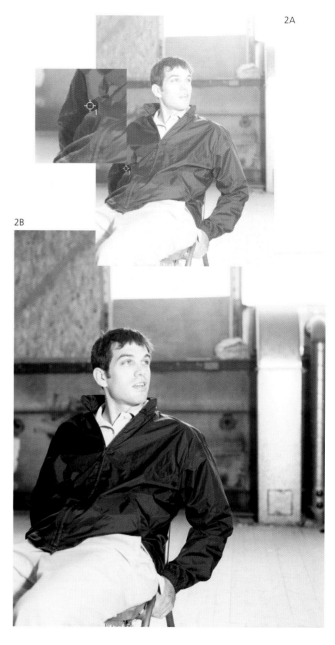

2A

uncorrected scan

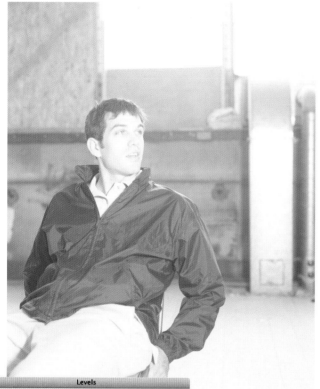

2B

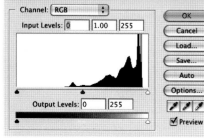

Levels

Channel: RGB

Input Levels: 0 1.00 255

Output Levels: 0 255

OK
Cancel
Load...
Save...
Auto
Options...

☑ Preview

1

1 As always, we first look at the *Levels* dialog. Not surprisingly, all the image data is clustered in the right-hand half of the scale.

2 We have both a tonal and a color correction to make, so rather than trimming the composite RGB levels and then addressing the color, we try to work on both together. We look for a point that we think should be the darkest shadow in the picture, and settle on a fold in the left sleeve (as we look at it) (2A); then reopen *Levels* and click our shadow eyedropper there with the black value set to 0, 0, 0 to set a true black. This goes some way toward addressing the color cast as well as giving us proper shadows (2B).

3 Now to handle the highlights. In *Levels* (3A), we slide the highlight slider in to allow the window areas to go to almost flat white. This gives us a much improved, punchy picture (3B).

3A

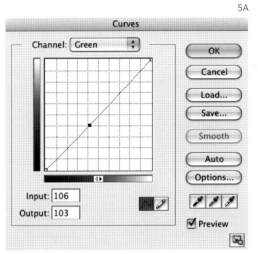

4 But we still have a color cast. To fix this, we use the midtone (gray) eyedropper in *Levels*. Fortunately, the picture contains something that should be a neutral gray—the stainless steel extractor pipes the background. A bit of trial-and-error clicking in the midtone parts of these gives us a better color balance (4). You can click as many times as you like, as each click effectively starts the neutralization process afresh—you don't have to undo a click that didn't work.

3B

4

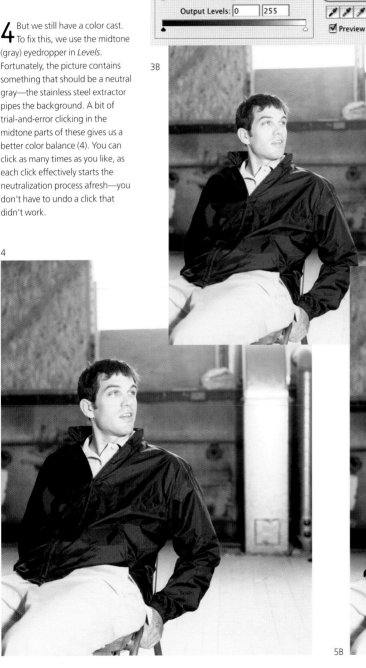

5 The color balance now looks basically OK, but on closer inspection some of the background looks a little green. A small move in the green curve (5A) with a point selected from the midtone area fixes that (5B). (Hold the mouse button down while you move around in the image to see where you are on the curve.)

5A

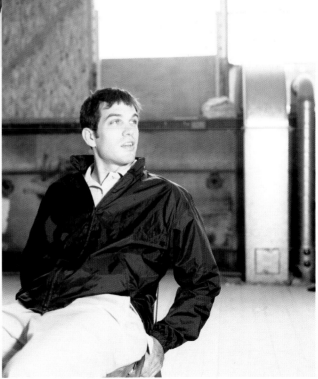

5B

fixing a simple color cast

There's an overall greenish look to this shot (*right*), which gives a certain laid-back feel but is just a bit too strong, especially on the subject's skin. The whole picture feels a bit flat too, though there are clearly some bright highlights in the windows at the back to watch out for.

1 As usual, our first moves are with the *Levels* dialog (1A), giving us a slightly punchier image (1B).

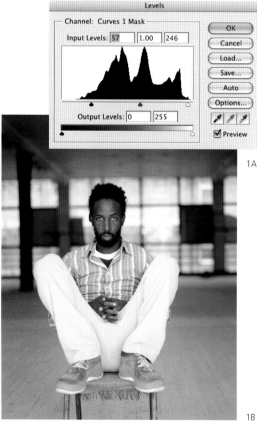

1A

1B

uncorrected scan

2

2 Still in the *Levels* dialog, we double-clicked the shadow eyedropper to set a target shadow value of 8, 8, 8, a not-quite solid but still neutral black. We do this to choose a very dark shadow area where we might still want to see some detail, but making sure that it's neutral (see part one of this chapter for a discussion of when and why we use eyedroppers instead of the *Levels* sliders).

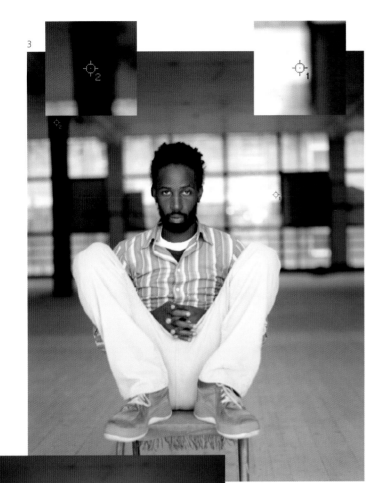

3 We did a similar exercise with the highlight eyedropper, to set the last level of highlight detail we wish to preserve, setting all three values (R, G, and B) to 247 so that our chosen highlight isn't quite pure white (255 in each channel). Closing the dialog, we put permanent sample points on the image to mark where our minimum (shadow) and maximum (highlight) points were; we found them using the threshold display, using the read-out in the Info palette as a check for our visual selection. Back in *Levels,* we chose the shadow eyedropper and clicked it on our marked point in the image and then likewise with the highlight one.

4 Setting our shadows and highlights to the desired neutral values and densities partially corrected the green cast in the midtones (4A). To completely remove it, we next opened the *Curves* dialog, chose a point in the skin tones (command-shift click in the appropriate part of the image) and then lowered the output value in the green curve by a few points (4B) to get a more balanced result (4C).

4C

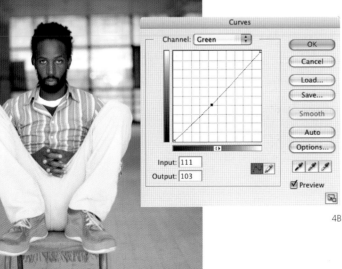

4A

4B

117

handling mixed source lighting

This image (*right*) combines light sources of different types—artificial light in the alcove on the left, natural daylight from the doors at the far end. The muted, pastel tones in the image serve only to show up the effect further, and the whole thing looks flat and unnatural.

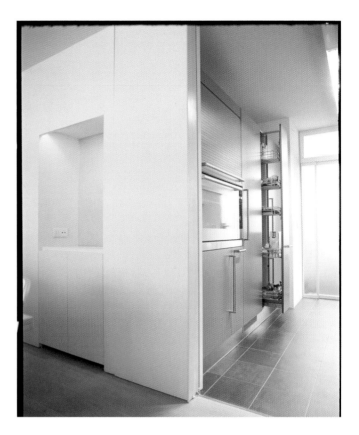

1B

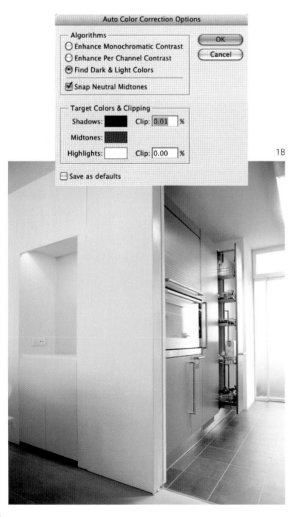

1 As an experiment, we thought we'd see what Photoshop's *Auto Color* function made of it (1A). Although it improved the punch and saturation of the image, it served mostly to introduce a strong yellow-green cast that was worse than the original problem. It's always worth taking a look at what the *Auto* function does. Sometimes it's pretty much right first time, assuming the default settings have been reset sensibly (use *Find Light & Dark Colors*, *Snap Neutral Midtones* on, *Clipping* set to 0.01 highlight and shadow; see page 94 for details). Unfortunately, this wasn't one of those times.

2 Reverting to the original image, we go through the usual manual *Levels* trimming process (2A) to improve the tonal range (2B). We trim a bit into both the black end of the histogram (because the film rebate is included in the scan) and the white end (because there is no image detail to preserve in the window and oven door highlights).

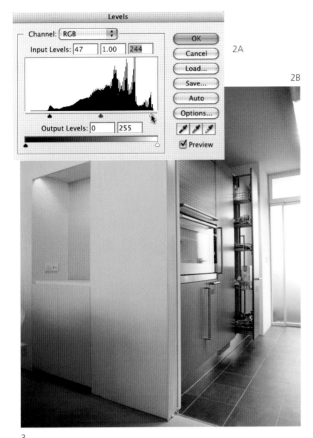

2A

2B

4B

3

4A

3 Although this gives a punchier image, the color casts are only made more apparent. As the image is already in 8-bit, we add a *Curves* adjustment layer and, rather than play around with individual channels to try and fix the color casts, we use the gray eyedropper to see if we can correct the color balance by fixing the grays first. We choose the shaded part of the steel handle of the oven door to click on as something that should be a neutral gray, which makes for a much cooler and more balanced appearance (*left*), especially in the left-hand side of the image, where the artificial light dominates.

4 But we've gone too far and made the picture a bit too cold. Using the *Opacity* slider for the adjustment layer in the *Layers* palette (4A), we adjust the strength of the gray eyedropper correction until we're happy we've achieved a good balance (4B).

mixed lighting—localized color correction

This looks like a difficult picture to fix (*right*). It's a dark, low contrast scan from a desktop scanner with no supplied profile. On top of that, it's got mixed light sources—evening sunlight on the church tower, artificial light on the base of the building, and reflected twilight-sky light in the courtyard.

First we assign a profile in Photoshop. With none embedded, it's a question of trial and error, but a monitor-based color space is likely to be the most suitable. ColorMatch RGB gives a good result.

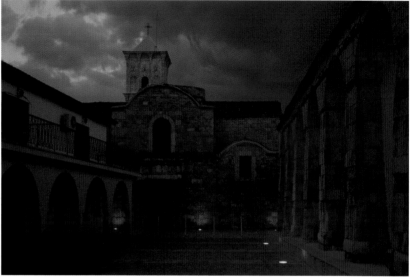

uncorrected scan

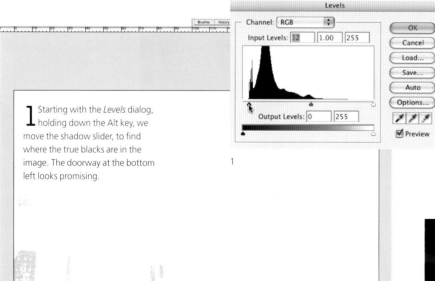

1 Starting with the *Levels* dialog, holding down the Alt key, we move the shadow slider, to find where the true blacks are in the image. The doorway at the bottom left looks promising.

1

2 As we moved the slider, we could see the different channels filling in separately. This represents an unwanted color cast in the shadows, so we need to use the shadow eyedropper to fix the blacks. We place a permanent sample point (shift-click with the eyedropper) (2), and then check back in the *Levels* clipping display that it is in the right place (by holding down Alt/Option while moving the shadow slider). Having confirmed that we picked the darkest spot, we set the shadow dropper to RGB values 0, 0, 0 (double-click on the shadow eyedropper to set the values) as we want a true black here—no detail is needed—and we then click on the permanent sample point.

2

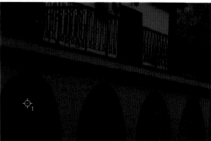

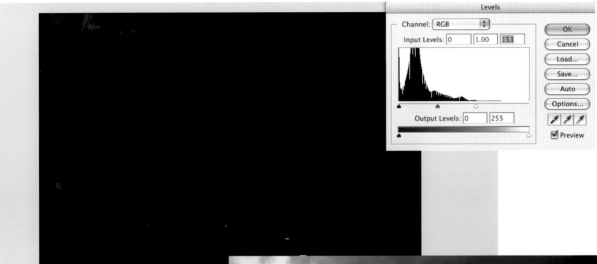

3B

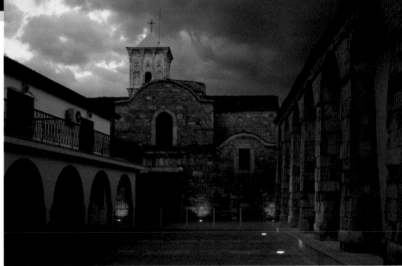

3A

3C

3 Before clicking *OK* and closing the *Levels* dialog box, we need to adjust the highlights. Using the slider with the alt key held down, we bring the highlight level down far enough to just catch the floor lights (3A) as they're the brightest thing in the picture. Now we've set both shadows and highlights in one *Levels* operation (3B) and the image is noticeably better already (3C).

4

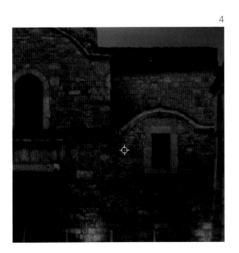

4 But it's still too dark, and there's a blue cast in the stone of the church. This cast might be affected by a tonal move, so we should lighten the image first. We select a point in the stone that has a tonal midpoint (4) in order to set values in our *Curves* box by command-clicking in the image with the eyedropper. The permanent sample point shown is for illustrative purposes only; you wouldn't actually need to place one, instead. you would just move the mouse around and click on that point.

5 Next we move the curve point up in RGB to lighten the overall image (*right*).

5

6 The tone is fine, but we now want to fix the blue cast, so stay in *Curves* (don't click *OK*). In the blue channel, we pick a midpoint in the blue-ish stone in the columns at the right and pull the curve down a little.

7 Now it looks a bit red in the walls on the left and right of the courtyard, so we pick a midpoint in the red curve and make a very small downward adjustment using the cursor keys.

8 The result of pulling down the curves in two of the channels is that the image has gone a bit dark again, so we go back to the RGB curve and pull it up a bit to compensate.

6

7

8

9 We click *OK* and leave *Curves*. That's fixed the brightness and overall cast (*right*), but now we need to look at the localized color casts caused by the mixed lighting.

9

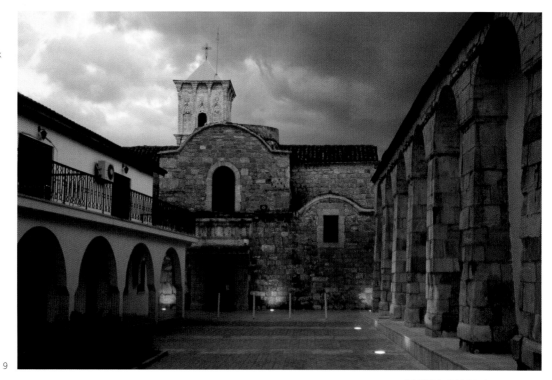

10 The clouds in the sky are too blue. In the *Hue/Saturation* dialog we select *Blues* and then click on a central blue tone. Then we make a big *Hue* shift (10A) to view the automatic selection to check what has been selected (10B) and adjust if necessary.

10A

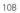

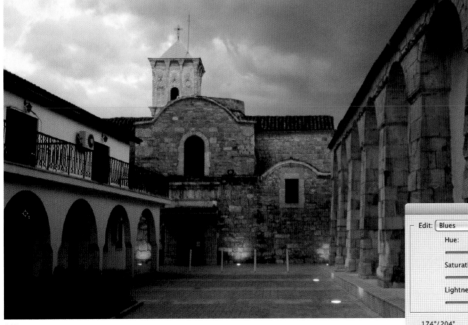

10B

11 We put the *Hue* setting back to 0 once we're happy with the selection (we fine-tune it using the + and - eyedroppers; you could also use the color range and drop-off sliders on the color bars at the bottom). We experiment with a subtle *Hue* shift, but don't like the results, so instead try decreasing the *Saturation* and increasing the *Lightness* (11A) to get a more neutral sky (11B).

11A

11B

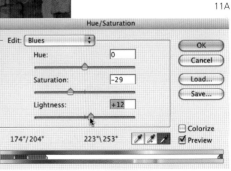

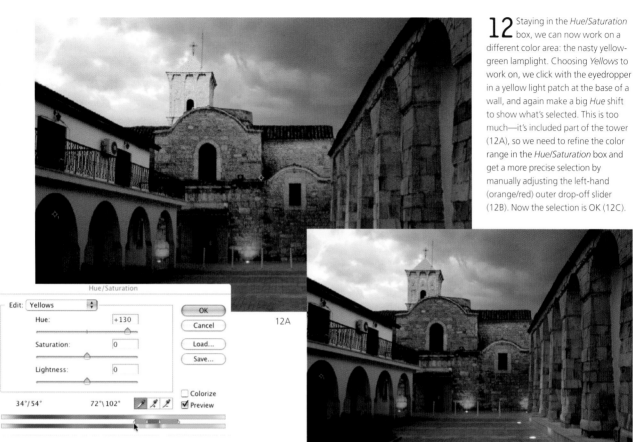

12 Staying in the *Hue/Saturation* box, we can now work on a different color area: the nasty yellow-green lamplight. Choosing *Yellows* to work on, we click with the eyedropper in a yellow light patch at the base of a wall, and again make a big *Hue* shift to show what's selected. This is too much—it's included part of the tower (12A), so we need to refine the color range in the *Hue/Saturation* box and get a more precise selection by manually adjusting the left-hand (orange/red) outer drop-off slider (12B). Now the selection is OK (12C).

12A

12B

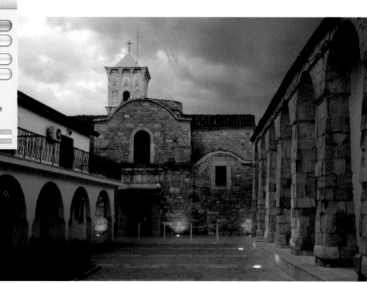

12C

13A

13 We remove our drastic *Hue* change and make the real adjustment. We shift the hue of the selection toward the orange/red portion of the color spectrum to lose the green tinge, then add *Lightness* as it looks too dark (13A). This deals with the lamps (13B).

13B

14 Now we need to work on the tower to lighten it to match the rest of the picture; it's looking too dark and orange. Keeping the *Hue/Saturation* box open, we choose the *Reds* to work on, and click the eyedropper on an area in the middle of the tower. We refine the selection to a very narrow color range to select only the tower plus a little bit of the church's stonework. A small increase in *Lightness* (14A) is all that's needed. Then we make a whole image *Saturation* boost (14B) to put some punch back, and a slight *Lightness* decrease for an evening feel.

14A

14B

15 We noticed a magenta cast in shadows of the white building on the left. So, keeping the *Hue/Saturation* box open, we select *Magentas* and desaturate slightly to fix it (15A). With everything looking good (15B), we finally click *OK* to close the *Hue/Saturation* box.

15A

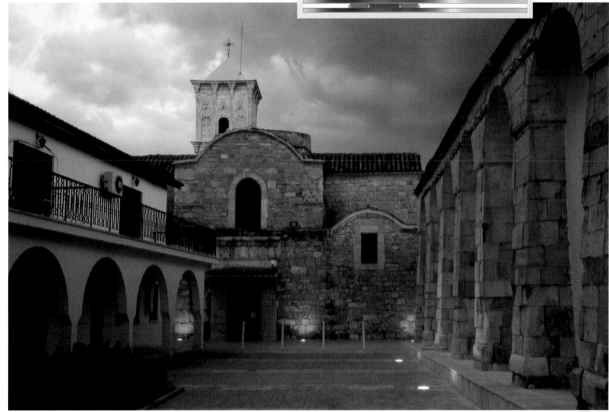

15B

creative hue changes

The target of this exercise in creative color editing is to make a postcard image from this shot of motor scooters (*below*). The trouble is, the art director doesn't want yellow scooters, she wants cyan ones.

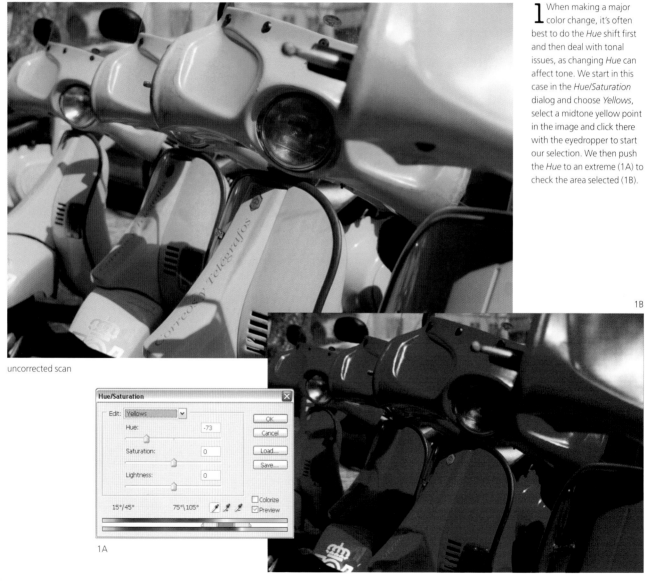

1 When making a major color change, it's often best to do the *Hue* shift first and then deal with tonal issues, as changing *Hue* can affect tone. We start in this case in the *Hue/Saturation* dialog and choose *Yellows*, select a midtone yellow point in the image and click there with the eyedropper to start our selection. We then push the *Hue* to an extreme (1A) to check the area selected (1B).

1B

uncorrected scan

1A

2 The selection looks fine, so now we move the *Hue* slider toward cyan to change the color (2A). We reduce the *Saturation,* both for visual improvement and to ensure printability—see page 106 to find out how to set up a soft-proof to warn of CMYK gamut problems without having to convert. We then increase *Lightness* for the same reasons. The main part of our color change is complete (2B).

2B

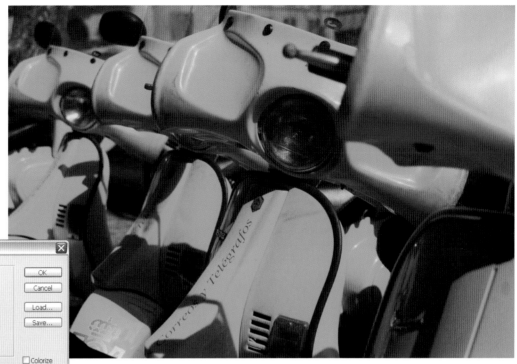

2A

3A

3 The desaturation move has toned down the largely monochromatic background quite nicely, but the little badges on the scooter windshields now show up distractingly (3A); we need to desaturate them to match the background. In Photoshop 7 we can't easily make an area selection on a 16-bit file or use the sponge tool to desaturate locally, so we convert the file to 8-bit (3B) at this point. It's safe to do this as the major color change has already been made.

3B

127

4

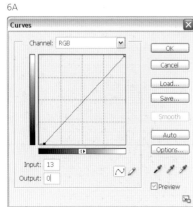

4 Now we can "paint out" the badge color using the sponge tool set to a suitable brush size.

5 With the distracting spots of color removed, we're ready to think about tonal correction.

5

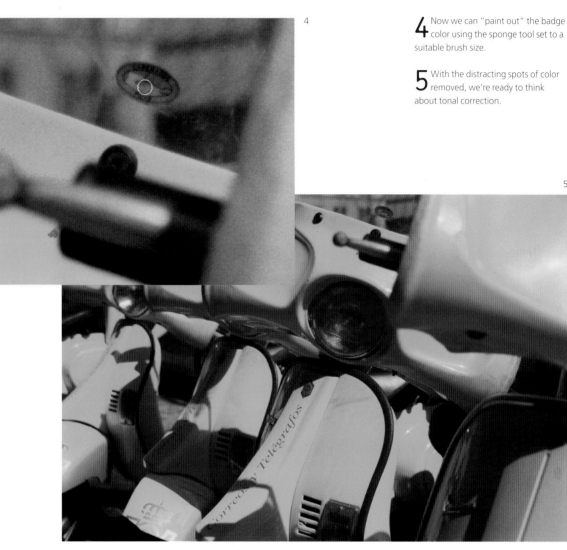

6A

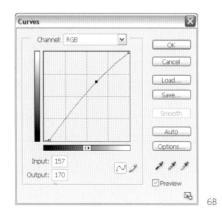

6B

6 The image looks a bit flat; it needs more punch. We use a *Curves* adjustment layer first to force all the darkest blacks to go solid (6A) and then experiment to increase the midtones for more contrast (6B). If these moves need to be large, we might think it better to go back to our archived 16-bit image and do them there before converting to 8-bit for the *Sponge* tool procedure. Of course, this means we can't use adjustment layers. In this case, the tonal move turns out to be relatively small and the adjustment layer adds useful functionality, so we carry on as planned.

7 Although it looks great on screen, our soft-proof gamut warning (7A) shows that it would be a problem to print these colors, so we soft-proof using the profile of our CMYK output space. This is a very good example of how using an ICC profile as a guide to output capability can assist in color correction. We back off on the midtone adjustment point until the out-of-gamut area is reduced. The bright green (our choice for the gamut warning color in Photoshop's preferences) shows the parts of the image that are out of gamut; you can preview the actual effect of conversion on the real colors by using *View > Proof Colors* to decide whether the conversion of out-of-gamut colors is acceptable. Satisfied that we've boosted the mid-tones without completely blowing any chance of printing them adequately, we click *OK* to close the *Curves* dialog box. Our postcard's done (7B) —wish you were here?

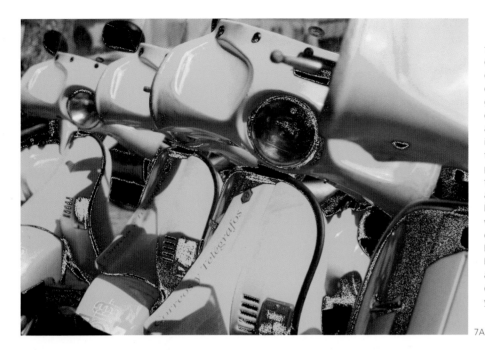

7A

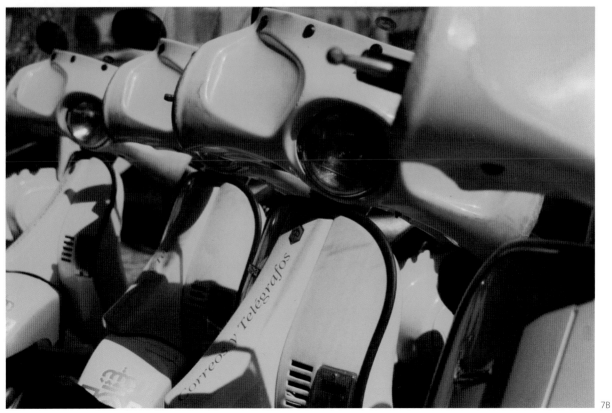

7B

boosting colors for effect

uncorrected scan

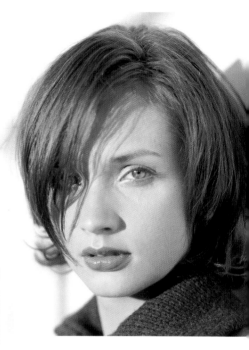

This hair-fashion shot (*right*) appears to have been badly processed or scanned—it has no real black, it's flat, and has bit of a yellow/green cast and reflection in the model's face. We want to achieve a light, high-key look, but with lots of rich color in the hair.

1 We start by converting the image to our ColorMatch RGB working space. We take the black eyedropper (set to 0, 0, 0 for a solid black) and click in the film rebate. Rather than imposing a pure white, we try the highlight eyedropper set at 247, 247, 247 (a number arrived at by trial and error over years of working with Photoshop) and click in an area with highlight detail that we wish to preserve, on the lower lid of the right eye. This lightens the skin tone and removes some of the cast, but at slight expense to the hair (*below*).

2A

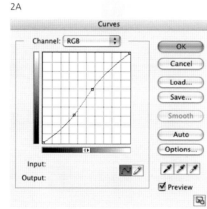

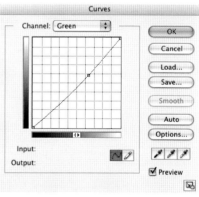

2B

1

2 Now to fix the contrast in the hair: in the *Curves* dialog we pick dark and light control points from areas in the hair that can afford to go darker or lighter as necessary, then move them apart to increase contrast and add detail (2A). The model's skin is still a bit green, so without closing the dialog, we go to the green curve, add a control point sampled from the side of the cheek, and pull it down (2B).

3 The green reduction has left the face a bit light, so we go back to the RGB curve, and add a third control point (*right*) in the highlight quarter of the curve (sampled from the side of the nose) and pull it down a little to darken the face.

3

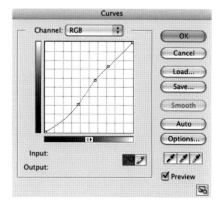

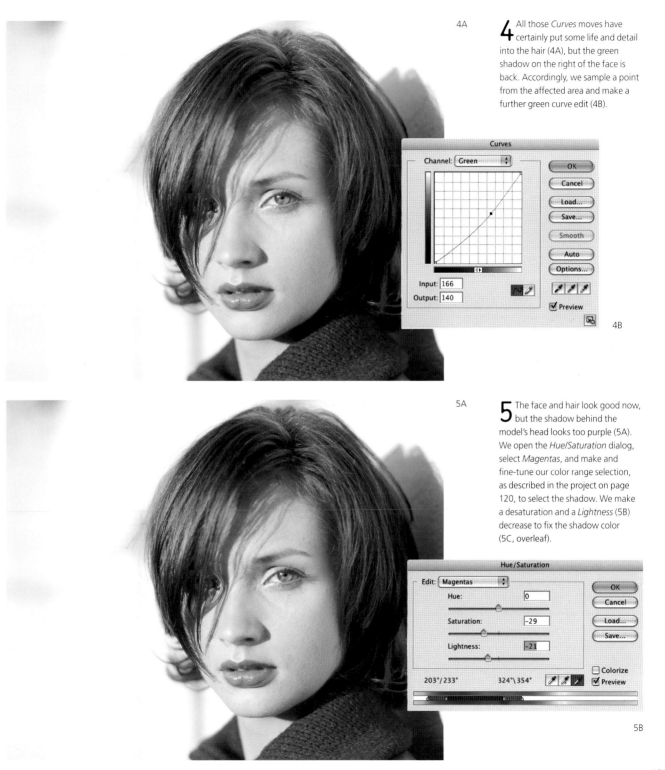

4A

4 All those *Curves* moves have certainly put some life and detail into the hair (4A), but the green shadow on the right of the face is back. Accordingly, we sample a point from the affected area and make a further green curve edit (4B).

4B

5A

5 The face and hair look good now, but the shadow behind the model's head looks too purple (5A). We open the *Hue/Saturation* dialog, select *Magentas*, and make and fine-tune our color range selection, as described in the project on page 120, to select the shadow. We make a desaturation and a *Lightness* (5B) decrease to fix the shadow color (5C, overleaf).

5B

131

5C

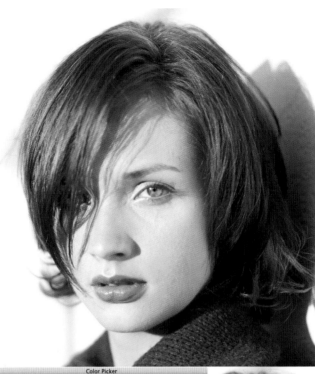

6 This is as far as we can go with the 16-bit image because the next step—boosting the hair color—has to involve layers, so we archive the image and convert it to 8-bit.

We make a new layer (a normal image layer, not an adjustment layer), and set its blending mode to *Color Burn*. We click on the background color in the Photoshop tool palette to open the *Color Picker*, and we sample a strong version of the color we like from the image (6A). That color now appears as the background color in the *Toolbox* (6B).

6C

6B

7 Selecting the new layer we just made, we type Command-Delete, which fills the layer with the new background color. We add a black-filled mask to the layer (by Alt-Clicking on the mask icon in the *Layers* palette) and click on the mask to make sure that we will be painting on the mask, not on the image (*right*).

7

8A

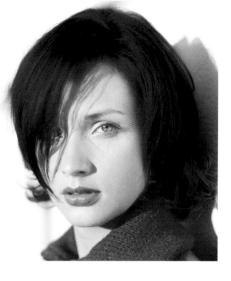

8B

8 Now we paint on the mask with a white brush of suitable size to allow the *Color Burn* effect through on the hair (8A). It's a bit extreme, so we tame the effect with the adjustment layer *Opacity* slider. The skin is perhaps too pink, so we do a final slight overall desaturate in the *Hue/Saturation* dialog box (8B). The hair is now the way we want it.

9

9 Having completed the color correction, the next stage in a beauty shot would be retouching to smooth the skin and remove any blemishes. We actually fixed a few other things in our final stage that we don't have room to illustrate here: we noticed a bluish highlight on the model's lower lip, probably reflected skylight. To fix it, we repeated the process used to boost the hair color by adding a layer, but set the new layer blend mode to *Color* (not *Color Burn*), sampled the lip color we wanted from the edge of the mouth, added a black layer mask, and brushed in

the background color on the lip as needed. Similarly, we boosted the color in the right eye with another layer filled with green (we chose the color from the *Color Picker* by eye; there's nothing in the image to sample it from), then painted onto a black mask with a brush sized to match the iris, and brushed out the overspill on the eyelid. We also did some localized unsharp masking on the eyes and lips, the kind of thing an advertising/ beauty art director would ask for. The finished result shown right.

boosting color 2

In this typical travel brochure image (*right*), one of the main ingredients is the blue sky. Although the picture is flat and lacking adequately rich color, there is also a blue cast in the clouds to contend with.

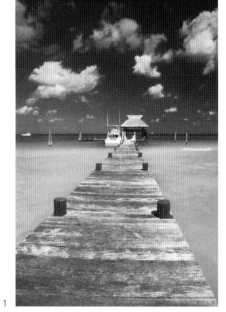

2

3

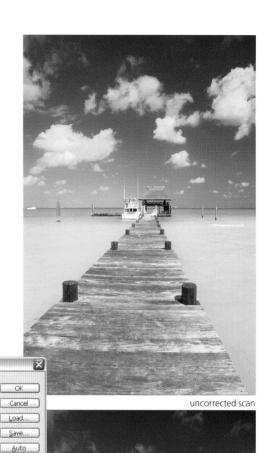

uncorrected scan

1

1 We need to make the clouds whiter, which will add depth and improve contrast. Normally we might use *Color Range* or the *Hue/Saturation* selectors to reduce the blue in the clouds, but if we do so we run a risk of affecting other blues in the image, which we would not want to spoil. A better method is to look at the channels individually and find the channel with the most contrast from which to make a selection. In this case, the red channel (*above*) offers a good degree of contrast.

2 We duplicate this channel (Control-click in the red channel in the *Channels* palette above right) as we don't want to change the original color data in the red channel.

3 We need to make the clouds stand out more in the red copy channel. Working in the duplicate red channel only, in *Levels*, we move the highlight and shadow sliders inward. This increases the contrast in that channel and accentuates the clouds more clearly.

4 Now we load the red copy channel as a selection (click on the "load as selection" button at the bottom left of the *Channels* palette) and activate the composite RGB channel once again. Where our duplicate red channel is white, pixels are selected; where it's black, they are not. The resulting selection neatly encompasses the clouds, most of the water, and parts of the wood (*right*). We clean this up using the *Lasso* selection tool with Alt held down to reduce the selection to the clouds only.

4

5 To reduce the blue in the clouds, we use *Hue/Saturation*. We choose *Blues* from the *Edit* drop-down menu and reduce the *Saturation* to –100 (*right*). With the *Preview* enabled, we can judge how much blue is being removed from the selected areas. We could do with removing a little more cyan/blue from the clouds, so we increase the color range of the desaturation process by moving the *Color Range* sliders further apart.

5

6 That gives us our white clouds. Now we'll intensify the blue of the sky a little to add more contrast against them. With the selection still loaded, invert it (*Select > Inverse*), and subtract a rectangular selection from the horizon downward (use the *Rectangular Marquee* tool and hold down Alt to subtract from the existing selection). We now have a selection of just the sky, minus the clouds (*below left*).

7 Next, we add a *Curves* adjustment layer to strengthen the contrast in the blue of the sky by adding control points on the composite RGB curve in the lighter and darker shades, then moving them up and down respectively to increase the slope of the curve between them (7A). Our sky now looks suitably tropical and we give a final overall boost to the saturation of the blues and cyans, keeping an eye on our CMYK preview with gamut warning enabled, to finish the image (7B).

7A

6

7B

boosting color 3

The impact of a perfect blue sky and turquoise sea in this image (*below*) is rather reduced by the washed-out color of the sand. The sand itself is a near-neutral gray with hints of pink and yellow, a common combination on tropical beaches. Accurate though the original photo may be, our task is to warm up the color of the sand to make an appealing picture postcard.

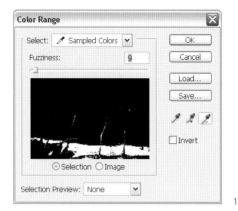

1

1 First we need to select the sand. It mingles with the surf, and in some places we can see it through the water. The *Color Range* selector is a good option here, providing plenty of flexibility for fine-tuning the selection. We pick *Color Range* under the *Select* menu, and click in areas of sand to make a selection based on its color (*above right*). Our first click didn't select it all, so we use the expand selection eyedropper (the one with the + symbol by it) and click in one or two unselected spots that we want to include. However, parts of the tree trunks have been selected as they are virtually the same color as the sand.

2 This isn't a problem: working in *Quick Mask* mode (click the *Quick Mask* button in the *Toolbox* below right), we paint out the tree trunks and any other areas of the mask that need refining, using a suitably sized soft-edged brush (2B). The strength of the *Quick Mask* over layer masks is that the mask can be created from any existing selection, meaning any selection tool can be used to help create the mask (not just the painting and drawing tools). With the mask perfected, we now deal with the pale sand. There are several ways to tackle this, but Curves gives us the greatest choice while maintaining realism.

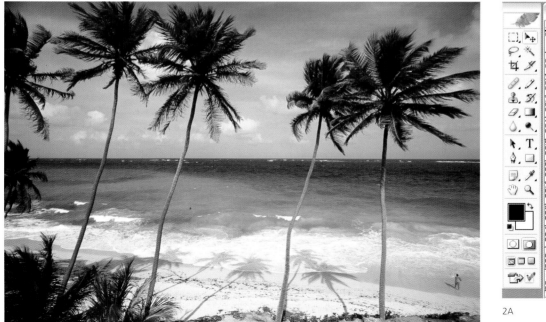

2A

3

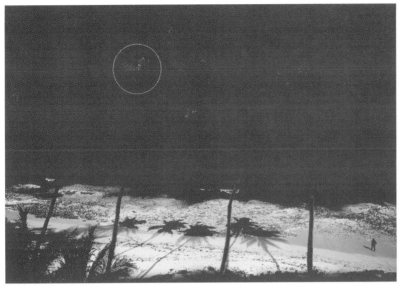

3 We add a *Curves* adjustment layer to allow us to go back and make fine tweaks later if necessary. We shift-command-click in the sand to add control points on all three curves, then add a little red by raising the red curve (3A) and quite a lot of yellow by lowering the blue curve (3B). Because we cut the blue so much, it's darkened the sand, so we stay in the *Curves* dialog make an overall lightness increase by Command-clicking in the sand to put a control point in the composite RGB curve and then raising it (3C).

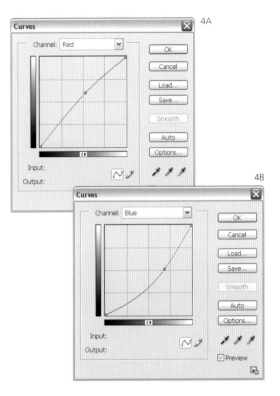

4A

4B

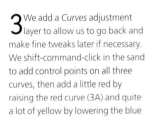

4C

4 This gives the sand a golden color everywhere it appears but the effect is a bit garish. Using the adjustment layer's *Opacity* slider, we tone it down slightly (*right*).

5

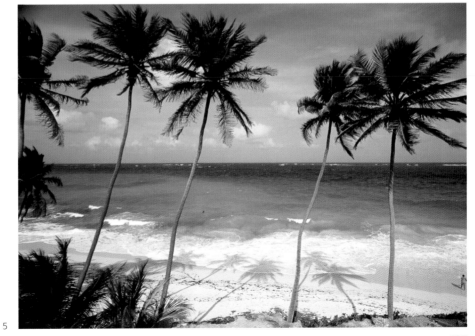

increasing saturation for effect

The whole thing about chameleons is that they blend into their surroundings, but if we want to have a picture of one, it would be nice to be able to see it properly. It's hard to see this chameleon in among the grass stalks (*below*), so let's see if we can bring him out a bit.

1 We have a 16-bit image to start with, scanned from a color negative on a desktop scanner. There's no color profile, but we find that assigning ColorMatch RGB looks like a good starting point.

In the *Levels* dialog, we look at the tonal distribution. We can't do anything with the highlight end of the scale as there are already some pure whites, but as we look at the shadow end of the tonal range (*below*) we can see that there's a color cast—the channels don't all start to clip at the same point (*right*).

1

uncorrected scan

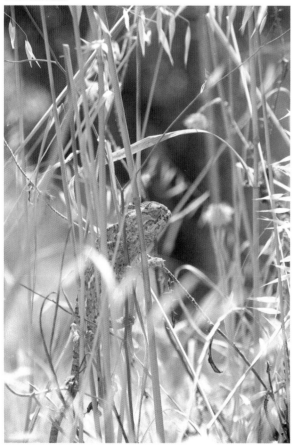

2 This makes the image a candidate for setting blacks using the shadow eyedropper, but is there a real black anywhere in it, and do we want to impose a neutral black? We pick the shadows in the extreme bottom right corner, and zoom in. Using threshold display (hold down Alt while moving the shadow slider to the right), we hunt for the first pixel to go black as we clip the shadows. We put a sample point on it to mark the spot (*right*) and then go back to the threshold view to double-check our positioning (2B, opposite page).

2A

2B

3 We want to set a solid black, so we set our shadow eyedropper color to 0, 0, 0, then move the eyedropper over the sample point we placed until it's exactly aligned and the cursor disappears. We click to set our blacks. Already, the chameleon has gained some definition (*above*) and the color balance is improved, validating our choice of the eyedropper technique.

4A

4 Next we look at *Curves* to see if the contrast in the chameleon can be improved. We pick dark and light points that can afford to go darker and lighter respectively, and increase the gradient between the points (4A) to increase the tonal separation in the chameleon. Again, we see an improvement in definition and "punch" in the image (4B).

4B

5A

Hue/Saturation

Edit: Greens

Hue: +12

Saturation: +25

Lightness: 0

46°/52° 74°\94° ☐ Colorize ☑ Preview

OK
Cancel
Load...
Save...

5B

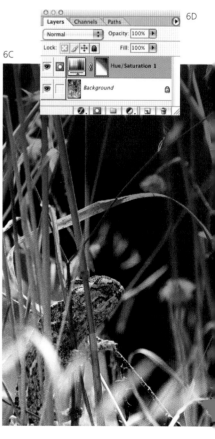

5 The picture's looking pretty good on the whole, but we'd like to bring up the green in the chameleon's skin a bit to make it stand out even better. We've gone as far we can with the image in 16-bit mode, so we archive a copy of the file at this point and then convert the original to 8-bit.

We can now add a *Hue/Saturation* adjustment layer and select the green in the chameleon's skin as well as we can (we check our color selection using the same extreme *Hue* shifts seen on page 123). We can fine-tune the selection in order to select the skin but not the surrounding foliage by tweaking the color range (the rectangular sliders) and "fall-off" (triangular sliders) settings. We then boost the green by making a slight *Hue* change and increasing *Saturation* (5A) . The chameleon is now a more vibrant green (5B).

6A

Brushes

Brush Presets
Brush Tip Shape
☐ Shape Dynamics
☐ Scattering
☐ Texture
☐ Dual Brush
☐ Color Dynamics
☐ Other Dynamics
☐ Noise
☐ Wet Edges
☐ Airbrush
☐ Smoothing
☐ Protect Texture

Master Diameter 19 px

Set the diameter for the primary brush and scale the dual brush

6B

6 We think the chameleon is OK, but some of the same green is now apparent in the top right corner and distracts from the animal. The answer is to do some masking in that corner. When we made the *Hue/Saturation* adjustment layer, we automatically got a mask with it, so we can go straight to brushes palette, and pick a large brush (6A). We need a brush that's both much bigger and softer. We increase the brush size with the close square bracket key (]) until it's a substantial fraction of the size of the whole image (6B); then pressing shift-square open bracket (shift-[) we increase the brush softness (there are only five settings available here).

We set the brush *Opacity* initially to 30 percent and use it to build up a vignette in the mask over the top right corner of the picture, increasing opacity to make the extreme corner stronger. This effectively "paints out" the saturation increase in this corner of the picture (6C). To make sure we're painting on the mask and not on the image itself, we check that the mask icon is visible on the left in our adjustment layer band in the *Layers* palette (6D).

6D

Layers Channels Paths

Normal Opacity: 100%
Lock: ☒ ◢ ✛ ☐ Fill: 100%

Hue/Saturation 1

Background

6C

7 We're happy now with the image in terms of tone and color, but it all looks a bit soft, so we need to do some unsharp masking. To do this, we have to work on the image while viewing actual pixels (100 percent view, where one image pixel = one screen pixel). However, it's also useful to see the whole picture at the same time to judge the effect. So we make a new window on the document using the *Arrange > New Window for...* command (*below*), which lets us work at 100 percent view in one window while seeing the effect on the whole image in the other (*right*). We then flatten the image as it's rarely advisable to sharpen while working in a layered file.

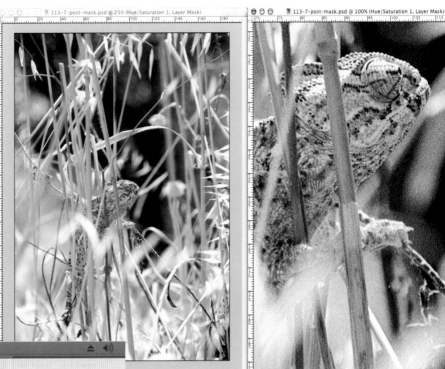

7B

7A

8 We then select *Unsharp Mask* (it's under *Sharpen* in the *Filter* menu) and start by setting the unsharp masking *Amount* at its maximum, 500 (*below left*), with the other two settings at their minimum values.

9 We then slowly bring the *Radius* up to somewhere between 0.5 and 1.5 (*below*).

9

8

10A

10B

10 The effect is extreme, especially at the 100 percent view (10A), but we started like this so we could be sure of seeing what the sharpening is doing everywhere in the picture. Now we've set the *Radius*, we can back off the amount until it's more reasonable (10B), allowing for the fact that the effect is always reduced in offset printing.

142

11 We didn't set a *Threshold* value in this example, as there are no important smooth areas in which we'd like to prevent USM from being applied. If it were a portrait or fashion shot, we'd set a threshold so that the skin wasn't sharpened but details like eyes and hair were—if you need to do localized sharpening you can make a duplicate layer, apply sharpening to it, and then mask off as necessary. Once we're happy with the sharpening, we click *OK* to apply it to the image, giving us an altogether more visible chameleon (*right*).

look sharp

Unsharp masking works by comparing the values of adjacent pixels and increasing the contrast between them in order to accentuate edges, giving the appearance of a sharper image. There are three controls in Photoshop's *Unsharp Mask* dialog box:

amount controls the strength of the contrast increase made between neighboring pixels

radius controls the width of the effect

threshold is the amount of difference required between pixels levels before unsharp masking is applied

The effect always looks greater on screen than it will in print, so amount settings of the order of 150–200 percent are normal for print. If you're working on a Web image, it'll be seen at actual size, so you can just go by what looks right on-screen to you.

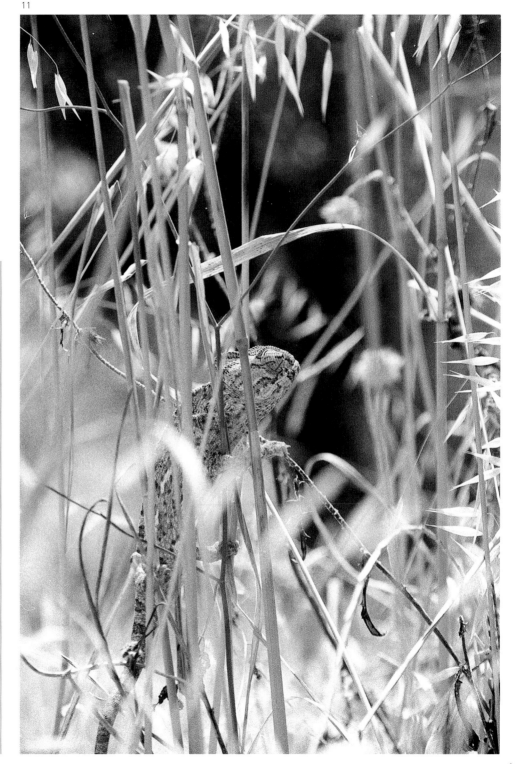

creative use of desaturation

Sometimes you can't fix pictures the way you intended to, so you have to allow some creative license. This shot of a woman (*right*) has some kind of yellow-green light flare in it, possibly from the lighting setup or even from mishandling during the processing of the transparency.

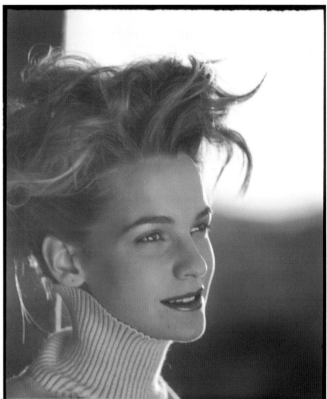

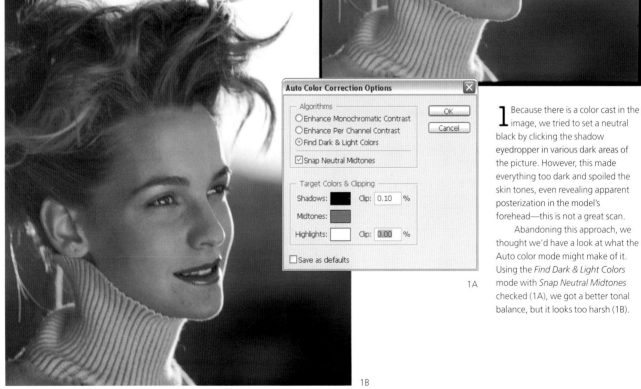

1A

1B

1 Because there is a color cast in the image, we tried to set a neutral black by clicking the shadow eyedropper in various dark areas of the picture. However, this made everything too dark and spoiled the skin tones, even revealing apparent posterization in the model's forehead—this is not a great scan.

Abandoning this approach, we thought we'd have a look at what the Auto color mode might make of it. Using the *Find Dark & Light Colors* mode with *Snap Neutral Midtones* checked (1A), we got a better tonal balance, but it looks too harsh (1B).

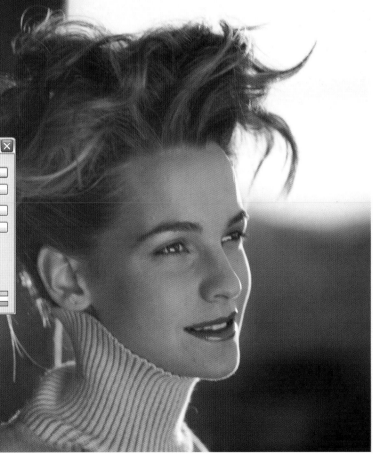

2A

2 We try to fix this using the *Hue/Saturation* dialog, selecting the skin and hair tones (*Yellows* as Photoshop sees them) and making a tiny *Hue* shift toward the greens (any move toward red destroyed the skin tone immediately) accompanied by a sight desaturation (2A). But it doesn't work; the color is still unconvincing (2B).

3B

2B

3A

3 Even after this color correction, we decide that the best option for the picture might be to desaturate the whole image. By quite heavily reducing the *Saturation* in the "master" color selection range (3A), we produce a much more pleasing version of the image. The muted color suits the subject while doing away with the flushed skin tones.

building saturation

You could argue that to color correct a sunset would be to defeat the object of taking the picture in the first place—the most interesting sunsets often display highly pronounced color casts of warm reds and oranges. If these colors existed in the original scene and were preserved in the digital image, no color correction would be necessary, but if the final image failed to live up to the original, we can easily fix it by introducing a color cast.

This image (*below*) is lackluster as sunsets go. It has poor contrast and lacks the highlights that might be expected in an image of a low sun over water.

1A

1 First we increase the contrast and bring back some of the richness of the hues. We convert from the 16-bit original scan to 8-bit so we can add a *Curves* adjustment layer (1A) for fine-tuning flexibility. We apply a contrast-increasing S-shape to the composite RGB curve (1B) to give some extra 'snap' to the image.

1B

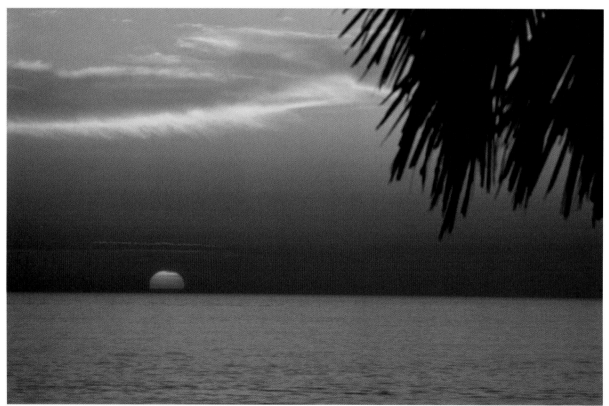

2

2 The water still looks very flat, however. The rich hue of the sun's reflection isn't coming through, so we try a technique designed to enhance that element. Using the *Marquee* tool, we make a rectangular feathered selection of the body of water (*left*).

3 We paste the selection to a new layer (*below*)—with the background layer selected in the *Layers* palette, go to *Layer > New > Layer* via copy or press Command-J. We name the new layer Water just to remind us what's in it.

3

4 Now we can use Photoshop's layer blend modes. Applying the *Overlay* blend mode (4A) to the Water layer certainly boosts the brilliance of the water reflection, but the effect is too crude and unreal to work (4B).

4A

4B

147

5

5 For more subtlety and realism, the *Color Burn* mode provides the ideal balance, putting more shimmer into the water (*right*).

6 The sea is much too dark now, so we set the adjustment layer's *Opacity* slider to around 50 percent (6A) to balance up the brightness without losing the shimmer, as you can see in the finished result (*right*).

6A

6B

DIGITAL COLOR CORRECTION

tonal and color correction in CMYK

We start with this digital camera shot from a polo match (*below*). It has already been converted to CMYK with our output profile embedded, having perhaps already been used for offset print elsewhere. It looks a bit flat and the grass color doesn't seem realistic.

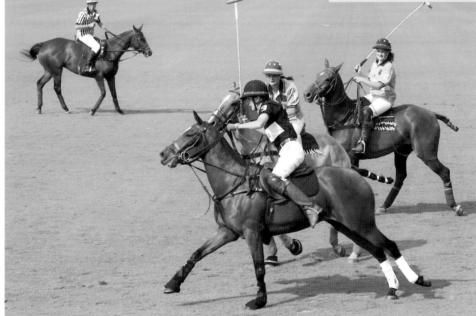

2 So we double-click the shadow eyedropper to set a suitable shadow value. Because we don't know the CMYK values for the press, we enter RGB 12, 12, 12 for a neutral black and let the CMYK profile calculate the CMYK equivalent values (*above*)—which aren't equal percentages in CMYK, as cyan is weaker than the other inks and so is set to a higher maximum value of 94 percent, against 83 or 84 percent for magenta, yellow and black. These add to give a total ink value of 344 percent, which is within the 360 percent limit specified in our CMYK profile.

1 We start by taking a look at the tonal distribution histogram in the *Levels* dialog (*right*). We can see that the highlights are already clipped (something that's common in images from digital cameras), but working in CMYK, means we don't have the threshold display mode available that we use so much in RGB, so we decide to use eyedroppers to set shadow and highlight points. In our normal RGB working, the CMYK output profile would take care of white and black point conversions and ink limits, allowing for the characteristics of the printing process. However, as we are already in CMYK mode, we can't be sure of remaining within acceptable values when manipulating the image. The maximum black/shadow mustn't exceed the total area coverage ink limit, while the highlight must equate to a dot value that can be held on press—anything too low might be lost, giving patches of bare white paper with no dot at all.

3 We go through a similar process for highlights, and after some trial and error we set the RGB highlight values to 240, 240, 240 to keep the equivalent CMYK numbers to a 4 percent minimum dot (*right*), which ensures that ink prints properly in the highlight areas. A good press should be able to hold a lower dot than this, but we're being conservative here and think that slightly muddy whites are less objectionable than patches of bare paper.

4

3

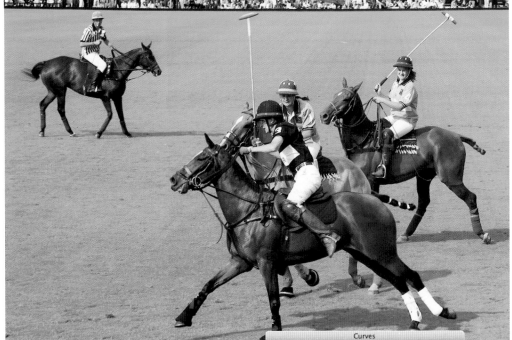

5 Now we'd like to increase the midtone contrast to bring up the detail in the players and horses. However, another drawback of working in CMYK is that we can't see where any given part of the image falls on our composite CMYK part of the *Curves* dialog, so we can't easily add control points as we do when working in RGB. (It does works for the individual CMYK channels, though.) Working by eye, we put control points in the quarter and three-quarter tones to anchor the tonal extremes and then add a third control point to increase midtone contrast (*left*).

4 Now we're ready to do some clicking with the eyedroppers, so we choose a point in the picture that is light but where we want to retain some detail—the front horse's spats, and a shadow on its rider's black shirt for our shadow point. This gives us a punchier version of the image (*above*).

5

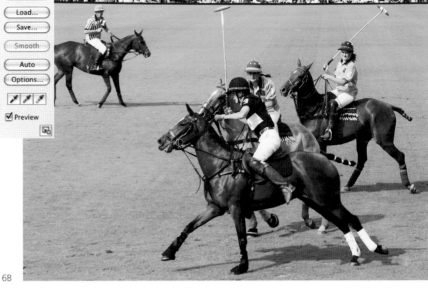

6A

6 That puts better contrast into the horses, but we feel the grass is perhaps too yellow. So, with the *Curves* dialog still open, we go to the yellow curve, add a control point to "pin" the midrange point, and then add a point in the shadow end—which appears in the top right of the graph—and pull it down to reduce the amount of yellow in the three-quarter tones (6A). Note that the tonal scales are inverted in CMYK working, with shadow values at the outer ends and highlight at the origin, though you can change this by clicking on the black and white triangles in the middle of the horizontal scale. This improves the grass color and that of the horses (6B).

6B

7A

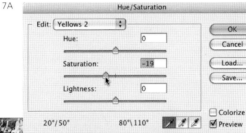

7 We're still not happy with the grass—it's too vivid—so we open the *Hue/Saturation* dialog, select *Greens* and click in the image with eyedropper (*left*). Photoshop decides that the color we've sampled is closer to yellow than green (it calls it *Yellows 2*), but whatever the program thinks the color is called, we will need to desaturate it if we want to make it look more natural.

7B

8

C :	100%		C :	100%	
M :	96%		M :	96%	
Y :	84%		Y :	84%	
K :	49%		K :	49%	

X : 1395 W :
Y : 820 H :

8 As we can't use Photoshop's conversion gamut warning— we're already working in the final CMYK color space—we do a manual inspection of the image (8A), using mouse and watching the Info palette to check that our manipulations haven't exceeded the ink limits in the dark areas or produced any highlights that will drop out on press. All looks well, so we're finished (8B).

making good mono from color

The color doesn't really add anything to this candid picture (*below*), so we'd like to experiment with it as a monochrome image.

There are several ways to make a mono image from a color one with Photoshop. They don't all produce the same result and they give you varying degrees of control over the conversion of color values into grayscale tones.

1 The *Image > Mode > Grayscale* conversion (1A) doesn't give you any options to play with, but usually does a fairly good job (1B). You wind up with a grayscale file rather than an RGB one—which is good, because it's smaller—but you need to make sure you've got an appropriate grayscale profile selected (1C). If you're going to print, you should use one based on an appropriate dot gain figure (we've conservatively chosen the 20 percent dot gain profile); for Web pick a gamma-based one, 1.8 only if you know your viewers are all using Macs, 2.2 for PCs or if it's a mix (most likely for the Web).

1A

1B

1C

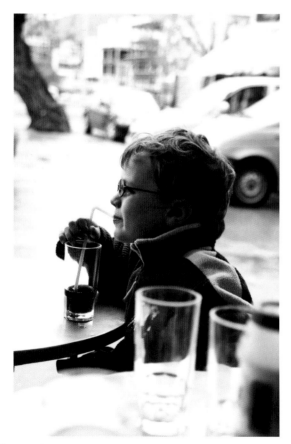

2 Another no-options route to mono is the *Desaturate* command (2A). In this case, it gives an almost identical result to *Grayscale* (2B), but it doesn't always. In our experience, *Desaturate* often gives a noticeably poorer conversion. You still have a RGB file after conversion, so it's the same size as the original color file. When you give it to a printer, it will be converted to CMYK using all four colors, which will print more richly than a grayscale that prints on the black plate only—though with the potential danger of a color bias appearing if the press isn't tightly controlled. Of course, if you're printing only in one color, you would need to supply a grayscale file anyway.

2A

2B

3 A method of conversion to grayscale that gives a lot of interactive control is the *Channel Mixer* (3A). The default settings with the monochrome box checked give a better conversion of our image—it's lighter, and reveals slightly more detail in the hair and the fleece jacket (3B).

3A

3B

4 The strength of the channel mixer is that you can vary the percentages of each of the RGB channels contributing to the image, taking equal amounts from all three for example (4A). This looks more like the *Desaturate* version of our image (4B), but you can vary the strength of the source channels to lighten or darken particular colors, in the same way that shooting monochrome film through colored filters does.

4A

4B

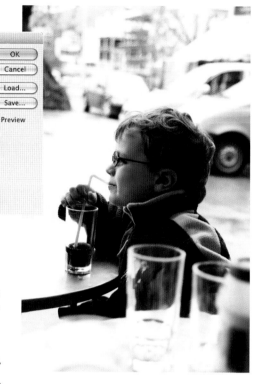

5 When playing with the *Channel Mixer*, you would normally aim to keep the total of the three channels to 100 percent (you have to calculate the values yourself, Photoshop can't do it for you). If you let it go beyond 100 percent total by boosting one channel (in our example, the blue channel; 5A), this has the effect of pushing the highlight contrast without losing detail in the subject. With a subsequent, slight midtone *Curves* adjustment to lighten the skin, this gives a pleasing high-key effect (5B). The beauty of the *Channel Mixer* is that you can play with the settings endlessly, while getting a constantly updated preview—you may not have to do any subsequent tonal manipulation at all.

5B

5A

6 Another route to a mono image from a color original is to use the *Luminance* channel of a Lab image. Convert the image to *Lab* color (6A), then delete the a and b channels in the channels palette (drag them to the trash icon at the bottom right), and convert the remaining channel to grayscale (and thence to RGB or CMYK if required).

6A

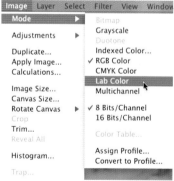

6B

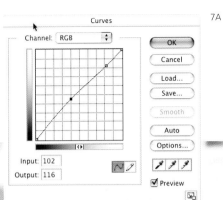

7A

The result is very similar to the default
Channel Mixer version, but doesn't
give the latter's flexibility for subsequent
manipulation. However, this method is still
worth a try if the other single-command
approaches don't yield a good result or you
don't fancy playing with the *Channel Mixer*.

7 The best of the mono conversions with
our picture is the default *Channel Mixer*
one. To finish it, we open the *Curves* dialog
(7A), fix a highlight control point from the
cheek under the eye, then place another point
sampled from the hair to open up the details
in the hair (*right*). With not a great deal of
effort, we've arrived at this compelling shot.

7B

coloring mono images

There is one more way to make mono images from color, a way which also opens up a host of colorization options. Let's start with a different picture: we want to make a great mono shot from the picture of the girl in the work-through on page 130, but the best of our standard mono conversion options, which in this instance was the L channel of a Lab conversion (*below left*), still wasn't right.

1 Our additional technique is more complex, but it's also much more powerful. Here's how we do it: to the original color image we add two *Hue/Saturation* adjustment layers (*right*). We make no changes in the *Hue/Saturation* dialog that appears when adding the first layer, and after clicking OK in the *Hue/Saturation* dialog box, we set the blending mode to *Color*. In the *Hue/Saturation* dialog box for the second adjustment layer, we set *Saturation* to −100, click *OK*, and leave the blending mode at *Normal*.

2 So why have we done this? The first *Hue/Saturation* layer isn't doing anything and all the second one is doing is desaturating the color to turn the image to mono. Surely we could just have used the *Desaturate* menu command to get to this point?

Stay with us; this is where it starts to get clever. Now we double-click on the *Hue/Saturation* icon of the first *Adjustment Layer* in the *Layers* palette, and adjust *Hue* on the *Master* selection to +125 (2A). This changes the colors in the image and consequently the way in which those colors are interpreted when the desaturation is applied by the upper layer, giving us a mono image with a more brunette feel (2B). If we turn off the upper adjustment layer visibility—by clicking on the eye icon on the left (2C)—you can see what's happening to the color image below the desaturation layer (2D).

1

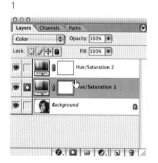

2A

2B

2C

2D

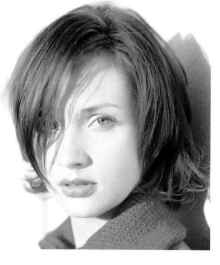

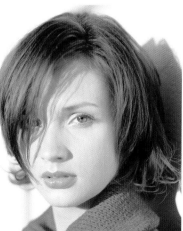

3A

3 Turning the upper adjustment layer back on, we go back to the *Hue* slider in the first *Hue/Saturation* layer (3A), change it to −17 and get a result closer to our original L channel starting point but with better contrast in the hair (3B). With the visibility of the upper adjustment layer turned off again, it looks like the image shown right (3C).

3B

5A

5B

3C

4 As you can see, there's a wide range of interactive adjustment available that's simpler to use than the *Channel Mixer* (because you don't have to worry about adding up percentages to make 100 all the time). And it lets you do other things too:

 If we go into the top *Hue/Saturation* layer and reduce the *Saturation* to −75 (4A), we start to see color-shifted tone creeping in (4B).

4B

5D

4A

5 Clicking *OK* to this, then changing the hue in lower *Hue/Saturation* layer to +180 (5A), we get a pleasing cyan effect (5B). We think this one might be nicer with more color coming through, so we change the *Saturation* in the upper adjustment layer to −50 (5C) for a stronger effect (5D).

6 You'll notice that the background shadow doesn't change much in any of these— that's because it's a neutral gray and is largely unaffected in the *Color* blending mode. If you want everything to change, check

Colorize (6A) on the upper *Hue/Saturation* layer to get a result like the one shown below (6B). You can play with these settings to your heart's desire to get a huge variety of effects.

6A

duotones

Another approach to colored mono images is the Duotone option. Duotoning is a way of adding tonal depth (and usually a degree of color tint) to monochrome images by printing in black or another dark color plus one, two, or three additional inks. Photoshop comes with an extensive library of preset duotones designed for printing with process (ordinary CMYK) or special Pantone colors, but any of the latter can be converted to RGB or CMYK for printing. And they're all editable—you can change the duotone colors and edit the curves to control the appearance. It's a big subject and a thorough discussion is outside the scope of this book, so we'll just run through a basic example to get you started.

1A

1B

1C

1 We start with a grayscale-as-RGB file (1A), which we made from a color original using the *Channel Mixer* technique outlined previously. To use the *Duotone* tools, we first have to convert to grayscale (although duotoning involves "separations" for multiple inks, the process has to start with a single-channel image). We then use *Image > Mode > Duotone* (1B). Up comes the default duotone; by clicking on *Load Duotone,* we can choose between duo (two inks), tri- (three inks), and quadtones (four inks) from the predefined libraries installed with Photoshop (1C). You can also save your own duotones here.

2A

Duotone Options

Type:	Tritone				OK
Ink 1:		Black			Cancel
Ink 2:		PANTONE 340 CVC			Load...
Ink 3:		PANTONE 423 C			Save...
Ink 4:					☑ Preview

Overprint Colors...

2B

Duotone Curve

0:	0	%	60:		%	OK
5:		%	70:		%	Cancel
10:		%	80:		%	Load...
20:		%	90:		%	Save...
30:		%	95:		%	
40:	2	%	100:	60	%	
50:		%				

2C

Duotone Curve

0:	0	%	60:		%	OK
5:		%	70:		%	Cancel
10:		%	80:	50.6	%	Load...
20:		%	90:		%	Save...
30:		%	95:		%	
40:	2	%	100:	60	%	
50:		%				

2C

2 We pick a Pantone green and gray tritone we like as a starting point (2A). But we want to make the green tint a little bit stronger, so we edit (2B) the Pantone green curve (2C) to add more green in the shadow areas (2D).

3 We're not printing with the special-color inks specified in the tritone recipe, so we have to convert our image back to RGB via *Image > Mode > RGB* or directly to CMYK for printing (*right*). It probably won't come out quite the same as you'd get with the special inks, but it's a powerful creative tool for working with mono images in color printing (or for on-screen display) nonetheless.

3

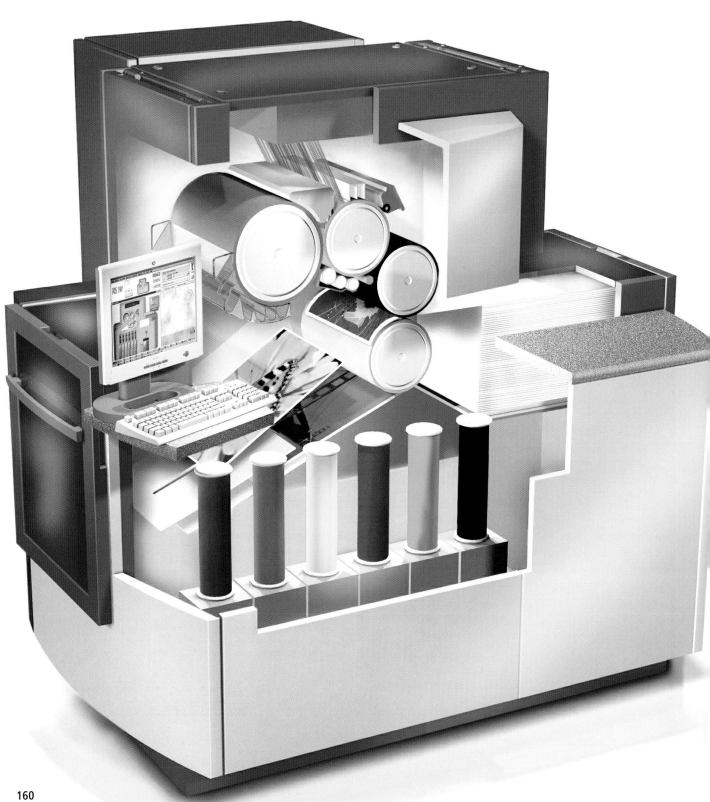

HANDING OFF YOUR FINISHED IMAGES

chapter 5

Once you've finished working on an image, you'll need to prepare it for its final use. That might be as simple as clicking on "save" for an image that you just want to archive, before burning it onto a CD or DVD, or it might mean converting to CMYK for offset printing on a particular press, setting up a multichannel file for special colors, or handing over to a video production facility for incorporation into motion footage. In each case, you'll need to make sure that the file is not only in an appropriate format, but also that it conforms to the conventions—and limitations—of the output process in question and conveys color information in a way that's going to be best understood and most accurately reproduced.

If you've adopted the color-management approach to maintaining image fidelity as advocated throughout this book, this process should be comparatively straightforward since a correctly built and appropriately chosen output profile will deal with many of the issues. However, it's likely that at some point you'll also have to feed your images into someone's noncolor-managed workflow. Further, there are always situations in which manual intervention is necessary or in which the color-managed approach is not possible—the ICC-based color-management model was primarily designed for printed output. The technology isn't so well understood or supported outside the print world (or everywhere within it, either). For these situations, having an understanding of the factors that affect—and limit—the various output processes is invaluable.

So, we will not only explain the vagaries of dot gain and the wonders of UCR and GCR in color printing, we'll also look at the implications of preparing images for the Web (where control of color is almost entirely out of your hands) and for TV or video use, where the requirements of broadcast and recording put their own restrictions on color.

The chapter is divided into two main parts, based on CMYK and RGB output routes and the issues to be aware of when preparing work for each. In the CMYK print section, as well as looking at routes for converting RGB to CMYK and performing CMYK-to-CMYK conversions when repurposing from one print type to another, we'll explain how to manage the synthetic colors created in drawing or painting applications and page-layout programs. The RGB part will address readying images for RGB printing/accepting hardcopy devices, for the Web and multimedia, and for TV and video.

5

the printed world— CMYK output

You'll recall that way back in Chapter 1 we introduced additive and subtractive color-mixing models and also explained that laying pigment onto paper means you have to work with cyan, magenta, and yellow primaries instead of the red, green, and blue used when mixing light. We also briefly explained why real-world printing uses four inks—black is added because real C, M, and Y inks don't mix to produce a proper black. We then spent a couple of chapters extolling the virtues of a color-managed RGB workflow, even if your eventual output destination was commercial print.

So, now you've reached that point. Your image is finished in terms of enhancement, color correction, or editing, and you need to get it ready for a magazine, newspaper, design firm, or printer who want it in print-ready CMYK. Perhaps they don't use (or understand) color management; what do you do?

Preparing your image for a particular output device (or process) is called "targeting." Once you've got your image looking the way you want it, you have to prepare or adapt it to suit the requirements—and limitations—of the output, process. In the case of targeting for print output that means converting the RGB colors into the C, M, Y, and K (black) values which will best reproduce the colors you intended.

Before we get to the mechanics of converting your files to CMYK, we should take a moment to understand the factors that affect print quality and which we must therefore take into account when making the conversion from RGB.

above left and below right
Digital colour presses from Indigo (*above left*) and Heidelberg (*below*)

roll the presses

The basis of most commercial printing is "offset" lithography. A printing plate containing an image of the page is mounted on a cylinder and rolled against an ink-bearing roller. The ink sticks to the plate in the image area and is repelled everywhere else. The plate is then rolled against an intermediate (hence "offset") rubber cylinder called the blanket, and the ink image transfers to this. The blanket is rolled against the paper, transferring the ink to the paper. Do that four times, once for each of the four "process" colors (as C, M, Y, and K are referred to in the printing business), and you've printed your color page.

There are variants in how the plate is made or how the ink is transferred to the paper, such as flexography (printing of foils and films, as in food and other packaging) or gravure (a high-quality method of printing for long print runs, in which the image is etched as tiny pits in a copper cylinder), but the basic principle is the same—getting the ink from a master plate onto paper.

A more recent alternative is the digital press. There are two types of machine in this category. One has a plate-imaging device built into the press, but then prints as described above (the Heidelberg GTO-DI or QuickMaster DI models, for example). The other uses a xerographic process similar to that found in color laser printer and copiers: instead of plates, blanket rollers, and ink, these presses write a page image in electrostatic charge on a drum and transfer that pattern of charge to paper, where it attracts particles of toner. The paper and toner are squeezed through a heated roller that fuses (partially melts) the toner onto the paper. Devices that work this way, such as the HP Indigo models, tend to be used for very short-run or extensively customized printing in which part (or all) of the content of each document is different.

gains from stock

Whichever type of printing process your work goes through, there is one inescapable fact about putting colored ink or toner on paper—it spreads. The halftone dots that make up your image (*see Chapter 3*) get squashed out on the press, making the image darker. How much they spread depends on the type and condition of the press you're printing on, the kind of paper (how absorbent it is), and how much ink you were trying to lay down—highlights tend to suffer least, midtones darken more, and shadow tones may block up completely as the ink spreads to fill in the gap between dots. You can see all of these effects in the images below. This phenomenon is known as dot gain, and whatever you do you can't avoid it. It is possible to measure it, though, and thereby compensate in advance by lightening your image.

The good news is that in a color-managed workflow, dot gain characteristics can be built into a CMYK output profile, or alternatively, handled via custom conversion curves (see section later in this chapter) so you probably won't even have to know a value for it. Typically, though, it's anywhere between 10 and 20 percent—that is, a 50 percent tone can grow to as much as 70 percent in the printing process, depending on the paper stock and press.

below before dot gain

below after dot gain

the dynamic duo:
UCR and GCR

There's another factor that rears its head when mixing inks to print color images: black generation. This means, "How do you decide how much black to use in an image when C, M, and Y are supposed to mix to make black?" In theory, equal percentages of C, M, and Y should mix to produce an equivalent percentage of black (though in practice, cyan tends to be lighter than the other two). You ought, therefore, to be able to subtract the common percentage of the three colors in any mix, then replace that with the equivalent black plus the remaining unequal proportions in the nonblack colors, and it should look the same.

This is the basis of two parameters that are critical in CMYK color (and one of the reasons that it's more difficult to edit color in CMYK)— under color removal (UCR) and gray component replacement (GCR). They both do the same kind of thing, though UCR works on the neutral parts of pictures only (where C, M, and Y are more or less equal) and GCR works across all colors,

replacing a proportion of the C, M, and Y with black. GCR uses less ink, which as well as saving money, is important on newspaper or uncoated papers. Too much ink coverage can cause drying problems or even cause the paper to tear on press, an expensive and highly undesirable event.

The downside of GCR separations is that they can make shadow areas look flat or thin. UCR, which uses more ink (and is therefore better suited to coated and/or thicker stock) produces better dark, saturated colors.

Once again, in a color-managed workflow, UCR or GCR types of black generation would normally be built into an output profile, so you won't necessarily have to know anything about them. That said, an understanding of the process is helpful, especially if you have to deal with files that were originated or worked on in versions of Photoshop prior to 6.0. In sophisticated CMYK workflows, as found in some prepress bureaus, different types of black generation may be used for different types of image. To do this, what's sometimes called a "Photoshop 5"-style workflow is used. This involves the use of editable Photoshop-generated settings as opposed to the standard ICC profiles made by measurement (as described in Chapter 2).

below The basis of black generation: the common amount of the three subtractive colors can be subtracted from any CMY color and replaced by black to save ink and produce stronger shadows. Exactly where you do this, and by how much, are critical in making CMYK images that print well on different presses and paper types

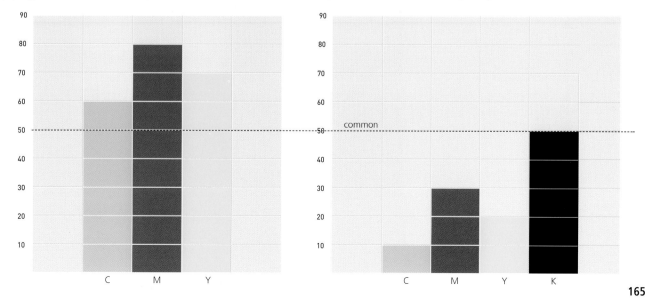

know your limits

The other factor that putting ink on paper entails is making sure you don't put too much of it on not only for cost reasons, but to avoid the drying and tearing problems outlined above. (A web press prints on a continuous roll or web of paper, which is cut after printing, as opposed to a sheet-fed press, which as the name says, is fed with precut sheets of paper.) The ink limit or total area coverage specifies the maximum permitted density of all four inks. It's usually expressed as a percentage that's the sum of the individual ink densities ("density" here means the relative value from 0 to 100 percent, from no ink to solid color, and is not an absolute measure of how dense or dark any particular ink and paper combination is). For newsprint, it might be a little over 200 percent; on good-quality coated paper, it's more likely to be somewhere between 320 and 340 percent or even a little higher.

Although a conversion to CMYK using a proper output profile will automatically ensure that your file conforms to the ink limits specified within it, you need to be aware of them if you then edit your image in CMYK, especially if you need to darken the image or increase saturation —it's easy to violate the ink limit without realizing you've done so, which is why we recommend you do edits of this kind in RGB if

you can. Photoshop allows you to soft-proof on screen, using the desired output profile, so you can see how it's going to turn out without actually having to do the conversion. If you're dealing with very rich, saturated colors in your image, you may find that you just can't reproduce them in CMYK, no matter what settings you try. This is because of gamut differences between most RGB and CMYK (*see Chapter 2*) and is a sad fact of life for photographers whose work winds up in commercial print.

proofing your work in CMYK

The gamut mismatch between most RGB and CMYK color spaces can work the other way too. Some of the more brilliant cyans and neighboring blues and greens that CMYK can print, don't show well on monitors. Even so, they might be present in your file. This is why we recommend that you invest in a good-quality inkjet printer and have it profiled, so you will be able to see these colors properly, as well as provide a reference for anyone else trying to reproduce your image. By "good quality," we mean an inkjet whose printable gamut includes the entire standard offset CMYK one—a color management and profiling specialist will be able to advise.

The profiled inkjet also allows you to simulate the appearance of your work as it should appear when printed. Called "cross-rendering," this is a process that uses the color management engine in your computer effectively to convert your document colors into the final output color space and then to render them into the space of your inkjet in order to simulate the final printed result. This process effectively passes your image data through the CMYK "bottleneck," removing any unprintable colors.

Exactly how you do this depends on what software you are using. Adobe Photoshop, Illustrator, and InDesign offer this facility in the print dialog boxes without actually having to convert your image from RGB. With other programs, you may have to convert the image to the final CMYK output space first and then print that to your inkjet using the inkjet's output profile—make a copy of the image before converting if you haven't finished editing and just want to check progress along the way. Of course, if you're in a graphic design or prepress environment and have a CMYK-driven proofer —perhaps a large format inkjet, color laser engine with a RIP or other high-end digital proofer— you'll need to convert to CMYK anyway to print to it. You should then use whatever proofer output profile or other color-management technique you would normally use with that device (some high-end devices have proprietary approaches to color management).

left and right Cross-rendering in Adobe Photoshop (*left*) and InDesign (*right*) allows you to use the color-management engine in your computer to get an inkjet printer to simulate the output of the final print process

send profiled data or "final" values?

If you're sending a CMYK image to someone, it can only be because they want to print it and that they're going to put it into a page layout or illustration program such as QuarkXPress or Macromedia FreeHand. Whether you give them an RGB or CMYK file with an embedded profile, or a file with "final" CMYK numbers and no profile embedded, depends primarily on two things: how savvy they are in color-management terms and (to a lesser extent) what page layout software they use.

In the ideal situation, the recipients of your file would also be working in a fully color-managed environment and quite happy to receive either RGB with embedded output profile or CMYK with embedded output profile (for convenience, we call these "tagged" RGB or CMYK files). In the former case, you wouldn't need to work in CMYK at all and they would take care of the transformation using

below Color-management settings in QuarkXPress 6.0

their own output profiles. Unfortunately, this situation is still comparatively rare in print, so it's more likely that you'll be asked to supply a CMYK image, probably without an embedded profile. Even if they can handle RGB, some prepress facilities and printers prefer you to make the conversion, so that if it's wrong it's not their fault.

Note that—assuming your CMYK values have been generated using an appropriate CMYK output profile—such a file can have completely correct CMYK values, but the file can still be difficult to proof accurately. Without a profile, there's no key to calculate what actual colors were meant to be represented by the CMYK numbers in the file. Most proofer RIPs tend to assume a particular color space, so unless you can find out what it is for each instance, you just have to hope it turns out to be the right one.

Different applications have different color-management capabilities. Of the programs prevalent in professional design and publishing, Adobe's Illustrator and InDesign handle color management pretty much the same way that Photoshop does—profiles in incoming "placed" images will be respected and used in conjunction with the monitor and output profiles set up in those programs; conversions to other working or output spaces can be applied to placed images, with rendering intents honored or manually overridden as desired.

With Quark XPress, it's not so straightforward. Version 4.x will only properly support conversion of ICC profiled images with the addition of an XTension such as CompassPro XT. Otherwise, all embedded CMYK profiles are ignored and Quark's own CMYK conversion is used with RGB images. Quark XPress 5 and 6 include improved built-in color management and should recognize and use ICC profiles, provided color management is turned on. It's off by default and, after that, CMYK-to-CMYK and RGB-to-RGB conversions have to be enabled independently. Given the range of Quark versions in widespread use, it's not surprising that popular opinion still deems it best to color manage image files (i.e. convert to final output values) before placing them in QuarkXPress.

Color Management Setup

Convert to Profile

Save As

above and right
Saving for untagged output in Photoshop. Convert using the most suitable profile (*above*) but without embedding the profile (*right*)

above left Color-management settings in Macromedia Freehand MX

Macromedia FreeHand also works with ICC profiles, but with the restriction that CMYK elements (whether placed or created in the program) are assumed to be press-ready. That's fine if you're handing off a tagged RGB file to a FreeHand user (assuming they understand color management and have it turned on). Otherwise make CMYK for them, but you'll need to know which CMYK they want to use for output and do the conversion yourself.

This last bit of advice applies to any instance where you're asked to give a CMYK file. You should try to find out the ultimate output and use the appropriate profile when converting your image from RGB; otherwise the recipient might wind up using the wrong CMYK values for their print process. If they have profiled their press, they can give you their own CMYK output profile so you can prepare and proof your image specifically. Failing that, they may work to a generic standard such as SWOP or Euroscale, profiles for which ship with Adobe Photoshop, or an analog proofer standard. In either case, the printers should be able to supply you with a profile if you don't already have it.

If questions on what profile to use are met with baffled silence or "We don't use color management," it's safe to assume that you will need to supply "final" color data. This means that instead of sending a file with an embedded profile that explains what colors the CMYK values represent, you're just sending the raw numbers calculated for a particular output

process. In Photoshop, that means using the *Mode > Convert to Profile* command (we think it's misnamed; it should be "convert using profile") to convert the image using a suitable output profile as usual and then save it without embedding the profile (as illustrated above). The CMYK numbers in the file will be exactly the same, but without the information contained in the profile, they can't be used with confidence for any other CMYK output, including making proofs.

It's fine to do this, as long as that actually is the device that gets used to output the job. If there's a late decision to use a different press or printer, any assumptions about inks and device characteristics could become invalid, with detrimental results. This doesn't just affect photographers and designers—it's a perennial problem for prepress bureaus as well—so it's a good idea to send an inkjet print-out as a "guide print" along with your file so that everyone has an unambiguous reference to work to. You can't make them look at it, but you can give them the option. It's a bit like the old days of repro, when you'd always send the original transparency for reference.

CMYK-to-CMYK conversions

Sometimes you might be starting from a CMYK file that was produced for a particular output process (type of press, stock, dot gain, and so on) but need to send it on for output under different conditions—the same stock perhaps, but a different press (a web press instead of a sheet-fed one), with different dot gain characteristics and a different ink limit. Obviously, you'd have to do any color correction or other image enhancement in CMYK, but how do you then "re-purpose" the file for the new CMYK output process?

HANDING OFF YOUR FINISHED IMAGES

don't try this at home

below Photoshop's *Convert to Profile* dialog lets you specify custom CMYK settings (*top*) including individual curve editing (*bottom*)

The simplest route is to convert the data to the new color space after doing any color correction you thought necessary. In Photoshop you'd do this using the Mode/Convert to Profile command (*see below*). This will make sure you don't inadvertently violate the ink limits for the output process when editing your colors.

There is debate in prepress circles about just how good CMYK-to-CMYK conversions using ICC profiles are, particularly in terms of preserving the black plate generation. If all that's different between the original CMYK profile and your new desired output is the dot gain characteristic of the press, you don't necessarily need to do an ICC color-space conversion. In Photoshop you can use Convert to Profile and click the Custom CMYK option, which allows you not only to define custom CMYK ink colors but to edit the curves for each color, provided you have all the relevant values from your printer (this is the "Photoshop 5" method referred to earlier in this section). It gives you a US SWOP coated specification as a starting point, and as well as dot gain, black generation type, and amount (UCR or GCR, preset strength or editable curve), you can vary the CMYK ink colors too. The resulting settings

can then be saved and used as an ICC profile. A serious word of warning, though—this requires specialist prepress and press knowledge, so don't get into this kind of tinkering unless you're sure you know what you're doing.

If you start with an untagged CMYK image, you could begin by assigning the desired output profile, then check the appearance on your profiled screen and color correct the file as necessary, again keeping an eye on your ink limits. The differences between CMYK color spaces are usually smaller than between RGB ones. These mostly relate to dot gain characteristics, although there are differences in gamut when moving to newsprint from coated

stock, for example, or if using different ink colors (as sometimes happens in the Far East); there is also an all-round gamut loss in switching stock from coated to uncoated (*illustrated below left*) or from sheet-fed to Web press.

If you have a tagged CMYK image to start with, you can always turn on the gamut warning in Photoshop's proof setup to see if the conversion to your destination CMYK is going to lose anything. If you're doing something fairly extreme, like repurposing a glossy brochure image for newsprint, you will almost certainly lose some colors—it can't be avoided. Do your color correction in the source color space and then convert, and don't try turning the colors back up using curves or saturation shifts in the target space; you'll just wind up breaking the ink limits—and maybe even the paper on the press.

top left Color gamut comparison for Euroscale coated (wireframe) and SWOP sheet-fed coated (solid)

bottom left Color gamuts for SWOP coated vs. SWOP uncoated sheet-fed vs. Web press

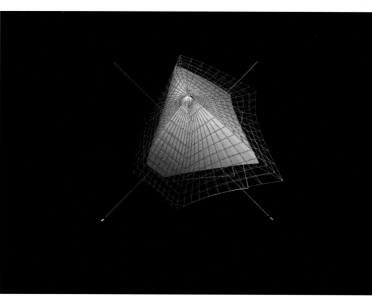

Hexachrome

Earlier in the book, we talked at length about how CMYK printed output generally misses out on some of the more bright and saturated colors that RGB images may contain. You don't absolutely have to grin and bear it, if you can print in Hexachrome.

Hexachrome is a six-color printing process developed by Pantone. In addition to cyan, magenta, yellow (which in Hexachrome are purer, more saturated colors than the normal process inks), and black, there are also green and orange inks. This has the effect of considerably expanding the gamut, in the same way that "hifi" color inkjets do, which means that more of the brilliant saturated colors available in most RGB color spaces can be printed (*see the illustration, top right*). Hexachrome also enables a wide range of the Pantone solid colors to be matched out of the six-color set, making it possible for graphic designers to use a number of "special" colors in a six-color job.

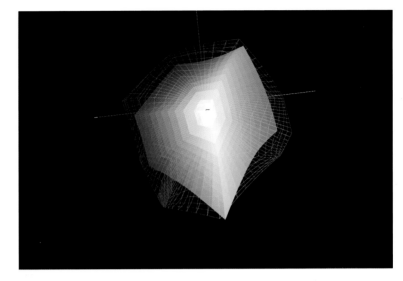

above Color gamuts compared for Hexachrome glossy (wireframe) vs. US sheet-fed coated

To use Hexachrome with your images, as well as working with a printer who uses the process, you'll need Pantone's HexImage software, a plug-in for Photoshop that converts your files into six-color "separations" (*illustrated below*). The software includes color correction and soft-proofing capabilities and a selection of ICC-compatible Hexachrome output device profiles, enabling color management to be applied here too.

Channels ▸ Layers History Info

👁	Hexachrome Cyan	⌘1
👁	Hexachrome Magenta	⌘2
👁	Hexachrome Yellow	⌘3
👁	Hexachrome Black	⌘4
👁	Hexachrome Orange	⌘5
👁	Hexachrome Green	⌘6

above Hexachrome separation setup in Adobe Photoshop using the Pantone HexImage plug-in

PANTONE® HexImage® Color Separation

Profiles

Source | Use Embedded/Working Profile
Separation | CTP Coated Hvy
Rendering | Perceptual

(Update Preview)

Cursor Color

C	7%	M	62%	Y	97%
K	18%	O	76%	G	0%

(Cancel) (Separate)

getting the synthetics right

For the vast majority of this book, we have talked about correcting and managing color in photographic or photorealistic images. But you'll remember way back in Chapter 1 that we mentioned another graphics type—vector graphics. Vector graphics applications work by creating objects (lines, circles, rectangles, irregular shapes) whose attributes (colors, fills, strokes, gradients) you define. As all the elements are described by vectors, there are no pixels, although all professional-quality vector-drawing programs will let you place pixel images within your vector art.

If you're creating a vector graphic image from scratch, you should in principle have complete control over your colors and therefore, on the face of it, not need to be reading a book about color correction. But if you're defining colors within a vector file and are concerned about how those colors will appear once you send your illustration to someone else, what should you do?

It used to be the case that drawing programs such as Adobe Illustrator, Macromedia FreeHand, and CorelDraw were intended only for print output and would allow you to specify colors only as CMYK percentages. At that time, it was presumed that you were familiar with print color and probably had a swatch book to help you select tints of process colors. More recently, with the increasing interest in the Internet and other screen-based delivery, RGB color capabilities were added to these programs, and fortunately, so was color management.

All three applications mentioned above support ICC-based color-space conversion and soft-proofing, both of elements created within the program and of images placed from other programs (although they do it to a greater or lesser extent, in slightly different ways and with different peculiarities). This makes it possible to see an on-screen prediction and (with Adobe Illustrator, at least) a cross-rendered inkjet print of final output color in RGB or CMYK for any destination for which you have a profile.

top right The Color Settings dialog in Adobe Illustrator

bottom left Soft-proofing colors for CMYK output in Adobe Illustrator

file formats for print

below Don't leave layers in Photoshop TIFF files when using the *Save As* dialog

TIFF is pretty much the ubiquitous file format for handing off bitmap images for page layout and print. However, beware of Photoshop's extended TIFF capabilities—the layers that you can save in a Photoshop TIFF won't necessarily be recognized by page layout or prepress software, so make sure you always flatten files first.

If you've made a duotone (or tritone or quadtone, for that matter) and you know it's going to be printed using special inks (Pantone or any of the other solid-color ink systems), you'll have to provide it as EPS because the special colors can't be contained in other file types. If you're using the duotone as a creative tool (*see page 158*) but still printing in normal CMYK, you'll have to convert to CMYK (via RGB if you want to do some further work on it before output), although you can then supply a TIFF file. One more thing to be aware of with duotones: if you're passing Photoshop duotone files around for aesthetic judgements to be made by other Photoshop users, the way Photoshop will display them appears to depend on each user's working CMYK color-space setting. Differences between systems can produce unexpected results, so there's another reason to send a guide print from a properly profiled printer.

That said, EPS is fine for any professional page layout or repro system. Just make sure you haven't put in any output-specific controls like transfer functions or screening commands, because repro people won't be able to edit them easily (as with CMYK dot gain curve editing, you shouldn't be messing around with these unless you know what you're doing). The same goes for images intended for Hexachrome printing. However, this is still quite uncommon, so you may find that the printer or repro house will prefer to do the Hexachrome separation themselves and ask you for a tagged RGB file, in which case you can use TIFF.

RGB output

If your images are not destined for print, but for screen, whether computer or TV, then the good news is that by working in RGB as we advocate, you're starting from the right place. For hardcopy output devices that accept RGB (a category that includes film recorders, photographic printing devices, and the ubiquitous desktop inkjet printer), it's mostly just a case of using the right output profile—or trying to deduce and then testing the most likely one.

But if you're preparing images for use on the Web, in multimedia, or video/TV, there are some further requirements—and restrictions—that you need to know about.

hardcopy output from RGB

By RGB hardcopy devices, we don't necessarily mean only devices that image using red, green, and blue light, but all those that accept RGB image data as an input, even if they actually output using cyan, magenta, yellow, and black dyes, pigments, or inks. In this category are film recorders, which really do output using RGB light because they are exposing transparency film, though the dye clouds in the resulting processed film are cyan, magenta, and yellow, as in all color films and papers. Other RGB hardcopy devices include photographic paper-based output devices (also RGB-sensitive as they're photographic emulsions), such as the Durst Lambda, Cymbolic Sciences LightJet, and Fujifilm Pictrography printers; and the ubiquitous desktop and large-format inkjet printers.

Taking those in reverse order, we have already recommended that you get a proper ICC profile made for your own inkjet printer to get reliable proof print-outs (and you don't need a model with a PostScript RIP for this). The same applies for making your own final prints, whether they're for personal or commercial use.

The photographic paper-based printers tend to have proprietary approaches to color management. However, given their wide-gamut printing capabilities, it's probably best to keep your images in your chosen working space (which ought to be a suitably large one if this is the only kind of output you need). As these machines are large and expensive, they are usually operated by specialist service bureaus, so you should always discuss your file type and color-management options with the staff there. These output devices can be profiled successfully, and some service bureaus will be happy to perform conversions of your data from your working space for output on their photo-printers, thus giving you the benefit of that profiling.

graphics for the Web and multimedia

If you think it seems difficult keeping track of the variables in hardcopy printing, the situation is far worse in preparing graphics for on-screen use on the Internet or in multimedia use. This is because you have no control at all over the equipment or settings that your audience will have when they view your images. Some will have state-of-the-art systems with calibrated monitors showing 24-bit color, and some will have old PCs running only 8-bit color (that's only 256 different colors). Some might even have grayscale screens. At the time of writing, there are only two browsers that can recognize and use color profiles—and they're both on the Mac (Microsoft Internet Explorer 4.0 and later, and Apple's Safari, to be precise). As a result, there doesn't seem to be a lot of scope for extending your color-managed workflow to the Internet. Even on the Mac, the main role of ICC color profile support is to help correct for the gamma difference between "standard" Mac monitors and PC ones, so that Mac users will see Web pages as PC users do.

But the sheer diversity of installed equipment out there serves only to make your choices

simpler. You have to make assumptions about the average configuration and target your efforts toward that.

In practice, this means converting your images to sRGB because it's the nearest easily available profile there is for a "typical" PC monitor. But don't rush to do this at the outset— as we've already said in Chapter 3, sRGB offers a comparatively small gamut for RGB. So, if your images are also likely to be used in another situation where a wider gamut output is possible (inkjet printing, good CMYK print, depending on what colors you have in your original image), it can be better to keep as much color information as possible by working in a larger color space and

above Selecting ColorSync color management in Internet Explorer on the Mac

converting your Web images to sRGB only right at the end of the production process.

Beware, though: it's meant to be monitor-based, but sRGB is a working color space and conversions between working spaces don't handle out-of-gamut colors very kindly. It might be an idea to turn on soft-proofing, set your proofing space to sRGB, and turn on gamut warning (see page 106 for an explanation of how to do this in Photoshop) so you can see what areas are affected and what the conversion to sRGB will do to them. You might find that you need to apply a bit of desaturation before conversion to avoid

clipping of the extreme colors and consequent loss of tonal detail in saturated areas.

There is another reason to archive images in a larger color space: Web resolutions are so much lower than for any other type of application that you'll almost certainly want to keep a high resolution "master" for all other purposes. So it makes sense to retain the maximum color information in that master file too.

Working for the Web immediately raises a cross-platform issue from a color management perspective—the different gamma between Windows PCs and Macintosh systems. Although you may calibrate a Mac monitor to a gamma of 2.2 (which is about the same as for PC monitors), viewers with uncorrected "native" Mac setups with gamma 1.8 will see your images looking lighter in the midtones (see below right) than will PC users, unless they are using one of the browsers that does manage ICC profiled images properly (and even then, you have to turn it on in Internet Explorer; it's off by default).

Simple numbers suggest that it's more use to more of the people to get it right for PC viewers. However, it is possible (if the website is under your control) to go so far as to have dual versions of your Web pages, optimized for Mac or PC browser clients, which detect the type of browser originating the request for a Web page and send the appropriate version. Of course, that's a lot of extra work in both site creation and maintenance and you'd have to sure that it was really worth it.

If you're determined that at least some of the people should see your work in all its color-corrected glory, you'll find it easier to embed the profile in your Web images. This doesn't add very much to the file size and you could put a notice on the site for discerning Mac visitors, advising them to use Safari or Internet Explorer with the ColorSync option enabled (and a suitable monitor profile selected in their own system-level ColorSync settings) in order to see your images as you intended them to be seen.

file formats for the web

The principal file formats for Web use are JPEG, which suits "natural" images such as photographs, and GIF, an indexed color file (see Chapter 3) best suited to synthetic graphics with text or large areas of flat color, or those that require transparency or animation. Although you can embed a color profile in a JPEG file, the value of doing so is limited, as discussed above.

There is a trade-off between image quality and file size when making JPEG files—the smaller the file, the worse the effects of JPEG compression. Photoshop has a handy Save for Web feature that allows you to fine-tune JPEG and GIF images, balancing file size against image quality (shown on next page). If you're preparing images for a fine art or photographic website, you'd probably want to keep the quality as high as you can get away with, or possibly even provide smaller and larger versions of your images, the small ones for the main Web page, the larger ones for download or display with a suitable warning about file size interposed before the link.

Because GIF files use indexed colors—and typically only 256 or fewer—you can't do "real" color with them very well, so they're best avoided if at all possible. Back in the days when most computer screens could run only 8-bit color (that's 8 bits-per-pixel, 256 colors total, not 8 bits-per-channel, which is 24 bits-per-pixel, as

above Image slicing reduces download times, but can give color mis-matches if not handled with care

below With Mac OSX's Display Calibrator you can calibrate a Mac monitor to the standard PC gamma

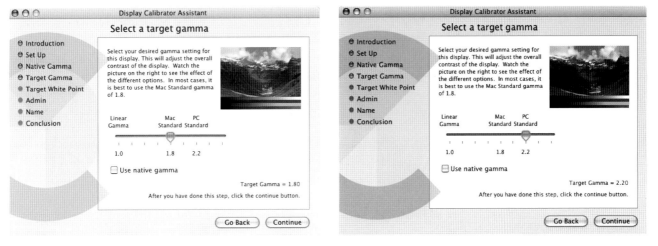

explained in Chapter 2), GIF was an adequate format for "real" color images. However, now that most people's screen run thousands or millions of colors, you may as well use JPEG. Anyone who is still viewing with a 256-color monitor is going to see a dithered version (i.e. the 256 colors mixed side by side to simulate the fuller range of colors), but then they're going to see that whatever they look at and will be used to it; everyone else will see something better.

Another issue that can affect the quality of your images on the Web is slicing. This means breaking a larger image up into a series of smaller but perfectly aligning pieces, usually in order to add interactive elements such as rollovers, but sometimes in order to apply different optimization (compression) to different parts of the image (see previous page). This can be pretty effective at reducing the download and display time for pages with synthetic graphics (i.e. logos, text and other navigation features). However, with photographic images it's less likely that you'll have large areas of single flat colors, and applying different levels of compression or even different file types (some parts JPEG, some GIF to support animation or other interactivity) to a photographic image is not likely to do it any favors; you might even see the joins between JPEG and GIF slices of an image. So, if GIFs need to be used, it's probably better to convert the whole image to GIF before slicing.

above and right
Photoshop's Save for Web dialog enables the careful fine-tuning of JPEG and GIFs for use online

images for TV and video

If you're supplying your images to a post-production house in order for them to be used as stills in a video or TV broadcast, there are some limitations to be aware of. Certain combinations and intensities of color are deemed "illegal" for video or broadcast. They cause "bleeding" of one color into another and in extreme cases can even break through and affect the audio.

The good news is that this applies mostly to highly saturated synthetic colors of the kind you're fairly unlikely to encounter in photographs that cause the problem. Better still, ICC color profiles exist for both major broadcast standards (NTSC and PAL/SECAM; there's also an SMPTE profile included with Photoshop and you can get one for the EBU color specification as well). By converting your images to whichever of these color spaces is appropriate, it should be possible to avoid problem colors.

You may find that video production specialists prefer to adjust colors themselves; they will know the technical aspects of the video standard they're working in. In this case handing off the file in a TV/video working space or in sRGB is as good a way to proceed as any. You only

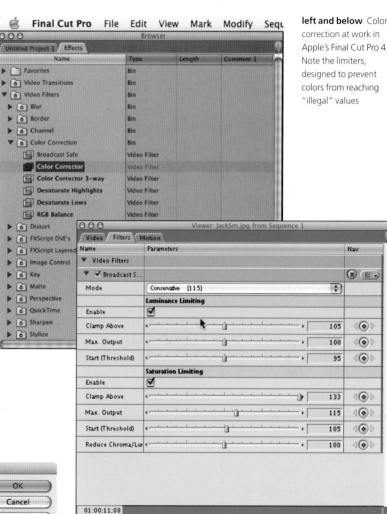

left and below Color correction at work in Apple's Final Cut Pro 4. Note the limiters, designed to prevent colors from reaching "illegal" values

have to go into a TV shop and look at rows of screens showing the same program on the same channel—all with slightly different color—to realize that maintaining color fidelity in broadcast TV or video applications is at least as difficult as it is on the Web. As always, the best you can do is to hand off the highest quality file consistent with any limitations you know about.

appendices

appendix I— key software and equipment suppliers

Here are Web addresses for a selection of key suppliers. The list is by no means exhaustive but includes suppliers whose products we have used:

Adobe—Photoshop image editing software
www.adobe.com

Chromix—ColorThink and other color management utilities
www.chromix.com

Color Solutions—basICColor color management profiling equipment and analysis software
www.color-solutions.de

Epson—consumer scanners, inkjet printers
www.epson.com

Fujifilm—digital cameras, professional flatbed scanners
www.fujifilm.com

GretagMacbeth—spectrophotometers/colorimeters, color measuring and profiling equipment
www.gretagmacbeth.com

HP—consumer scanners, large range of inkjet printers, digital cameras
www.hp.com

Monaco Systems—spectrophotometers, color profiling software and hardware
www.monacosys.com

PANTONE—Hexachrome color separation software, inks and solid color matching system swatch books
www.pantone.com

X-Rite—spectrophotometers, densitometers, color measuring equipment
www.xrite.com

appendix II—further reading on image editing, color correction and color management

Some useful Web links for color management information:
www.colormanagement.net
www.pixl.dk
www.chromix.com
www.colorremedies.com
www.hutchcolor.com

The International Color Consortium's Web site is at **www.color.org**

For more Photoshop tips and extensive color management advice, we recommend:

Real World Adobe Photoshop 7 by David Blatner and Bruce Fraser, Peachpit Press, 2003

Adobe Photoshop 7.0 for Photographers by Martin Evening, Butterworth-Heinemann, 2002

Real World Color Management by Bruce Fraser, Chris Murphy and Fred Bunting, Peachpit Press, 2003

Various publications on color theory and print-related topics are available from the US Graphic Arts Technical Foundation (GATF), whose Graphic Arts Information Network Web site is at **www.gain.net**

The European graphic technology research organisation FOGRA can be found at **www.fogra.org**

The series of ICC CMYK press output profiles developed by FOGRA is available from the European Color Initiative (ECI) Web site, **www.eci.org**

RGB working space profiles not included in the Photoshop set are available as follows:
BruceRGB—**www.pixelboyz.com**
EktaSpace PS 5, J Holmes is freely available at **http://www.colormanagement.net/downloads.html**; The Ektachrome family of color spaces is available by contacting Joseph Holmes directly at **jh@josephholmes.com**.
Kodak ProPhoto is available from **http://www.kodak.com/global/en/service/software/colorflow/rgbProfileDownload.blind**

There are various online user groups dedicated to Photoshop and imaging discussions, in addition to the Adobe's own forums. These include:

The Digital Imaging listserver at **www.prodig.org**

Apple ColorSync Users mailing list at **www.lists.apple.com/mailman/listinfo/colorsync-users**

appendix III—color management consultants

If you want to investigate having your color equipment profiled rather than attempt to do it yourself, here are some color management consultants who will be glad to help. If you don't see one in your country, contact the nearest one, who will probably be able to put you in touch with someone more local.

Continental Europe (Denmark):
Thomas Holm, pixl
Web: **www.pixl.dk**
Email: th@pixl.dk

Continental Europe (Germany): Hans-Peter Harpf and Karl Koch, Color Solutions
Web: **www.color-solutions.de**
Email: hh@color-solutions.de or karl.koch@color-solutions.de

United Kingdom: Neil Barstow,
www.colormanagement.net
Web: **www.neilbarstow.co.uk**
Email: info@neilbarstow.co.uk

USA (East coast): Dan Hutcheson, Hutcheson Consulting
Web: **www.hutchcolor.com**
Email: don@hutchcolor.com

USA (West coast): Steve Upton, Chromix
Web: **www.chromix.com**
Email: upton@chromix.com

glossary

additive color mixing: the mixing of red, green, and blue light to create white light with all at equal strength, or one of the millions of other colors when mixed selectively. The basis of all screen display and digital image capture.

Adobe Gamma: Adobe's display calibration application, which enables Windows users (and pre-OS X Macs) to adjust brightness and contrast values of their monitor by eye for improved color display accuracy. Replaced in OS X by the 'color' tab of the Displays System Preferences panel.

Adobe RGB (1998): a large color space encompassing the majority of printed CMYK and many of the smaller RGB gamuts. Gaining acceptance as an RGB color space for files made for printing purposes.

Apple RGB: an older color space based on the original Apple 13-inch color monitor and Photoshop 4 standards, with a lower gamma setting (1.8) than Adobe RGB or sRGB (both have gamma 2.2). Not widely used any more.

bit: the smallest possible unit of digital data, a 1 or 0 in a binary string.

bitmap: strictly, a digital image mode in which the pixels in the grid are either on (black) or off (white), creating a monochrome image. More recently the term is used to describe any digital image stored as a grid of pixels, each with their own color and brightness values, as opposed to a vector image.

Camera RAW format: a file format used by high-end digital cameras,which can be thought of as a high-quality digital negative, containing the image data in uncompressed form, plus information about the camera settings and light conditions at the time of exposure.

CCD: Charge-Coupled Device, an array of light-sensitive cells which proportionally transform light coming via a lens into a small electrical charge which is in turn converted to a digital signal. CCDs are used in digital cameras and all desktop scanners.

channel: the pixel data for any one of the primary colors in an image or document. Channels can be viewed individually in image editing programs like Photoshop, where they appear as grayscale images representing the strength of the primary color across the image. Channels are usually red, green, and blue or cyan, magenta, yellow, and black (where they directly correspond to conventional color separation plates), but additional 'spot' color channels are also possible within Photoshop for assigning special inks or varnishes, or for duotone production.

CIE: Commission Internationale de l'Eclairage. The international scientific organization behind the CIE LAB standard.

chroma: the intensity or purity of a color, and so its degree of saturation. Technically it refers to the mixture of wavelengths in a light source, where a single wavelength is the maximum chroma and an even mixture of all wavelengths is the minimum.

CMYK: the four printing-process colors based on the subtractive color model (black is represented by the letter K, which stands for key plate). In subtractive color reproduction the colors are created by mixing cyan, magenta, and yellow, the theory being that when all three are combined, they produce black. However, this is rarely achievable in real world printing, and even if it were the print produced would use too much ink and take too long to dry. For this reason, black ink is used to add density to darker areas, replacing a percentage of the other inks. Black values are calculated using GCR or UCR.

clipping: the loss or removal of color image data outside certain tonal limits. Converting an image from RGB to CMYK for print typically involves clipping of the most saturated greens and blues as these colors cannot be reproduced in print.

colorimetry: the technical term for the scientific measurement of color.

ColorMatch RGB: a smallish, and now somewhat outdated RGB color space, originally designed by Radius to match the typical gamut of its high quality monitors and provide a good match between screen and offset print.

ColorSync: Apple Computer's system-level implementation of ICC-based color management.

color cast: a bias in a color image, which can either be intentional or undesirable. If the former, it is usually made at the image editing stage to enhance the mood or feel of an image; if the latter, the cast could be due to any number of faults or limitations in the reproduction process, from the lighting in the original photograph to an error or malfunction in the final printing process.

color constancy: the ability of the human eye and brain to perceive colors accurately under a variety of lighting conditions, compensating automatically for the difference in color temperature. This phenomenon is also known as chromatic adaptation.

CMM: Color Matching Module. The 'engine'of a color management system, the CMM uses device and working space profiles to transform color data accurately between different platforms, software applications and devices. CMMs interpret pixel values using the ICC profiles that describe the RGB or CMYK behavior of devices (scanners, digital cameras, monitors, printers) so that they can be taken into account when working on an image.

color space: Description of he full range of colors achievable by any single device in the reproduction chain, along with any tonal and color deviations. The color space models device behavior. While the visible spectrum contains millions of colors, many of them are unachievable in digital imaging, and even though the color gamuts of different devices overlap substantially, they are unlikely to match exactly. For example, the colors that can be displayed on a monitor cannot all be printed on a commercial four-color press, and vice-versa – the press can print some colors that the monitor cannot display.

color temperature: a measure of the wavelength composition of white light. This is defined as the temperature—measured in degrees Kelvin (a scale based on molecular thermal energy in which 0 corresponds to about -273 degrees Celsius)—to which a theoretical object (a 'black body radiator', an object that reflects no light at all but can be made to emit it by heating) would need to be

heated to produce a particular color of light. A typical tungsten lamp, for example, measures 3200 K, whereas the temperature of direct sunlight is around 5000 K, and is considered the ideal viewing standard for printed materials in the graphic arts.

color wheel: a circular diagram representing the complete spectrum of visible colors.

cones: one of two forms of the eye's photoreceptors, found on the retina. Cones are sensitive to color, while the other type, rods, respond only to intensity.

cross-rendering: to render colors from one color space in another, usually for proofing or soft-proofing purposes, simulating one device on another, such as simulating a press using an inkjet printer.

curves: a tool for precise control of tonal relationships in image-editing applications, such as Photoshop. The curve graphically represents the relationship between input and output tonal levels in the image as a whole or in an individual channel.

DCS: Desktop Color Separation. A file format used for saving image files as color separations. Originally developed for use with the QuarkXPress page layout application, DCS files combine a low-resolution image for the working screen display with high-resolution EPS format data for output.

dithering: a technique of simulating many colors from a few by arranging the available colors in patterns of dots or pixels. When viewed at an appropriate size or from an appropriate distance, the dithered image will resemble a continuous tone print.

dot gain: the darkening and filling-in respectively of mid-tones and shadows in a printed image, caused by the spread of ink.

downsampling: the reduction of resolution in a digital image. Samples are made over groups of pixels, which are then processed to calculate the pixels of the new, smaller image.

dpi: dots per inch. A measurement of printed resolution, in terms of dots of ink or toner per inch on paper, film or printing plate. Not to be confused with halftone screening, which is usually specified in lines per inch or centimeter. For screen and digital file resolutions, pixels per inch (ppi) should be used instead.

drum scanner: a scanner used in high-end reprographic work, where original artwork is fixed to the outside of a drum enclosing a light source. The drum rotates at high speed while a receptor moves along its length. Drum scanners usually win over flatbed scanners for dynamic range because of the type of light detector used (see PMT).

Ekta Space PS 5, J. Holmes: a freely downloadable archive-quality working space designed to just cover the color gamut of Ektachrome transparency film, ensuring little or no color is clipped during transformation from the input space.

EPS: Encapsulated PostScript. A standard graphics file format used primarily for storing vector graphics files generated by applications such as Adobe Illustrator and Macromedia FreeHand. An EPS file usually has two parts: one containing the PostScript code that tells the printer how to print the image, the other a screen preview. EPS is also used for bitmapped images that contain PostScript clipping paths (as used in cut-outs) or other PostScript production instructions.

fovea: the spot in the center of the retina with the greatest concentration of photoreceptors, and hence gives the sharpest vision.

gamma: the (non-linear) relationship between input and output levels in an image reproduction process. Most often used when describing the behavior of computer monitors (in which 'input' is the signal applied and 'output' is the measured brightness) but can also apply to photographic film, paper, or processing techniques.

gamut: the full range of colors available within a particular color space, for example the range that can be captured by an input device, reproduced by an output device or described in a working color space (which may be larger than that of any real-world device).

GCR: Gray Component Replacement. A color separation technique in which black ink is used (instead of overlapping combinations of cyan, magenta, and yellow) to create a proportion of both gray shades and the neutral (equal C, M and Y) part of colors. This technique reduces ink use, avoids color variations and trapping problems during printing but can lead to 'thin' or gray-looking looking shadow areas

GIF: Graphics Interchange Format. A bitmap file format that uses up to 256 indexed colors to minimize file size and simulate a wider range of colors. Not a good choice for realistic color reproduction but a favorite in Web design as it supports transparency and animation (multiple images displayed sequentially).

gray-balanced: a property of an RGB color space such that equal levels of red, green and blue will always create a neutral gray. Working spaces are always gray-balanced.

halftone dot: the basic element of a printed image, where a continuous tone original is reproduced ('screened') by breaking it up into patterns of equally spaced dots of varying sizes to simulate the tonal values. Color images are reproduced by overprinting halftone patterns in each of the primary colors (see Separations).

Hexachrome: a printing process developed by PANTONE based on six inks rather than the traditional CMYK four. In true Hexachrome, orange and green are the extra colors. Hexachrome should not be confused with other six-color print processes, such as 'six color' inkjet printers that have extra cyan and magenta inks.

HiFi color: any process that increases the color range (gamut) of an output device, usually by adding extra inks to the standard CMYK set. The three main HiFi systems are the Kuppers approach (CMYK + RGB), PANTONE Hexachrome (CMYK + orange and green), and MaxCMY (CMYK + extra CMY).

histogram: a visual representation in an image editing application of tonal levels in an image, with the tones running from dark shadows to bright highlights along the horizontal axis, and the number of pixels of that tone in the image represented as a bar in the vertical axis.

hue: the attribute of a color defined by its dominant wavelength and therefore position in the visible spectrum. Hue is what we normally mean when we ask "what color is it?". Red, yellow and violet are examples.

ICC: International Color Consortium. The organization responsible for defining cross-application color standards for digital imaging and reproduction.

indexed color: an image mode that uses a limited range (up to 256) of pre-defined ('indexed') colors. Pixel values are calculated by matching original colors using a color look-up table. If a color in the original does not appear in the table the application selects the nearest color or simulates it through dithering. Indexed color was widely used in the early days of the Internet and the proprietary online services that preceded it to reduce file size of RGB images for quick download over slow modem connections. In variants such as GIF it's now used to add interactivity to Web pages.

ink limits: the maximum permissible amount of ink that can be laid down on paper in commercial printing. Expressed as a percentage, it can range form 240 per cent for newsprint to 360 per cent for high quality art books. Exceeding ink limits can cause drying problems, set-off or even cause the web to tear on a web press. Also known as total area coverage.

IT-8: a series of test color targets and tools for measuring color behavior of materials and devices, defined by the ANSI committee for digital data exchange standards. Different IT-8 targets are used to evaluate different devices. In color management an IT-8 target is used for building scanner or digital camera profiles.

JPEG: Joint Photographic Experts Group. An ISO group that defines compression standards for bitmapped color images, and the lossy compressed file format of the same name. Compression and quality are inversely related, making the format ideal for images that are to be used online or stored on a digital camera's memory card, but visible artifacts appear at lower quality settings, or when the file is manipulated, especially if resized. This effect makes it a poor choice for image reproduction or manipulation.

LAB (sometimes L*a*b*): the perceptually-based color model created by the CIE through a series of experiments which involved subjects varying the strengths of red, green, and blue lamps to match a set of sample colors. L, A, and B stand for the three parameters in this color model: L is luminance (or brightness) and

A and B are color axes ranging from red to green and blue to yellow respectively.

levels: an image editing tool which maps tones in an image, from the darkest shadows to the brightest highlights, as a histogram. By adjusting sliders on the histogram, you can remap tones across the image to improve the use of available tonal range.

luminance: the brightness of a color, from solid black to the brightest possible value.

metamerism: an undesirable property of printed material where the gray balance appears to change in response to the lighting conditions depending on the spectral content of the lighting. This is the effect responsible for items whose colors match under one lighting type (fluorescent, for example) no longer matching under another (daylight or incandescent).

offset lithography: the most commonly used commercial printing process. An image of the page is transferred photographically – or imaged directly – to a thin metal or plastic printing plate. Rollers apply oil-based inks and water to the plates but the ink only adheres to the imaged areas of the plate. This ink image is then transferred to an intermediate rubber cylinder, and from there transferred to the paper running between it and another cylinder.

phosphor: the light-sensitive coating in a CRT screen which glows when hit by a beam from the electron gun. Phosphors are arranged in patterns of red, green, and blue in order to create the appearance of a full-color display through additive color mixing.

pixel: contraction of 'picture element'. The smallest component of a digital image.

PMT: Photomultiplier Tube, the light-sensing element in a drum scanner. PMTs are more expensive to make than CCDs but because they effectively amplify incoming light signals are capable of better discrimination of tonal levels and hence better dynamic range. In reprographics, PMT can also stand for Photo-Mechanical Transfer, a process that creates high-quality, black and white prints on photographic paper. This is not part of a digital workflow and for most practical purposes is now virtually obsolete.

PNG: a flexible image file format that supports lossless compression, 24-bit color and transparency. Although technically well-suited for both Web and print reproduction purposes it has yet to catch on in either.

PPI: pixels per inch. The measure of resolution for a digital image or screen display, in terms of how many pixels fit into a single inch of screen or image space.

primary colors: pure colors from which theoretically all other colors can be mixed and which themselves cannot be created by a mixture of other colors. In printing, the primaries are the 'subtractive' pigments (cyan, magenta and yellow). The primary colors of light, or 'additive' primaries are red, green, and blue.

process colors: the colors of the inks used in a particular printing process, usually assumed to be cyan, magenta, yellow, and black unless otherwise specified. The process colors might be supplemented by spot colors that fall outside the gamut achievable using the primaries, such as very intense saturated colors and fluorescent or metallic colors.

profile: the colorimetric description of the behavior of an input or output device, which can be used by an ICC-aware application to ensure accurate transfer of color data. There are usually some generic ICC profiles installed on your computer by ICC-compliant applications such as Adobe Photoshop; you can also create your own or have them created for you by a color consultant. A profile describing the color space used during image creation or editing should ideally be embedded in the image, so that it can later be used as a reference by other users, other software applications or display and output devices.

PCS: Profile Connection Space. A component of a color management system used to transform color information between device-specific color profiles. In commercial products the PCS is a device-independent color model, such as CIE LAB or CIE XYZ.

raster: an image created by building up rows of pixels or dots. CRT TV and computer monitors show raster images.

resolution: the degree of clarity and definition with which an image can be reproduced or

displayed. Resolution is measured in terms of dots or pixels per inch or centimeter.

retina: the sensory membrane lining the back of the eye, consisting of several layers including one containing the rods and cones. The retina responds to light coming through the eye's lens and passes it to the optic nerve for transformation into an image by the brain.

RGB: Red, Green, Blue. The primary colors of the additive color model, and the color system often (and preferably) used for digital images until the print output stage.

Rods: the most common form of photoreceptor found on the retina. Rods are more sensitive to intensity than cones, but are not sensitive to color. There are eighteen times more rods than cones in the human eye.

saturation: the variation in 'purity' of color of the same tonal brightness from none (gray), through pastel shades (low saturation), to pure color with no gray (high or full saturation). *See also* Chroma for a scientific definition.

Separations: the 'split' versions of a page or image that has been prepared for process printing. Each separation is used to print a single process color or spot color.

simultaneous contrast: a human perceptual anomaly whereby colors or shapes are affected by surrounding colors or shapes. For example, a red square surrounded by a thick black border will seem brighter than the same red square surrounded by a white border.

soft proof: a feature in professional publishing and graphics applications where the effects of a CMYK or RGB conversion or printing process are simulated onscreen as accurately as possible within the gamut limitations of the screen used.

spectrophotometer: device for measuring emitted or reflected luminous energy at various frequencies throughout the spectrum. Spectral data can be displayed as CMY, density, LAB or XYZ values.

sRGB: a common RGB color space with a relatively small gamut, originally designed to characterize a 'typical' PC monitor, but also frequently used as a color profile for

consumer-level digital cameras. sRGB is gaining in popularity, and is not as bad a working space as it its limited gamut makes it appear.

subtractive color mixing: the color model describing the primary colors of reflected light: cyan, magenta and yellow (CMY). Subtractive color mixing is the basis of printed color.

tag: a color profile embedded in a digital image for color management purposes. A 'tagged' image is one that contains a profile.

TIFF: Tagged Image File Format. A popular graphics file format which can be used for any bitmapped images and for color separations. TIFF can be used for black-and-white, grayscale and color images. It can contain embedded color profiles and offers a lossless compression option. TIFF is an ideal format for image archiving and reproduction, but because it is extensible TIFF versions created by different programs (particularly Photoshop, which can save layers in TIFF) may not always be compatible with each other.

UCR: Under Color Removal. A method of black generation in the creation of CMYK separations for printing, in which common percentages of cyan, magenta and yellow ink are subtracted from color in neutral areas only and replaced by black. UCR uses more ink than GCR (see separate entry), which puts demands on the paper and press but produces richer and more contrasty results, especially in deep shadow areas.

USM: Unsharp Masking. Originally a traditional film-compositing technique used to sharpen an image, USM is now achieved digitally in scanning and image editing software via calculations that enhance the apparent sharpness of an image by increasing the contrast of edge pixels.

Vector graphic: a digital image defined not as a grid of pixels but as a set of mathematical instructions. These detail the positions, lengths and line-widths of lines and shapes in the drawing, and the colors, blends and textures used to form and fill those shapes. Vector graphics are resolution-independent, meaning they can be resized indefinitely without pixelation, and the small size of the instructions generally keeps file sizes low.

web press: a printing press that uses rolls of paper (known as webs) rather than the cut sheets of a sheet-fed press.

white point: the color of 'pure' white in an image. In an RGB image it corresponds to R, G and B values all at maximum, the brightest white that a monitor can show or scanner can read; in print or other CMYK hardcopy output it usually means the paper or other substrate color. The white point is usually treated as a movable reference point in color space transformations, except in cross-rendering where you might want to simulate the actual paper color in a proof. In digital photography white point refers to the color temperature of light under which a picture was (or is assumed to have been) taken; altering it can have a significant effect on colors in the image.

wide gamut: a large color space (almost always RGB) or device (usually CMYK plus additional colors for print devices, *see* HiFi color) that can represent or reproduce a larger range of colors than standard devices. Rarely used for commercial print, this is vital in high-quality photographic work where final output is to transparency recorder, photographic printer, or wide-gamut inkjet printer.

working space: a device-independent color space which, since it behaves more-or-less perceptually (similar changes to numerical values in any part of the color space result in perceptually similar changes in the image) and is gray balanced, can be used as a predictable and controllable working environment for image editing.

Xerography: a reproductive process where the surface of a drum is electrostatically charged so that it picks up particles of plastic toner on the charged areas only and transfers them onto paper to which they are fused by a heated roller. Xerography is the technology behind the photocopier and the laser printer and some 'digital' presses.

index

biographical notes

Michael Walker is a technology writer and keen amateur photographer. His career has included trade journalism, PR and creative marketing services, throughout which he has been involved with personal computer-based illustration, design and production. In addition to editing award-winning customer magazines, he has been involved in the conception and delivery of a wide range of printed and online publications, including the prestigious Adobe Calendar/CD-ROM, featured in the British Design and Art Direction (D&AD) Annual two years running.

Neil Barstow is the founder of color management consulting, equipment supply and remote profiling service company www.colourmanagement.net. He pursued a successful career in advertising photography, working with Stak Avialiotis and at Collett Dickenson Pearce & Partners before going solo. Dissatisfaction with digital image reproduction led to an increasing interest in the fledgling technology of color management and an association with Thomas Holm of Pixl in Denmark. In 2003, Barstow, Holm and Paris-based photographer/consultant Neil Snape formed consulting group colourcartel to work with manufacturers.

acknowledgments

We would like to thank the following individuals and organisations for their help in the preparation of this book: Julia Claxton, Craig Revie at Fujifilm Electronic Imaging, Hayley Bennett and Peter Virgo at Fujifilm Graphic Systems, Joseph Holmes, Steve Upton at Chromix, Thomas Holm at pixl, color-solutions, Fujifilm Digital Imaging UK, Gretag Macbeth, HP Indigo division, Heidelberg, PANTONE UK, Sony, X-Rite UK.

production notes

The worked example images shown in this book were variously scanned on Fujifilm FineScan 2750 and Lanovia Quattro professional flatbed scanners, on an Epson Perfection 3200 Photo desktop scanner or shot using a Fujifilm FinePix S2 Pro digital camera. They were manipulated on an Apple Power Macintosh G4 computer with Apple 20-inch Cinema Display, profiled using basICColor Display with Gretag Macbeth eyeOne Monitor spectrophotometer. Scanner and printer profiles for proofs were made with Gretag Macbeth ProfileMaker Pro and the iCColor spectrophotometer was used for measuring printed charts. Adobe Photoshop 7.0 was used throughout with ColorMatch RGB for the working RGB color space as requested by the prepress house and soft-proofing carried out using Light GCR 360 UCR CMYK Euro Positive Proofing as the CMYK output profile, as supplied by the prepress house.